"In *The Zombie Gospel*, Danielle Strickland does a masterful job of drawing out deep lessons on what it means to be human from the popular TV series *The Walking Dead*. Avoiding the pitfalls of sensationalism and overspiritualization, Danielle's treatment of the messiness of life, the consumptive nature of modern society, and the hope of the Christian message as themes emerging from this series is superb. It will make you want to watch *The Walking Dead* a second time so you can understand it for the first time. This is the best spiritual analysis of a television show or movie I know of."

Ken Wytsma, founder of The Justice Conference, author of *The Myth of Equality* and *Create vs. Copy*

"I don't know much about zombies, except I'm pretty sure I never want to meet one. I can't say I've ever watched a zombie movie. Danielle Strickland is one of the only people who could get me to read a book about them. And here's why: I try to read and listen to everything she has to say. She is a shining light in a world full of darkness. And this book is her invitation to love dead people back to life, to detox from our addiction to violence, and to turn this world around so that life rather than death captures our imaginations."

Shane Claiborne, author and activist

"Danielle Strickland takes a cultural phenomenon—*The Walking Dead*—and uses its insights to shed new light on ancient biblical truth. The result is a book that is refreshingly nonreligious and relevant—a life-giving message for our zombie world!"

Pete Greig, Emmaus Rd and 24-7 Prayer

"The whole zombie genre resonates deeply with audiences because we know our world is broken and yearn for a way for everything—and everyone—to be repaired. Danielle Strickland gets it. And she gets that the way of Jesus offers us a radical new vision of what it means to be a human person. Read *The Zombie Gospel* and come back to life—real life."

Michael Frost, author of *To Alter Your World* and *Incarnate*

"I'll be honest and admit that I just love everything my friend Danielle writes, says, or does. She is the real deal. *The Zombie Gospel* is no exception. In this book she offers us a vision of a life well lived."

Alan Hirsch, founder of 100Movements and Forge Mission Training Network

THE ZOMBIE GOSPEL

THE **WALKING DEAD**
AND WHAT IT MEANS TO BE HUMAN

DANIELLE STRICKLAND

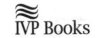

IVP Books

An imprint of InterVarsity Press
Downers Grove, Illinois

UNAUTHORIZED

InterVarsity Press
P.O. Box 1400, Downers Grove, IL 60515-1426
ivpress.com
email@ivpress.com

InterVarsity Press® is the book-publishing division of InterVarsity Christian Fellowship/USA®, a movement of students and faculty active on campus at hundreds of universities, colleges, and schools of nursing in the United States of America, and a member movement of the International Fellowship of Evangelical Students. For information about local and regional activities, visit intervarsity.org.

All Scripture quotations, unless otherwise indicated, are taken from The Holy Bible, New International Version®, NIV®. Copyright © 1973, 1978, 1984, 2011 by Biblica, Inc.™ Used by permission of Zondervan. All rights reserved worldwide. www.zondervan.com The "NIV" and "New International Version" are trademarks registered in the United States Patent and Trademark Office by Biblica, Inc.™

While any stories in this book are true, some names and identifying information may have been changed to protect the privacy of individuals.

Cover design: David Fassett
Interior design: Jeanna Wiggins
Images: destroyed city: © verlite/iStockphoto
　　　　red stains: © Photoslash/iStockphoto
　　　　blurred hand: © baona/iStockphoto
　　　　torn paper: © autsawin/iStockphoto

ISBN 978-0-8308-4389-3 (print)
ISBN 978-0-8308-8925-9 (digital)

Printed in the United States of America ∞

Library of Congress Cataloging-in-Publication Data
A catalog record for this book is available from the Library of Congress.

P	19	18	17	16	15	14	13	12	11	10	9	8	7	6	5	4	3	2	1
Y	32	31	30	29	28	27	26	25	24	23	22	21	20	19	18	17			

Dedicated to Lt. Col. Joyce Ellery,

*who loved me as a zombie and
introduced me to the Cure.
And to all those who, like her,
never give up hope, offering Jesus
as the way to be human.*

*You are living witnesses of God's
resurrection power in real life.*

CONTENTS

INTRODUCTION

For a long time I considered zombie shows a colossal waste of time and energy, and evidence of a dark and sinister reality threatening our common sense of goodness. I suspected it was yet another fascination with darkness that could desensitize us to the foreboding realities of everyday darkness. At least that's what I thought.

I continued to be amazed at the rising popularity of zombie shows, but once I got past my initial contempt, I gave in to curiosity. Tucked up by myself so as not to contaminate anyone else, in the late evening hours after my kids had gone to bed, I put in earbuds and watched *The Walking Dead*—trying to get a grasp on why this show is so prevalent in our culture.

What happened was amazing. I glimpsed a realm of media communicating some of the deepest themes of humanity. I became increasingly convinced, as I watched with wide-eyed wonder, that far from an excessive, dark fantasy feeding a lackadaisical attitude toward evil, the show offers us a window into the most important questions of our time.

Really? you may be wondering. I understand. I was decidedly dubious myself. You might think that shows like *The Walking Dead* are simply the latest entertainment to satisfy

our shallow culture's need for the latest thrill. But as I watched, I learned. I heard a cry, a warning, an invitation. The whole story seems to be a way into another realm with more questions than answers. But the questions are like answers because they are important questions—elemental and existential at the same time. It felt like—well, it felt like the *gospel*, which simply means "good news." But more than a happy little announcement that makes for a Hallmark moment, the gospel is a pronouncement that important news is coming, more like the rumor of an uprising or the birth of a new king. Think *overthrow*.

The good news is now mostly associated with the Christian faith. And when the founder of that faith, Jesus, came on the scene, the backdrop was pretty dismal. Things were unhinged; the tension was *palpable*. Against this backdrop Jesus declared that he had come to bring good news. Contrary to popular opinion, the good news wasn't delivered by a fairy-godmother–like Jesus who granted our wishes and promised we'd live happily ever after. Many of us don't have a clue of what "good news" means.

We forget, at our peril, that Jesus called for a new humanity and the end of an old one. He challenged a system based on greed, exposed religious folks as frauds, and announced a new world order. If anyone had a way of creating havoc, it was Jesus. There was nothing neat about the ministry he led or the results it produced. The early church followed in his footsteps—confounding the wise, exposing corruption, and refusing to cooperate with existing powers. They paid for this

good news with their lives—but it was worth it. The results? Social inclusion, poverty relief, wealth redistribution, public mercy (think social services), and eventually hospitals and schools. This is good news! It changes things. Everything, actually.

The real gospel has been co-opted by a religious fairy tale for so long that, for many of us, it's lost its power. The gospel has been hijacked to support and encourage a "personal relationship" at the expense of community overthrow. But even more, it's created a vacuum in the middle of our society. And into the vacuum have disappeared meaning, authentic relationships, and hope. We've been living among shallow and inconsequential things for so long that we've forgotten what it means to be human. Are love and pornography related? Is knowledge the same as wisdom? Why doesn't higher education lead to happier lives? Does wealth mean prosperity? Shallow and shiny things fill in for the deep and beautiful realms of life, which has created our desperate times.

So, the meek and mild Jesus we've all heard about might not be so meek after all. To overthrow economics as a driving force of religious worship, he resorted to whips and table crashing. He sent evil spirits into pigs, and in so doing destroyed the financial systems that kept peasants trapped in systemic poverty. He liberated a man chained and living in graveyards. When Jesus was done, the villagers "begged him to leave their region." That's right. The most amazing miracle just happened, but it was too much for them. "Please go away," said the leaders to this man who had the nerve to challenge power with love.

This gospel was good news, all right. It was good enough to set the world right side up, and it created havoc in the process. *If you've only heard about the personal Savior, you have heard right—but you haven't heard enough.* A new world is possible. A new humanity is emerging—not one based on power or gender or stereotypes or religion. It's fully alive. It's humanity as it always was intended to be. It lies at the heart of the creation story, rooted in God's original intention for this world—love.

When I heard about *The Walking Dead* (spoiler alert: the contents of this book will tell you what happens), I was intrigued by the premise. An apocalyptic virus infects most of the human population, leaving them as "the walking dead"— zombies. The survivors make their way through the wreckage and chaos. Everything has changed, and it's up to them to make a new world. Will they survive?

That night as I watched my first episode of *The Walking Dead*, I was shocked to find in its emerging story a *greater story*—a story I recognized. I felt a holy presence, a rush of adrenaline, deep inside calling to me. Like a warning and an invitation at the same time, an announcement of good news evoked in me a longing to live the *deeper story* in real life. See, I believe God will use anything to talk to us. He beats on the doors of churches trying to get us to open up and let him in. But often—like the pig farmers—we beg him to leave us alone. So he comes to us in other places, in places we'd least expect. When he walked on earth, he spoke from unlikely places too. Unclean ones. Unholy ones. Gory places filled with horror and filth. Why would we be surprised to hear him speak from these places again?

In that gospel tradition we can hear him shouting about a new humanity—through a genre that may offend us in order to awaken us. We are called to deeper places, to ask hard questions and seek answers from the depths of our being. It's good news because it leads us to see the world in a new way and offers us a chance to live a new way in that emerging world. Let's call that invitation the "zombie gospel" and discuss the question it raises—namely, can this world be saved?

IT'S THE END OF THE WORLD AS WE KNOW IT

Rick (the former sheriff of the town) wakes up in a hospital where he's been recovering from a gunshot wound. Though he expects life to be the same, it isn't. Normal is the furthest thing from the truth. While he's been in a coma, the end of the world has commenced. The zombie apocalypse has spread like wildfire through city centers around the world, and everyone has scattered in the terrifying reality, simply trying to survive. Anyone who is bitten by an infected human (now a zombie) will turn into "the walking dead." Rick is unprepared and overwhelmed by the horrific reality confronting him. He stumbles around, heads back to his house, and tries to regroup. Dazed and confused, he is slowly getting a grip on the new reality that is ahead of him. Life has forever changed. It's the end of the world.

Deep inside we know we all must face the reality that the end is near. I know—it makes us think of a doomsday prophet holding a cardboard sign on a dirty downtown street corner. But all of us wonder if it's true. Whether it comes as an external

reality (a world war, global warming, terrorism, pick your own global calamity) or whether it's internal (the collapse of a marriage, the exposure of our façade, the unavoidable human condition of messing everything up), it seems inevitable. Whether it's outside of us or inside of us, the end of things is inevitable for us all. And the questions raised as a result are possibly the most important questions we will ever ask.

That's why it seems the apocalyptic genre never gets old. On YouTube I heard an apology from a religious leader who had predicted the end of the world was coming the previous month—and believe it or not, he's not the first (or the last). The world is going to end—or is it?

The zombie genre plays with our apocalyptic fears. It plays out the story of our worst nightmare that something catastrophic will happen, and the possibilities of human survival is bleak—fleeting at best. The odds are against us. The atmosphere is hard.

Why do we like to explore this scenario?

Everything Is Deconstructed

Bill, my friend from northern Canada, calls himself a "redneck with a heart." We were friends around the turn of the millennium when there was nonstop paranoia about the world's computer systems shutting down when their internal clocks changed to the year 2000 (Y2K). It was crazy. But Bill told me not to worry about it. The week before New Year's Day he mentioned it again, "Don't worry, Danielle, I've got it all sorted out." I asked him what that meant. He began describing

a room in his basement with supplies, water, canned food, shotguns, and ammo. I said it sounded great, but why did we need the shotguns and ammo? Bill looked me in the eye and said, "Have you ever seen people when they get hungry?"

I've got a hunch that aversion to bad news is built into our DNA. We have fears! Deep inside, we fear that we will lose things. Things that matter. Stuff that gives us meaning. People we love. The zombie genre plays on our fear of losing the things that give our lives purpose.

A friend and I were chatting about this very subject over lunch at a restaurant. What's the big deal about zombies? I asked our waiter (an early twenties university student) if he was into *The Walking Dead*. He said he was. I asked him why he thought it was such a popular show. He said he thought it was all about existential angst. "Think about it," he said to me, "everything that defines your life has deconstructed. What then?" At that moment I knew I needed to look closer.

Rick tears through his house, looking for his family. He can't find them. He starts to panic but suddenly notices certain things about the house. The pictures are gone. So are some clothes and items for survival. He realizes that his family is on the run. He heads to the police station to "arm up," shower, and prepare for the journey to find his family. In the process he gets caught by "walkers" (zombies) and is rescued by a father and his son. In the unfolding hours and through the night, these two rescuers give Rick a fast-moving, head-swirling, reality-inducing tutorial on the walkers and the new realities of survival. No family. No job. No friends. Rick sets out on his own to find a new way to live.

So, what defines your life? Most people, when asked who they are, lead with what they do. They are, of course, talking about their jobs. We place a lot of value on what someone *does*. And there is a pecking order of most valuable jobs, which changes with each generation. Today, it seems jobs that make a lot of money are at the top of the list. Speaking of money, the richer someone is, the higher their social standing.

Our news outlets are filled with reports on the rich and famous. We don't look to doctors, politicians, or pastors to inform us about what is valuable—we look to wealthy people. Our culture esteems success. And to us the wealthy and famous define success. When I Googled most successful people in America, I got over one hundred lists of the richest. It's safe to say that our current value system measures our lives by money, fame, and power.

But what if this system fell apart? Shows like *The Walking Dead* explore such a scenario. What if there were no jobs—for anyone? What if there was no more "work" to give us identity? What if there was no need or use for money? What then?

Poverty Mentality

My father-in-law lived through the Great Depression and still tends to hoard things just in case he needs them later. Once I caught him at the stove (a shocking surprise) and witnessed him scraping into a pot the stuff stuck in the bottom of empty underarm deodorant bottles and melting them to make another deodorant. This image is forever etched in my mind. It's a clear sign that he had lived through a depression. Living in an

unfamiliar and harsh world changes a person. It changes the things we value, how we measure worth, and alters our behavior.

The Great Depression began in 1929 when the stock market collapsed. By 1933, nearly half of America's banks had failed and close to fifteen million people, or 30 percent of the workforce, were unemployed. If ever there was an "end of the world as we know it" moment in American history, it came during the Great Depression.

I've read countless interviews with children who had to leave school and start working as day laborers to make sure their families didn't starve. It changed everything. Bartering became the preferred method of buying and selling; they couldn't survive with money because there wasn't enough food to buy. People had to figure out another way to live.

Like a scene out of *The Walking Dead*, all we have to add to the Great Depression is an infectious disease (like tuberculosis) and we've got ourselves a horror show. Life had changed forever. And what is most striking about the interviews is how it changed those who lived through it. They can't let go of anything. Turns out my father-in-law is not alone. Some survivors of the Great Depression are "pack rats"; they can't let go of stuff because they might need it later. This is a survivor skill.

A friend recently adopted children from another country—where they lived without. One of them kept taking food and hiding it in her room. When asked about it, she said she assumed she wouldn't be fed again for a long time. This "poverty mentality" had become her way of surviving. Survivors hang on to what they have and never let go. Not ever.

Why, in today's culture of more than enough, are we still so close-fisted? We fear we won't have enough. And since we were little we've been taught that what is ours is *ours*. Though we are fairly well-off, we still have a poverty mentality. When it comes to tough times, it will be "me and my family" who survives. Fear tells me to grip my life and never let go. We can't share because we hold so tightly to what we have.

> *After Rick is reunited with his family, he makes a decision to go to town to rescue another member of the community they have joined. He risks his life for someone else. Rick just found a safe place, why push it? Why take that kind of risk? It seems that Rick was built to live for something bigger than himself; he has an ethos of sacrificial leadership. He has a purpose that extends beyond mere survival—to being a full human being. And being human is much more complicated than simply staying alive.*

Corrie ten Boom was placed in Nazi death camps for hiding some Jewish folks in her house. She lived through what could be described as a horror film that made *Night of the Living Dead* look realistic. She talks about her relationship with Jesus a lot. Somehow in the midst of that terrible place, she was able to sense his presence, peace, and kindness, and was therefore willing to live differently. It was difficult. In that bleak, horrible, survivor setting, she set her mind to live out what Jesus had commanded—to love her enemies, to share her food with the hungry. Watching Corrie share her daily food rations with the sick was a miracle to those who had lost their humanity because they were trying to survive. Talking

to Corrie ten Boom is one thing, but talking with those whose lives she impacted is another. It is breathtakingly powerful. And that's the other thing about survival.

In every interview, those who survive terrible circumstances explain how their values changed. Several of the interviewees suggested that our present way of life, which is focused on material wealth and its excesses, is empty, fleeting, and even "dangerous." They warn people not to value things that only money can buy. One older gentleman, recalling how he got through the hardest days he's ever lived, said he survived because of the *people* who helped him. People who sacrificed and shared. Folks who were already dirt poor and tired as dogs shared their bread or their house or their joy. These interviewees advise us to take time to love and enjoy each other—things that money can't buy. Even in the midst of a survival situation or poverty culture, humans can experience the things that really matter: love, hope, kindness, faith.

Taking Risks

In the second season of The Walking Dead *we meet Hershel, a farmer who still believes in the old-fashioned values of a world governed by God, trying to do his best for his family and the people he encounters along the way. He believes that everyone has something to contribute. Everyone can help each other survive. Explaining why he stays with the sick of the community instead of leaving to survive, he says, "You step outside, you risk your life. You take a drink of water, you risk your life. And nowadays you breathe, and you risk your life. Every moment now you don't have*

a choice. The only thing you can choose is what you are risking it
for. . . . I can save lives. That's reason enough to risk mine."

Living for ourselves for a long time teaches us things that keep our lives small. We start to believe that what we earn or own defines us. We forget that what Hershel says is bang on. It's a risky world. No one can guarantee our safety. We are convinced that by living safe and small we will survive. But perhaps the message of these survivors, both real and imagined, is that surviving isn't the same as living. Living means choosing to take risks, risks that make us truly human.

This leads us to the one question that really matters. When our world is turned upside down, when things aren't how they are supposed to be, or how they used to be, when our jobs and wealth and status no longer seem to matter, when we start failing to impress anyone with our credentials—what will happen? This is the first question of the zombie gospel, and it comes with an invitation. To answer it we will have to be brave. Honesty and humility will be our best weapons as we encounter a truth that could liberate us to be the people God made us to be—truly human. What makes you human? Will you survive? What gives your life value? What will happen to you and the people you love? What if your world deconstructs—what then? May the truth set us all free to live a life that at the end of all things still matters.

WHO ARE YOU NOW?

Rick continues to act like the sheriff he was before the apocalypse. He drives his squad car, flashes his badge, and brandishes his gun. However, it slowly dawns on him, and many others, that the world he used to be in charge of no longer exists. The badge doesn't cut it in a world where the law no longer applies. It's anarchy and chaos, and no sheriff is able to change that. Who is he now?

This story is pretty much repeated with each character we meet in *The Walking Dead*. On this side of the disaster, old identities are gone, and each person we meet is brand new. Good or bad, rich or poor, married or single, parents or not— in the end it doesn't matter anymore. What matters now is not who you were but who you are. Think about that for a minute.

New Humanity

We often use a story in the Bible to illustrate the difference between being *busy for* God and *being with* God. Martha is busy in the kitchen, and her sister, Mary, is in the main room sitting at Jesus' feet. Martha gets frustrated and asks Jesus to tell Mary to get back to where she belongs. When we tell this

story it seems obvious that Martha is upset because Mary isn't pitching in, but instead of instructing Mary to get back to work Jesus tells Martha that Mary has chosen the better thing. What? Is the better thing to not work, to neglect the dishes? Many Christians think this is what the story means. But what exactly did Mary choose? (This is where it starts to get apocalyptic on us.)

Mary is sitting in the part of the house reserved for men, and in this instance for male disciples. Sitting at the feet of a rabbi is what a disciple did. Martha is not upset about the workload—she's upset about Mary sitting with the men and learning as a disciple. When Jesus responds to Martha, her world is turned upside down. He is declaring his intentions to live in a society that doesn't limit people based on gender. He is breaking social norms and cultural barriers, and this upsets Martha. Jesus will not relent. This is the kingdom he is bringing.

Jesus continues to demonstrate that his kingdom rejects the old value system of money and power. A new humanity is emerging that judges people not on the basis of the dominant cultural values but by who they are in the new kingdom. Jesus chose the powerless and said they would lead in the emerging world. It would be that crazy.

In a world where women weren't even considered fully human, he invited women to govern, and people from the other side of the tracks were invited to dine with people of privilege. In Jesus' kingdom all were considered equal. Their status, their color, their accomplishments, and the size of their

bank accounts didn't matter. A new day is dawning. A new humanity is emerging.

Rick takes the initiative to form a team of the ragtag people who live together. Glenn, formerly a pizza delivery guy, turns out to be quick, clever, and loyal. As Glenn uses his intelligence to survive, he intuitively helps the others. Daryl, an "outlaw," has no use for rules or showers, and couldn't care less what other people think. But as Daryl experiences the group's acceptance, he becomes a trusted friend, someone who matters. They start to need each other. There is a deep camaraderie. It's not just about survival—it's deeper than that.

Shane, Rick's former law-enforcement partner who stepped in to care for his family (and have an awkward love affair with his wife), can't adjust to the new world. He wants to be in charge, but he's not the right guy. When Rick comes, Shane gets pushed aside in more than one way. His position shifts and he is left seething. Because of jealousy and fear, Shane slowly begins to lose the essential elements of his own humanity.

Shane heads out on a mission with a new member of Hershel's farm community. Their mission is to get some much-needed supplies for those at the farm. The mission goes sideways, and Shane and his new friend are running for their lives from what feels like a million zombies. Shane is in a tight spot and knows it. He has a gun but only a few bullets, and in a split second he makes a decision that ensures his survival, but also his death. He shoots his new friend in the leg. This makes his friend bait for the zombies and gives Shane the time he needs to escape. It's a pivotal moment in Shane's life and for his personal character. Shane is confronted with his own capacity for selfishness, and it ensures his end. Shane's life begins to unravel from the inside out.

The people who followed Jesus struggled with his new world and its upside-down rules, especially those who had wealth, power, and prestige in the old world. Do you understand the tension? If you had built a realm that made you a success, a "king," the new world wouldn't be good news. Many people felt this way about Jesus and his kingdom. Those with the most to lose often opted out of believing in Jesus and living in the new kingdom of God.

Judas Iscariot, one of Jesus' disciples, rejected the new world. He turned Jesus over to the temple authorities for thirty pieces of silver.

I think of Judas as I think of Shane. Judas wanted the new world to be about him. He hoped to acquire status and power and control. And as Jesus increasingly introduced a kingdom that opposed those values, Judas's internal struggle began. I imagine he thought Jesus was exaggerating about the weak being strong, the poor inheriting the earth, and other outlandish things. Certainly, Jesus would soon come to his senses. *Any day now*, I imagine Judas thought, *Jesus will take up the fight, overthrow the Roman oppressors, and liberate his people.* But that didn't happen. And as it became apparent that Jesus was not just spouting off but was increasingly enacting his radical ideas—inviting the poor, the broken, the unlearned, and the foolish to join his kingdom. Judas became increasingly uncomfortable.

Some people suggest that by handing Jesus over to the authorities Judas meant to speed up what he considered to be Jesus' mission to stick it to the Romans. And when Jesus

allowed the Romans to crucify him, Judas simply couldn't handle this upside-down world. He would rather bail than live out the kingdom Jesus had proposed. Judas's and Shane's experience is similar. Essentially, Judas shot Jesus and enabled a bloodthirsty crowd to consume him. Although it ensured Judas's short-term survival, it also ensured his own death, like Shane's decision to sacrifice his friend. Judas could no longer live with himself. And he took his life rather than face his personal shame.

Shortly after Jesus left earth and it was up to his followers to lead the charge, they followed his radical example. They weren't impressed by people with great old-world résumés. Instead, they were much more interested in who people were in relation to the new kingdom: what they did, how they acted, what they shared, how they lived. These are the things that matter.

The Revolution Begins

You may have heard of St. Francis, a thirteenth-century friar and preacher who practiced the words of Jesus, which stirred up trouble and sparked a revolution in the church. Raised in a wealthy merchant's home, he partied a lot and wasn't particularly saintly. Life started unraveling for Francis when he returned from the frontlines of a battle—he had an encounter with a leper.

Lepers disgusted and terrified Francis, but as he was embraced by one, the leper turned out to be Jesus! Francis supernaturally encountered Jesus through a leper and was forever changed as a result. He suddenly saw the world differently and

his whole world was turned upside down. He woke up to the reality that the material world was of little value. When he read that Jesus said we should share our wealth with the poor and hungry, Francis started to give away his father's stuff. His father got furious and eventually took Francis to court. The whole town gathered while the judge heard the grievance against Francis. When the judge asked if Francis had anything to say, Francis simply stripped down (completely naked), laid his clothes at his father's feet, and declared he had a Father in heaven who would look after him. He then turned and went to live among the town's beggars. Crazy! Francis has clearly lost his mind, right?

A few days later his rich friends went after him. They figured they'd find Francis repentant and depressed, and they'd offer him a way out and get his life back on track. Sounded like a plan, but what happened couldn't have been more different. When they found Francis, he was filled with joy. He was the happiest he had ever been. He told them he was so happy he was completely filled with love. He understood God and saw the way the kingdom worked. He wanted them to know it as well. His joy, love, and happiness was so infectious that instead of Francis going with his friends, his friends joined Francis. And the revolution commenced.

Wouldn't it be refreshing to no longer be defined by external realities? But if your life is driven by looking good rather than being good, this thought can be terrifying.

Paul, a biblical character, understood what it was like to follow the old system of power and control. He actually killed

people who refused to conform to it. He was part of the old order's high society. But through a massive revelation of Jesus, some blindness, and a sort of personal apocalypse, his world collapsed. It took him years to figure out how to live in the new kingdom, but once he did he began to invite everyone he could into the new, emerging world. In a letter he wrote to the church in Rome, he asks the people of God to stop being squeezed into the pattern of the old world. Instead, he encourages them to let God renew and transform their minds so they can live as new humans.

This is shocking stuff!

Shortly after the collapse of the Soviet Union, I spent a year in Russia volunteering with the Salvation Army. One day our headquarters in Moscow got a call from Yalta, a port city on the Black Sea. It was from a man known as the "General from Yalta." No one at HQ had heard of him, so they sent me (the only expendable member of the team) with a translator to check him out in his hometown. It turns out the most impressive man I've ever met couldn't afford to buy me lunch. He had spent years in work camps scattered throughout the Soviet bloc. "Gulag" was his middle name.

The General was a new kind of human. He held no regard for normal systems or structures. He simply didn't care for the things of this world. He knew of a better one. As he shared his life with me, he deconstructed mine. I felt it crumbling. Position, power, and command no longer seemed to hold any sway; they actually looked small and irrelevant. Those caught up in them were like children playing a silly game.

He told me about beatings and imprisonments and years of hard labor, but also about amazing times of provision, love, goodness, and grace. With tears rolling down his cheeks he told me of the God he had known and the people he had met along the way. He never spoke with regret, disappointment, or hurt, but only with great gratitude and humility. His life was filled with meaning and purpose. As he spoke, my world changed. I'm not really sure how to say this, but it was like the first time I had recognized what it means to be alive, like a new way of living was introduced to me. *It was the end of the world as I knew it.*

From that day on I began to long for something else. I longed for what this man had introduced me to: a new way of being human. He unleashed a hunger inside of me for something more.

A New Way of Seeing

This is the effect Jesus has on people too. One man who got filthy rich at the expense of the poor had Jesus over for dinner. Actually, Jesus gatecrashed the man's party. But by the end of the dinner, the man started giving his money away. He literally gave it back to those he had taken it from and more besides. Jesus hadn't even brought up his money-grabbing, greedy, unjust treatment of the poor. Jesus brought up something else, something deeper, something truer. His invitation calls us into deep places.

To enter into this new reality involves *repentance* (which means to change the way we see), and that opens up the way

to a new life. Jesus offers a new way of seeing. He demonstrates his ability to do this by literally healing blind people and offering to heal our (spiritual) blindness too.

So, if you are struggling to see another way, you can ask Jesus to help. The easiest way to start the process is by admitting you need help because you are blind to God's ways in this world. And then, by God's help, you simply start living it out. As in *The Walking Dead*, it's the reality of waking up to a new world; the old world no longer makes any sense. A new world is emerging, and the main point is, who are you? Notice how I'm not asking you what you believe. This is important. I don't care what you believe but what you are doing. How are you acting? Blind people who pretend they can see can't fake it well. Neither can we when it comes to spiritual things. If you don't know how to navigate the realities of the new world, you need to see differently. Admit your need and ask for help. Repent. And you can see and live a new way.

In The Walking Dead, *a pizza delivery guy becomes a strategic leader, an outlaw becomes a good guy who cares about other people, an abused woman becomes a strong survivor, a sheriff becomes a complicated savior. They don't just lose their old identity, they gain a new one.*

Before anything else, Jesus unleashes hunger for something new, something possible. What if the world you are in were deconstructed? What if it no longer mattered who you have been or what you have accomplished in the past? What

if money wasn't the driving force of your life? What if you didn't care what other people thought of you? That would be the end of the world as you know it and the start of something brand new.

FIGHTING THE ZOMBIE INFECTION

An episode of The Walking Dead *explains the disease that is causing the zombie apocalypse. It's the last few hours of the Center for Disease Control. Dr. Edwin Jenner, the lone surviving scientist, shows the group of survivors how the disease works by using a video of his own wife's death after being bit by a zombie. The infection invades the brain and quickly shuts down the body. Death. But then the infection restarts the brain stem to get the body moving, while the rest of the brain stays dark and dead. The "second event" of the disease causes the dead human to become an infected host and makes them hungry for living flesh. They end up as mindless, flesh-eating machines. Their bodies still function, but are not really alive. They are the "walking dead." As the disease is explained, the group knows by experience exactly what that means. Former people, now barely recognizable, are trying to consume them.*

In movies or TV shows, sometimes it's a disease unleashed on the world by accident or designed by some evil company. Sometimes it's just a genetic anomaly. No one knows why, but all of a sudden most of humanity has this manifestation of deadness. They are the "walking dead." Zombies. They have

only one aim: consumption. They must consume. And what they consume is what freaks us all out—*they consume us.*

The zombie genre got its big start with *Night of the Living Dead*, directed by George A. Romero. Everyone agrees this film launched horror movies into a new level of gore and violence. And its social commentary forced people to think about what was happening in the world. *Night of the Living Dead* was released in 1968, produced with only $100,000, and surreptitiously covered topics such as the Vietnam War and racism.

The film parodied the reality of America at war with itself. The zombies were considered "unhuman" and were killed without remorse, reflecting the realities of violence in the real-life war. Zombies were mindless killing machines, which was a nod to soldiers who were conflicted about fighting but fought nonetheless. The hero of the story was an African American man who manages to fight off a horde of zombies and survive the infection only to be gunned down at the end by a group of white humans. An obvious attack on the vicious racism of America.

The connections of the zombie genre to social commentary was clear. Even if the original film was in black and white, the social implications were in living color.

In 1978 George Romero did it again with *Dawn of the Dead*. Bigger and in color, this film is about a global zombie apocalypse, and the setting is a shopping mall!

Consider this dialogue as characters observe the zombies in the mall:

FRANCINE *What are they doing? Why do they come here?*

STEPHEN *Some kind of instinct. Memory of what they used to do. This was an important place in their lives.*

The film critiques the apocalyptic nature of extreme capitalism, turning masses of humanity into mindless zombies whose only need is to consume. This film was released in 1978. If it was a warning, we weren't listening.

Consuming Machines

In that same way, *The Walking Dead* provokes us to imagine a world of mindless people. Their humanity is gone, and they are driven by their hunger for "flesh." In our contemporary world consumerism has taken on dark reality; humans are commodified as a convenient way to make our goods affordable. Women and children are sold by the tens of thousands to work in India and Bangladesh, picking cotton for the fashion industry. In West Africa hundreds of thousands of children have been trafficked into Ivory Coast to pick cocoa beans, which meet our chocolate demands. Even in America, private prisons use prisoners to produce goods at less than $1 a day. And what do we think about this? Well, the truth is we don't.

In our generation we are born to be consumers. Literally. We are raised with the idea that to consume is to be human. I cannot exaggerate this point.

It is estimated we see or hear five thousand commercial messages a day. That's once every 11.52 seconds. The advertising industry spends twelve billion dollars a year on ads targeting children alone. Children see forty thousand TV commercials a

year (on average). One report has shown that after just one exposure to a commercial, children can recall the ad's content and have a desire for the product.[1] Americans spend at least 15 percent of their household income on things they don't need to satisfy their vices or to keep themselves amused.[2]

We are spending a lot, and we've never been more miserable. According to the CDC, the rate of antidepressant use has surged 400 percent over the last decade, which may also be due to the heavy marketing of drugs like Zoloft, Lexapro, and Paxil.

More than one-quarter of American adults define themselves as obese, according to the Well-Being Index calculated by market research group Gallup and healthcare consultancy Healthways. But the real obesity rate is closer to one-third of the population, says Margo G. Wootan, director of nutrition policy at the Washington, DC–based nonprofit Center for Science in the Public Interest.[3]

These days, consumerism has passed the point of common sense. At this point companies don't just care about the merits of a specific product, but how you feel about it. Advertisers attempt to make us dissatisfied with our life or current products so we *naturally* consume more. Make us consuming machines and every company wins. But who loses? The zombie-like effect this has on our humanity is epic. It produces debt, hoarding unnecessary stuff, obesity. Like zombies, we are consuming ourselves.

Is this consumption disease a willful attempt to wipe out humanity? Is it a conspiracy? A genetic mutation? I don't know.

Who can tell the origin of this disease? It might have started with a selfish decision made a long time ago (more on that later). Excessive capitalism meets personal greed, and voilà—we have a new disease that threatens the very existence of the world.

Isn't that a bit of a stretch? No. We are at an unprecedented time in history. Never has there been a generation closer to the end of the world than today. Global warming threatens the earth. Pollution is killing the oceans and our food sources. Half the world is starving, and all it would take to change the course of history is for people to stop consuming. But we can't.

The Deep Need in Our Heart

The day after Thanksgiving in the United States is called Black Friday. It's when a multitude of products go on sale before Christmas. In 2011, at a Walmart in Muskegon, Michigan, an eleven-year-old girl was standing in line with her mother, waiting for the big shopping sale. When the doors opened, she couldn't keep up with the crowd and lost her footing. Rather than stopping to help her, people simply stepped on the girl and continued to shop, leaving her injured. Every year we hear reports of people being trampled or assaulted or killed. They are injured, and some even die, because people want to get to the best and cheapest stuff before it sells out. *They die from the desire to consume.*

I don't care how sick you think zombies are, you should take an honest look at our current society.

A few years ago I decided to try a new spiritual discipline: not buying anything. This didn't mean I wouldn't consume

anything, it just meant that if I had to purchase anything, I passed. I called it a "buying fast," and it lasted for forty days (during the season before Easter called Lent). I didn't think it would be a big deal. I was wrong. It was crazy. It was one of the hardest things I have ever done. Literally. It's very hard to go an entire day without buying something—coffee, a snack, dinner, those shoes I need. You get the idea.

And when I told people why I couldn't go to the movies or out for dinner, you'd have thought I had become a desert monk. (Actually, it might have been easier to sit on a pole in the desert for a while.) People were offended. I had no idea how much consuming I did or how important consuming is for our social life. I hadn't given it a thought; it was automatic. But it's apparent I've got a zombie disease. I live to consume. It's killing me. And it's killing everyone else too. It's a pandemic!

There is no way we can keep consuming at this rate and not kill each other and the entire planet in the process. But none of us want to hear that. Instead we buy bigger TVs and ignore the fact that people are dying, thousands of them every day, from extreme hunger, slavery, and our need to consume. We just keep consuming. And that is a sick and terrible disease. We need a cure. The deep truth is that external consumption is not the source of the disease but the effects of it. The source of the disease of excessive consumption is internal. The deep areas inside our hearts and minds make us human. This is the source of our consumption. The deep need we have to be satisfied, full, whole, and happy.

It's no surprise that Jesus begins the new humanity without money. Money, he suggests, is a deficit to this new way of living. You are blessed if you have less. That's because Jesus understood, in ways we have not, how much greed and money corrode our essential humanity. I read an address recently given by Pope Francis in which he talks about caring for the poor. Most of it is a nice, moral reminder, and then he asks a question—when you give to the poor, do you look them in the eye?

What does it really matter? you may ask. You give to the poor and that's good, right? But Francis says the gift is not the point. The gift is simply the way we engage. The interaction with the other person—the person in need, the person without—is as much for us as it is for them. It's to rediscover what it means to be human. By catching their eye, we remind ourselves that we are not the sum total of what we have in our pockets or our bank accounts. The money we give is not the point. Rather, money is simply a tool by which we can learn to be truly human. That's what makes the zombie gospel good news. The good news of Jesus reveals to us what it means to be truly human.

Once we find out what it means to be human, we can ask for a cure. We need a power greater than ourselves to save us. This is clear. How can a zombie become human? Well, what if there is a cure? What if someone could bring us back to life? What if we don't have to be consuming machines who alleviate our guilt by giving money to the poor? What if we can choose to use our things, resources, gifts, and money to contribute to humanity, the earth, and the world, and in so doing

we become more human. We deal with the disease at its root. On the inside, by resolving to admit our need and change our ways, we fight against the cultural norm to consume at all costs. We resist the dehumanizing process of this cultural infection, and we become human.

Zombies Don't Make Eye Contact

I'm a Salvation Army officer. I've been with the Salvation Army for twenty-two years, doing all kinds of things: leading churches, starting recovery homes, and creating housing schemes for homeless folks and rescue operations for trafficking victims. I've been doing pretty crazy things for years in this new kingdom called Christianity. I've spent my life trying to help people out of exploitation. Some of that work has included visiting brothels, massage parlors, strip clubs, sex shows, *and* Christian festivals—all kinds of things. And one thing I've learned for sure: *we are all human*. We are, all of us, the same. Same desires. Same hopes. We live stories of pain and struggle and hope and love, all of us. We are equal on the inside even though we look different on the outside. We are little girls and boys longing to be known and loved. We need a new world where we see each other that way.

The women I've worked with for years have been "meat" for most of their lives. Used, exploited, abused, bought, and sold. Commodities. The greatest evil our world has ever known is the commodification of humans. When we put prices on people, we have entered the zombie zone. We have even convinced ourselves that we can name our price. Within

each system, we believe that people sold at a higher price are worth more. It's sick.

I once had to step into a heated argument about how much money the women I was with should ask for when they sell themselves. One woman from another town suggested the price mentioned was too low. They should have some "self-respect" and demand a higher amount. It turns out the average woman that night was going for $40. I asked the woman who thought they should ask for more how much the price should be. She didn't know, but it should be more than what it was. I suggested that perhaps any price would be too low. Maybe she was worth more than money could buy. I saw a flicker of her humanity emerge as her eyes welled with tears. She said I might just have a point. Hope and value can awaken us from our zombie condition.

That night might have helped that woman remember a deep truth about herself. I pray it reminded her that she is worth far more than anyone could offer to pay. She is priceless. Her worth is not related to her abilities or gender; it is inherent, inside of her. She is already worthy.

Here's what I know for sure: that night helped me. It helped me remember that I am worthy too. In helping her and reminding her, I was also helping myself. I know it sounds a bit selfish, but it's true. Every good act I do has the capacity to awaken me to a deep truth that makes me more human. In those moments, I remember how being human helps others while it helps me. Our humanity is restored together. I think that's why consumerism is such a horrible

infection—it dehumanizes us. It removes from us the ability to see others as people, and in so doing it diminishes our own humanity.

I remember the day I first found out about chocolate slaves. I was in Australia leading a social justice unit for the Salvation Army. We had a guest speaker at a youth conference who showed us a video of a BBC reporter interviewing a child slave recently freed from a cocoa plantation on the West Coast of Africa. The child was about fourteen and had been enslaved on the cocoa farm for six years. Since he was nine years old he had been working fourteen-hour days cutting cocoa beans with a machete and locked in a tin shed at night with barely enough food to live. He was skin and bones and scars. I vividly remember the scars on his back. He showed the reporter how they would beat him when he didn't work hard enough, and how they had killed his friends for trying to escape.

The BBC reporter asked what he thought about chocolate. The boy hadn't heard of it. The reporter explained to him that millions of people around the world eat food called chocolate, which are made of the cocoa beans he picked. "What would you say to those people who buy the chocolate?" asked the reporter. The boy looked downcast and said he had no words. And then he looked into the camera and said, "I would tell them to stop. You are eating my blood." The room went silent. I started freaking out.

The first thing I did was cancel the chocolate fondue we had ordered for the end of the night. Ouch. Second, I issued a challenge: What would we do? Now we know. Now we are

connected to folks who are living a literal hell so we can eat chocolate. What will we do? This led to a connection with the chocolate campaign (stopthetraffik.org) that has spread around the globe and is challenging and changing the chocolate industry globally. We woke up from our zombie condition and chose to see the eyes of a cocoa slave. It changed us because we aren't zombies or made to be zombies. We are humans. The zombie gospel is the news that we don't have to be mindless consumers who can't see each other. We don't have to live like that anymore. We can be human again.

A few years ago I ran an outreach for women on the streets of a cold Canadian city. At the same time a good friend of mine ran a program for men. It was called "John School," which was for guys who get busted for buying sex. It's used as an alternative to the court system. Guys who have been caught buying prostituted women on the street go for a day and hear a bunch of information about the costs associated with prostitution: sexually transmitted disease, societal ills, family breakdown, and so on. But the most powerful part, they all explain afterwards, is when a woman gets up to tell her story.

She typically explains when it all began for her, usually as a little girl being sexually abused by a father figure. This man exploited her need for protection and tricked her, beat her, used her, and made her sell herself on the street. She explains how much she hates it. And how much she hates the men for buying her. She explains that even though she smiles and says she loves them, it's all an act. A guise for money. For survival.

And everything changes. These men, after they hear her story, wake up. The school has an unprecedented success rate. Over 90 percent of the men who take that class never re-offend. It's like a zombie cure! They begin to awaken to the humanity of the women they once commodified. Can you buy a life? Can you buy a sister, a friend, a mother, a child? They realize for the first time that they share a common humanity with the women they objectified. This is the sacred part of being human that runs through all of us. And it's what Jesus came to tell us, to model for us, to invite us into. Every person we encounter is an opportunity to see God.

The zombie gospel's good news is that there is a cure for our own disease. And part of that remedy is to see people differently. Once we've admitted our blindness and have asked Jesus for help, help will come. We will begin to see. And to see spiritually means to see others as made by God and bearers of his image.

Seeing People Differently

Jesus spoke about this all of the time. Actually, he kept saying that everyone needed to repent. Today, that word carries a crazy religious image. We envision a weird person holding a sign up on a street corner and talking about hell. But Jesus used the word to invoke an awakening similar to the John School. Jesus shows us how to see the world differently. He helps us recognize the times and to adjust our lenses to the new way of living. To step out of denial, admit our need, walk out of the dark, and into the light. Ask for help, and

everything becomes clearer; we can finally see. When we repent we recognize the common humanity of the people we try to consume—or destroy if they are in our way.

What does it mean to be human?

This is the zombie genre's main question, and our generation desperately needs to consider it. The world seems to have lost this reality—this amazing and beautiful truth—that we are human. That everyone, no matter where they were born or what race or gender they are, is born with value and dignity and freedom. We are human. And our need, more than any other at this point in history, is to rediscover that inherent value in each other.

The general thrust in today's news is that we must suspect the worst of each other. Everyone is potentially a suspect, a killer, a terrorist, a robber. Neighbors are scared to cross the street; they live in perpetual fear. If we listen to the experts, our fears are legitimate. But they aren't. Fear is a means to manipulate and control us. We don't need to be afraid of each other, because we are human. All of us. There is a cure for the zombie infection that threatens us and our planet. It is a new way of being human. It is the good news spoken by Jesus, whose voice we can still hear inviting us to life: "The thief comes only to steal and kill and destroy; I have come to that they may have life, and have it to the full" (John 10:10).

SURVIVING THE APOCALYPSE

In The Walking Dead *the survivors get to the Center for Disease Control and meet Jenner, the last surviving scientist in the place. While inside, the system begins to shut down. It is programmed to self-destruct. Jenner believes the logical thing to do is to stay and die quickly. He has no hope for the future. He closes all the doors and locks the team in. Panic ensues. And in the remaining thirty minutes before the self-destruct there is a discussion about the appropriate response to this bad scenario. Jenner is giving up. And he is joined by a few in the group who choose a quick and instant death over the ongoing struggle for survival. Rick and the close-knit community decide to keep going, to continue on, to survive. Listen to some of the dialogue:*

JENNER *There is no hope. There never was.*

RICK *There is always hope. Maybe it won't be you. Maybe it won't be here but someone, somewhere . . .*

A fight ensues, tensions are high, everyone is about to be exterminated.

RICK (to Jenner) *I think you are lying about no hope. Why did you stay when everyone else ran? You chose the hard path. Why?*

| **JENNER** | *Not because I wanted to. I made a promise. To her. To my wife. She begged me to keep going as long as I could. How could I say no? She was dying. It should have been me on that table; it wouldn't have mattered to anyone. She was a loss to the world. She could have done something . . .* |
| **RICK** | *Your wife didn't have a choice. You do. That's all we want. A choice, a chance.* |

Jenner lets them go.

The general storyline in the zombie genre is that only a few survive the apocalypse, and it is difficult for them to keep living. Survival becomes the dominate theme of their lives. Those who survive know that it takes everything they have to stay alive.

What does it take to survive? What will you do to survive? And everyone, and I mean everyone, who survives has had to live through and do things that they hate, that they are ashamed of, that they would never do if they weren't simply trying to survive. But they are. And to do that has made them damaged, hardened, and different than they were before.

The Condition of the World

Survivors are afraid, wounded, sometimes paranoid, and always broken. We can see the damage on their bodies and faces: the "lost boys" of Sudan with emaciated bodies, who had to drink their own urine and watch their siblings die; the women I work with who have traded their bodies and agreed to things that they can never speak of or ever get back. Or we

can look in the mirror and remember our own compromises and mistakes made. The things we keep hidden and secret for fear of letting that part of us show. The lies we've told, the image we've created, the compromised standards, the abuse we can't speak of.

The thing is, we are surviving something outside of us that invades us because of what we choose. The Christian word for this is *sin*, which is a misunderstood word. Most people think sins are pleasurable things we like to do that God says are bad. It's an old-fashioned word accompanied by judgment and punishment, by street-corner evangelists and TV preachers trying to sell more of their product. But it's much deeper than that.

More broadly, sin is the condition of the world. It's broken. The Bible says the brokenness of the creation happened when humanity chose selfishness over relationship. The world order broke. Consider the condition of the world in *The Walking Dead*. Things are out of sorts. Many things happen that the survivors don't want. They happen to them. But other things happen that the survivors are deeply ashamed of; they didn't happen *to* them but *because of* them.

And this is where everything gets familiar. Sin is the condition of the world, and it's also the infection inside of us.

Sin is what we do that messes up our lives. Sin happens whenever we put our selfishness above relationships. These two definitions of sin help us understand the relationship of shame and guilt. Shame happens when something wrong is done to us. It often accompanies abusive relationships and exploitation. Guilt happens when we've done something that

has contributed to the brokenness of the world. We lied about someone or something. We took something that wasn't ours. Our actions caused someone else to suffer.

I've spent a lot of time in recovery circles. I've been on my own survival journey from addiction for a while. If not for the grace of God, I'd have been consumed by now, either by the forces of darkness that have tried to gut me of my own humanity (the broad problem of sin in the world) or through my own ability to mess my life up (my own selfish decisions). It's refreshing to hang out with other people who understand what it is like to survive. People who aren't in denial about their own capacity to screw up or about what living in this broken world has done to them. The hope they share is infectious. They don't offer some sort of bubble zone where nothing goes wrong or we become immune to the realities of this life. They live in a joyful state of real hope because they know the way to survive. It's not to grit your teeth in a miserable, lonely state of survival, but to face your own pain and brokenness with strength and courage, and embrace a weakness that wins.

"We admitted that our lives have become unmanageable" is how one recovery program begins. It says that until we admit that our life has become unmanageable, we have no chance of changing anything. Fascinating. A new humanity is born out of pain and brokenness. It's not a start from a squeaky-clean kind of beginning, but a broken and beautiful hope. How is this possible?

If you go to In-N-Out Burger in Southern California, turn your cup over and read the reference on the bottom. It's the

most famous verse in the Bible, which says, "God so loved the world that he gave us his one and only Son, that whoever believes in him shall not perish but have eternal life" (John 3:16). People use that verse to sum up the gospel that Jesus is the way to life. This is true, but maybe it's deeper than we understand.

There is an interesting verse before it. John 3:14 says, "Just as Moses lifted up the snake in the wilderness, so the Son of Man must be lifted up." It refers to a story that happened thousands of years before Jesus showed up. The ancient people of Israel were in a desert, having escaped Pharaoh and slavery, and are trying to survive. Then they get attacked by poisonous snakes. (Sounds like something that could occur in *The Walking Dead*. The Bible has drama and horror like nothing else.) These snakes are biting the Israelites, so the people cry out to God to help them. And he does. He instructs Moses to build a bronze snake, put it on a stick, and hold it up. Seriously. He tells Moses to hold up an image of a snake, and when people look at it they would be healed. What?

I think I would have picked a different image, like maybe a dove or at least an animal that can take on a snake (an eagle?). But to make an image of the very thing that is killing you— that's weird, right? But this is the gospel truth, and you might want to pay some attention. See, until you face your truth, until you actually come face to face with your fear, your shame and guilt, your own internal suffering, there is no remedy. *The truth is the remedy.*

The Bible says that the truth will set you free. Once you embrace that, you are freed on the inside, which then enables

you to live free on the outside. This is the whole message of the cross. Jesus is the symbol of sin (the *big* sin of a broken world and the *little* sin of our own motivations). He is lifted up so everyone can see the truth about who they are and how sick and broken and twisted the world is. That truth is the starting place for a new way of life. This new way of life is the resurrection, and it floods into the world with bright lights, angels, and earth-shaking power. It forever changes the trajectory of the story from bad news to good news. But don't get too far ahead! Because it's the hard truth that needs to be told first.

Facing the Truth About Ourselves

One of the main themes of survival in *The Walking Dead* is getting the survivors to see the truth about themselves. What they are capable of. What choices they make. The trials of survival force them to face reality. The truth of who they are. Truth is the only thing that can save us. So when John 3:16 is used as a verse to sum up the gospel, we need to include John 3:14 with it. Jesus died on the cross, so we have to look at him. And the reason we have to look at him is because his rejection, denial, suffering, and death is the condition we live in. He represents us. Even the best of us. Left to ourselves, we end up dead and alone. We need fixing in order to truly live. So, just as Moses lifted a bronze snake, Jesus is lifted up on the cross so everyone who suffers, who feels alone, who is broken and bloodied, betrayed and denied, can look to him, a symbol of humanity's pain, and be healed.

Now, that's *some* zombie gospel. Right when we think there is no hope, no remedy, no cure, Jesus comes beside us and gives us a choice. Think back to Rick's dialogue with Jenner at the start of this chapter. Rick is not asking for a guarantee of an easy life. He is looking for a chance. He wants to choose his life. This is what Jesus offers: a chance to see the truth. To look our condition in the face and choose to get honest and bold.

I wish I could tell you there is a self-made remedy. That there is some way we could fix ourselves. But the reality is that none of us can. We need a remedy from somewhere else. And the good news is that we don't need to look very far for one. The remedy for our brokenness lies in Jesus. He made a way for a new humanity to emerge through his own death. The Bible says he made a mockery of death itself by embracing it. By his sacrifice we are offered forgiveness. Forgiveness is the secret remedy for our guilt and the world's shame. Everyone shares this condition together.

Rick and his crew could give up and die. But they choose life. They recognize that life in the apocalyptic world is difficult and ugly, but they choose it anyway. And choosing life together is part of their power. They model a new kind of family. They start to sacrifice for each other. They share their resources and gifts.

Once everyone realizes the reality of their own condition— what it takes to survive, the selfish decisions they have made, the people they left behind, having done what they said they would never do—once they realize this, all judging of others stops. This is their common reality. Their brokenness leads

them to the understanding that *everyone* is in the same con-dition. Everyone is in the same boat. We all have shame and secrets and guilt and fear. All of us.

My grandparents died from drinking, and each person in my family has struggled with their own curse. One of the steps toward treating my disease is to make a list of all the horrifying and shame-inducing things I've ever done and tell them to someone. Seriously. I've got a friend who hears a lot of people's "fourth step," and she starts by saying, "Tell me the thing you left off the list—let's get that out of the way."

We've all done things we are ashamed of. We've been in survival mode our whole lives. Once we realize that, we are liberated from it. Internally, we stop judging other people's behavior. In *The Walking Dead* the survivors ask the humans they meet along the way how many zombies they've killed. A number is offered. Then the survivors ask them how many humans they've killed. Based on their response to the second question, the team knows whether to trust that person or not. If you are still in denial, still pretending to be someone you aren't, still trying to sell yourself as pure and clean and perfect in a world that is stark raving mad, then you aren't yet trustworthy—not even by yourself. And that is some kind of horrible place to be. But so many of us are still there.

Feeling Clean Again

This is, of course, the gospel truth. Again the Bible is clear. There is no one on the earth who has not *sinned*. All of us have

done things we said we wouldn't do. Thought things. Acted in ways that dishonored ourselves. Broke relationships. Left people behind when they didn't serve our purpose. Used people. The list goes on. Bent on our own survival, our own self-focused lives have made us all participants in unspeakable pain. And Jesus knows this. All of us have also been *sinned against*. Things done to us have damaged and diminished us. We suffer from shame. Jesus knows this too.

The amazing thing about his creation of the new humanity is that Jesus does not start from scratch. He begins with the condition that humanity is already in. He uses broken survivors. He brings something beautiful from the muck and the mire of human existence. He makes it possible to feel clean again. To start over. This is the power of Jesus and his message. He made a way for humanity to emerge from death to life.

This is the deepest hunger in each of us. Picture the scene from Shakespeare's play where Lady Macbeth is trying to wash the blood off her hands, but the stains of what she has done can't be washed out. We can see ourselves in her: trying to cover up and convince ourselves that we are better than we are. But when we peel it all away and reveal our true self, we find that we are no better than anyone else. We are all the same. Broken. And when we realize that about ourselves, we can start to hear Jesus in a new way. He is offering us a new way to be human. A way to get the blood off our hands. To be washed clean. A way to start again. A new way to be human.

The problem is, we prefer self-sufficiency and denial.

Doing It Alone

A perfect picture of this is in season two of The Walking Dead *when we are introduced to Michonne. She comes to the aid of Andrea (one of the original members of Rick's community), who is about to be consumed by walkers. Michonne appears from the darkness and rescues Andrea by cutting the walkers' heads off with her sword. She emerges in a hooded cape with two subdued and chained walkers on either side of her. She had lost her partner and son, and her refugee camp had been overrun. After that trauma, she lost her mind—she later described it as "being gone for a long time." She lost the ability to live in real time—she was dazed and confused, and walked around in the woods with a chained-up set of zombies as her "guards." It's safe to say that Michonne was one creepy woman who had lost touch with her own humanity. She is a picture of hardened self-sufficiency in the extreme.*

After Michonne saves Andrea, they end up in a deep relationship. Andrea's presence in her life begins to restore Michonne to sanity. She remembers her humanity through relationship. In a later season of The Walking Dead *Michonne explains to someone who has yet to experience that kind of trauma why they have to be trained for defensive warfare to survive the inevitability of the zombie apocalypse. She explains why she had lost herself in the midst of survival: "Have you ever had to kill people because they had already killed your friends and were coming for you next? Have you ever done things that made you feel afraid of yourself afterward? Have you ever been covered in so much blood that you didn't know if it was yours or walkers' or your friend's? Huh? Then you* don't *know."*

When surviving has been difficult and painful we almost always choose denial and defense as a strategy. We want to live in isolation. To survive this stage of the chaos, we hole up somewhere as far removed from the carnage as possible. We hang tight and lie low. We avoid the world because it's coming unglued, and we simply get through the days by surviving. Retreat sounds like the best possible outcome for anyone who is facing the end of the world as they know it.

The trouble with this philosophy is that it only works for so long. It doesn't keep working because we need stuff to survive—food or supplies or safety or shelter or relationship. Whatever it is, something forces us out of isolation. Something forces our reentry into the world even though our first reaction is to stay away from it. There is no possibility of surviving without engaging life.

In *Amusing Ourselves to Death* Neil Postman says that a generation before us thought the world would end by tyranny, by a controlling superpower that would burn all the books and control our education. Think communism or the Nazi threat of world domination. But Postman presents another threat: that the real enemy wasn't going to be an external one but an internal one. That we would be more interested in our entertainment than current events. That we would be dominated by the internal desire to shut ourselves off than to engage. That we would dehumanize each other not by some horrible act but by refusing human contact. Our survival would depend on our willingness to wake up to the reality of our temptation to live isolated, empty lives.

The irony of the awakening that could come through *The Walking Dead* is that it comes through the very media that is numbing us. The time for holed-up isolation has to come to an end for everyone. No one has the capacity to exist by themselves and keep their humanity intact. It's not how we were created.

Nevertheless, we still have this persistent idea that we can do it. We think it's simply a matter of resources or resolve. All of us struggle with this delusional thought that we can survive by ourselves. If only we are smart enough, rich enough, or strong enough, we could do it alone. Yet all of us understand one way or another that we can't. This is the truth, and we might as well admit it—we need other people. This is the reality of humanity. From the start it was designed this way.

Designed for Others

The earliest story of human origins was that man was created alone, and God came to the conclusion that it wasn't good for man to be alone. So God created humans to be together. God created males and females, and gave them the capacity to have children so they would never be alone. And yet, even as we were created to be family, a whole and loving community, we fought it from the start. The first story of selfishness and survival has man blaming woman, brother killing brother, tribe killing tribe. We rebelled against the idea that we need each other, right from the start. But the truth is we do need each other. It's how we were created. Deep inside us we know that we need each other to survive. There is no other way to be human.

In *The Walking Dead*, people eventually come out of the woodwork, from sheds, farms, apartments, and forests, to move from isolation to community. And they struggle as if it were the beginning of time. Groups that form start thinking of others as competitors instead of fellow humans. They start killing humans for their stuff. It becomes a dog-eat-dog world, and people, even though they are surviving the zombie apocalypse, continue to lose their humanity because they refuse to honor each other, to live in community.

If you think surviving an apocalypse is a stretch, you should watch a documentary of the "lost boys" of Sudan. These young survivors of genocide walked thousands of miles to find a safe place. Our entertainment is their reality. And the same story is repeated throughout history. Today's world is in a refugee crisis. Never has there been as many people forced from their homelands. They are wandering the earth looking for a place where they will be seen for who they are: humans. They are called a threat to national security, enemies, and potential sources of economic despair. It goes on.

But when we read their stories and see their faces, we recognize their humanity is tied to our humanity. We need them, and they need us. This is the human condition. These people walk across borders to find a different, safe, fruitful life. As they walk they form new, temporary communities and long for a permanent one where they would be welcome. All of them come out of deep, personal trauma but learn to walk together in a new way. We need each other to be human.

Refugees are not alone in their need of others, of welcoming humans. World Relief helps North American families know how to properly welcome resettled refugees. These trained folks meet the refugee family at the airport, visit them in their new homes, and provide them with groceries and welcoming packs. They offer warmth and friendship as the newcomers adjust to the massive cultural differences. Obviously, the refugees are relieved, grateful, and overjoyed by this hospitality. But what's truly amazing is the difference it makes in the lives of their hosts. Their prejudices are challenged and changed. Their lives are enriched by friendships that extend further than their typical relationships. They venture into the vast expanse of our shared humanity.

This happens to me all the time. Right when I think I've got life sorted out, I realize there is a better way to be human. I'm surprised by how life-giving relationships can be. I feel a calling to be connected in relationship. And much like *The Walking Dead* it ends up looking like a band of broken people with a common desire to survive as humans in a mad world.

If you knew there was a way to survive that led to an interconnected life of community, wouldn't you want it? Being a truly alive human being involves relationship; first, in a relationship with God, who can offer you life in exchange for your own deadness. It's how we are designed. And then in a relationship with others, those who understand what it means to be a survivor and even more about what it means to be human.

We must reject self-sufficiency and come out of our various hiding places. Isolation will not help us. The strong cannot

survive alone. No matter how strong and confident you think you are, you will only ever be like Michonne—a shadow of yourself. Far from the Rocky Balboa scenes of a self-made person, with "Eye of the Tiger" blasting while you emerge the hero of your own story, there is another song being played. It's the melody of a restored humanity. In this picture we drop our gloves and embrace each other as brothers and sisters. A shared humanity is a better way to live.

A NEW WAY TO BE HUMAN

In season three of The Walking Dead, *Lori (Rick's wife) dies giving birth. While in an impossible situation, hiding from walkers in a prison, it is clear that Lori and the baby are going to die. Something is wrong with the pregnancy. Lori needs a cesarean section, and surviving that in those conditions will be impossible. In the midst of her own anguish and pain, facing her own imminent death, Lori begs Maggie, a main character in the series, to save the baby, even though it means the end of her own life. She tells Maggie to do it "for all of us."*

Lori understands that saving the baby will be an offering of hope in a dark reality. And she is right. Even though the grief of Lori's death is painful, baby Judith instills hope and forges the community closer together than anything else could. One beautiful portrayal of that is when Daryl, the tough guy, is holding the baby and feeding her a bottle of formula that he and Maggie had just scavenged from a nearby home. As the baby settles down, the entire community huddles together in trust and hope. Lori's sacrificial death has brought life not only to Judith but also to the entire community.

All authentic and life-giving community is built on trust. There is no way around it. That's why it often takes time. If you've been broken or wounded or spent most of your survival in constant fear of people consuming, cheating, or using you, it's hard to rely on others. It's hard to trust them. The strong survive. That's the motto many people keep repeating. The problem is it's not always true.

Not Only a Biological Matter

In *The Walking Dead*, survival has an edge to it. It brings out the worst and the best in people, but we're not sure which one is going to emerge. Actually, if we are honest, life does the same. It brings out the worst and the best in people. What is the difference between heroes and cowards? One person gives their life for another, while the other runs and hides. Who can tell what will emerge as we encounter that kind of situation?

In season three we glimpse another community introduced through Andrea and Michonne. Woodbury is led by a man called "the Governor," who makes a good first impression. Woodbury is a beautiful oasis in a harsh world. Or so we think. Michonne can sense that not all is what it seems, but Andrea can't bring herself to leave what feels like a "normal" place to live. When Maggie and Glenn are captured by Woodbury people, they are tortured and beaten by the Governor and his henchmen. The Governor reveals his true colors as he humiliates Maggie through sexual abuse and intimidation.

The survivor community launches an attack on Woodbury to rescue their friends, and everything goes wrong. The Governor makes Daryl (captured in the attack) fight his own brother "to the

death." This type of leader uses fear, intimidation, and deception to control his community. It brings out the worst of their humanity. It forces us to ask some questions about how we do community when we are afraid and desperate.

A key question *The Walking Dead* asks is, what are you willing to do to survive? Each character is faced with decisions, hard decisions, about survival and community.

So many survivors we meet in *The Walking Dead* are alive, but not really living. They don't really survive—at least not for long and not with the quality of life we aspire to. And this is an interesting thread. They don't survive, because being human is not merely about being alive physically. The key is retaining the essence of our humanity. How we treat other people tells us how alive we actually are. Even though we might not technically have the zombie disease, embracing the notion that life is about us and our survival at any cost, and not about each other, is a terrible way to live. Many people in the series choose to live that way. They do whatever is necessary to keep on living. And in the midst of their decision to survive at all costs, they slip away from their own humanity. Many of us live like that too. What makes us human is not only a biological matter. There's much more to it.

Creating Beautiful Things

In an important scene in *The Walking Dead*, two community members are discussing what they might have to do to survive, and one of them says he would rather die a human than live with what he'd have to do to simply survive. That's

an amazing perspective. I'd rather die as a human: living *for* others, not *on* others.

Shortly after this conversation, Rick makes a drastic change. He sets aside his weapons for farm equipment. He decides he will be a farmer instead of a fighter, because he can feel the survivor instinct taking over and his humanity slipping away. He wants to make the world a decent place for his children; he wants to create a community that cares for each other. He wants to be a man who exists for something larger than survival.

This is hinting at what it means to be fully human. The eerie thing is that it points back to one of the oldest Hebrew stories. It's a story about relationship. Adam and Eve's first sons are Cain and Abel. They don't get along. In a jealous rage Cain kills his brother and hides his body. God calls out to Cain and asks the obvious question, "Where is your brother?" Cain responds, "Am I my brother's keeper?" Of course, he meant that his brother's business isn't his concern. God replies to Cain's indifference, "Your brother's blood cries out to me from the ground." In other words, we *are* our brother's and sister's keepers. We must be in right relationships to be a thriving human. Broken relationships, cycles of senseless violence and revenge, diminish our humanity.

Woven into our DNA is the capacity to create. The first humans were caretakers of a garden. They also were intimately involved in caring for other living things, their children and the animals. Destruction is so contrary to our humanity because we are designed to create and nurture things.

We haven't always understood this. Society often holds weird ideas about God and our own creation. I've heard people suggest that God made humanity because he was lonely. But this couldn't be further from the biblical account. God is community: the Trinity. The Father, Son, and Spirit are in eternal, loving communion. And love, by its very nature, is expressive and expansive. At love's finest hour, it creates. Far from making humanity to keep himself from being lonely— God expresses his love by creating humanity and a good environment to live and love in. God created humans in his image. Thus, to be human is to be in right relationships that create beautiful things.

Ubuntu

I visited Robben Island, South Africa, and heard this truth from a man who lived through his own apocalypse. During the time of apartheid in South Africa, he was black and angry and young and frustrated. He organized student rebellions, was arrested, and sent to the infamous Robben Island for five years. The prison tour guides are ex-prisoners. Our tour guide showed us the conditions they had lived in and how they were mistreated. As we sat in his old cell block, he invited us to ask him anything. Someone asked what the hardest part of his experience was. He said it was leaving the island. We were shocked. What? How could that be? We had just seen with our own eyes how horrible that place was.

Our guide said when he had entered the prison he was resigned to anger—to hate. He wanted to kill every white person

he met. He wanted to meet violence with violence. But in the prison some men who knew where he had come from, and the anger that was eating him up from the inside, introduced him to a new way of life. To forgiveness. To hope. To freedom on the inside. He spoke about being made new. The hardest part was leaving, he explained, because he had to live a new way.

He left the prison and pursued a degree in economics so he could contribute to the coming new world. He started living for something larger than himself, bigger than his own survival. And that is what made him human. It's what helped him to live. He explained that he now understood that to be human means to be in right relationship with others. To create, not just to react. To be part of building a new world, not tearing it down.

After the old regime fell, South Africa teetered on the brink of civil war. The leaders of the new government used a Xhosa tribal concept to talk people off the edge: *Ubuntu*. Ubuntu means "I am because we are." It is the notion that individuals find their identity in the collective whole. Thus, when one member of the tribe is suffering, everyone suffers. It's a truth that goes much deeper than retributive justice.

The people of South Africa chose to embrace the truth that we are all human *and* we are all wounded. When any single member is suffering the reality and pain of injustice, then everyone else is affected. It doesn't matter if a person is a perpetrator or a victim, we were made for relationship. This impressive truth stopped the cycle of violence and set whole people groups free. We should be paying attention. This kind of practiced truth births the creative possibility of building a new world.

What does building a new world mean? It means there is a better way to live. There is a way of living that calls upon the best of our humanity instead of the worst. In this world we live for one another instead of ourselves. It means we are meant to flourish, to create, to love, to nurture, to give birth to lovely things, and not just to react to bad things. But we often feel impelled to fight off forces that suck the life out of us: time constraints, work hours, addictions and fears, habits that consume us. And before we know it, we haven't created a single thing. We realize that we lack deep relationships rooted in trust and love. Our selfish condition and fear have led to isolation, which leaves us feeling like survivors instead of creators.

What if we were to choose to escape the "work harder" and "pay it back" phenomenon of our present culture? What if we stopped glorifying violence and listened to the folks who have found their humanity again. One of the striking things about *The Walking Dead* is its glorification of violence in order to fight violence. We all get that to survive zombies we have to get physical. But at the same time, all that fighting and killing and destruction seems to leave everyone with less, not more. The main characters long to give, not take; to create, not destroy. What makes us human is reflected in the sacrifice of Lori for her baby, and in Rick laying down his guns to grow a garden.

The Myth of Redemptive Violence

We live in a violent world. The inevitable result of responding to violence with violence is the escalation of (you guessed it) more violence. There's a famous quote, usually attributed to

Gandhi, that puts it this way: "An eye for an eye leaves the whole world blind." *The Walking Dead* epitomizes this concept.

In our time, war has caused the largest global forced displacement of people in history. It's an age of gun violence, mass incarceration, school and hospital bombings, human trafficking, and the threat of nuclear weapons. These days even our kids are afraid of dangerous people in the neighborhood.

But the gospel that Jesus preached was the opposite of retributive violence. He stopped the violence with his sacrificial death on a cross. He experienced violence up close and personal, confronting it with the posture of powerlessness. He refused to play the violence game, and through his resurrection he broke the system for good. He made another way.

The gospel of Jesus is nonviolent. Nonviolent resistance is the notion that there is a third way—an option outside of the "be killed or kill" narrative. It's an option of love. And love has a power that violence doesn't. Love has the power to redeem everything: not only the oppressed, but the oppressor as well.

As I've watched *The Walking Dead*, I've been horrified and frustrated by the escalation of violence. Even the characters get fatigued by the same nonsensical (but seemingly inevitable) cycle. And in this way the show reflects the reality of our world. The cycle of violence won't ever stop aside from the third way that Jesus offers. The good news is that we can escape this trap and live another way. The way of love in a world of hate: the love that Jesus offers us in the gospel.

I've been praying that as we watch *The Walking Dead*, we'll see the true cost of living in a violent cycle and how it ends in

death—even the death of our own humanity—and that we can agree it's too high a price to pay.

You Are Forgiven

Jim Elliot, a Christian, wanted to deliver the good news of God's love to a tribal people in Ecuador. Though they were a violent tribe, Jim was convinced it was his life's calling to reach them with the gospel. They didn't have to live in violence and fear. They could live a better way. So, after some indirect preliminary contact, Jim and four friends flew into the tribal area, landed on the beach, and hopped out eager to share the good news. They were slaughtered. That's often the reality when good news people like Jim Elliot butt up against the violent world. This is the message we often hear: being a good guy doesn't pay off.

The families of the slain men had also moved to the jungle to pray and help in the effort to reach tribal peoples. Jim's wife, Elisabeth, was one of them. After a period of time to grieve and regroup, Elisabeth did a deeply human thing. She went to visit the tribe that killed her husband.

If you were in Elisabeth's shoes, what would your message be? More often than not, in our culture the message would entail revenge or violence. It's payback time. This is the survival instinct embedded within us. But Elisabeth dug deeper to a truer instinct—that humanity does not exist for itself. This instinct comes from the God who sent himself in the form of Jesus to die in our place, to take our pain and offer a better world. Elisabeth told them something they had never

heard before, "I forgive you." They didn't know how to translate it, because they had no notion of forgiveness.

The tribe only knew about destroying the enemy. For generations they had been caught in a system of retribution. When Elisabeth looked around the village, she saw that almost everyone was missing an eye, a leg, an arm, or a hand, and she realized that anyone who felt wronged would hurt someone else as retribution. It was literally a survival tribe. She interrupted this survival mechanism with a powerful truth: forgiveness. "I forgive you," she said. And it radically altered that tribe.

Once a new way was offered, the tribal people rediscovered the purpose of their lives. They discovered the creative gifts inside of them. Instead of destruction, creation was emphasized. Now, that tribe is notorious for its welcoming, forgiving, and healing nature. They built schools, and raised up nurses and doctors. They are busy discovering their own life-giving creative gifts. Neighboring tribes used to fear this tribe, now they ask for their help. The violence stopped. And a new kind of humanity emerged.

How many creative gifts do we fail to discover because we are too busy destroying our enemies? Let's instead invest in the creation of new things.

The Walking Dead never gets that far, or at least not for very long. The garden doesn't last and the group has to move on. It seems the show's priority is entertainment, and violence is more interesting to our culture than gardening and developing schools. But in the series we catch a glimpse of a deep longing for new life. Lori's sacrifice exemplifies this.

Our lives too could exemplify the capacity for life-giving creativity. There is a better way to be human. And maybe that better way starts with allowing God to reach deep into our DNA and remind us that we were created for each other. We could allow ourselves to feel the freedom offered in the words "you are forgiven," and then freely pass them on to everyone we meet, even those who may wound us. What negative cycles would that stop? Imagine the kind of life that would emerge, the kind of future we could make together. Certainly we would discover the energy to create life instead of destroying it. This journey is perhaps the hardest of them all— leaving our prisons of hate, fear, and violence, and entering into a new, creative way to be human.

THE LONGING

The situation is bleak. And then they see it. A sign, literally, on the side of the train tracks, right in the middle of the chaos of the zombie apocalypse. It's a sign of welcome and belonging. An invitation to "a community for all." A place called Terminus. It almost feels too good to be true.

Throughout *The Walking Dead* series a community of survivors keep looking for something. But what are they looking for? That is the question that is repeatedly asked as we watch them move from place to place. Is it safety? Is it a new world? Is it a better humanity? Is it a cure?

We are all searching. And sometimes our search somehow turns inward and ends up looking quite selfish. It's focused on fulfilling our own desires, even if it's at the expense of other people. This is a distortion of our original desires.

Our selfishness is rooted in a good desire that's been distorted. We long to be full, so we eat too much and become addicted to things that help us avoid our own emptiness. We long for connection, so we use porn, only to find out it leaves us lonelier than ever. We long for community, so we manipulate and abuse others so they won't leave us, only to find

ourselves alone. And the distortion of our greatest desire is how it all goes belly up. The source of all longing is from God and for God. Augustine, an ancient theologian, once said to God, "Our hearts are restless, until they find their rest in you." This restlessness is holy. It's the source of our desire.

Misplaced Desire

I used to think that desire itself is the problem. Many people do. For many generations the church has been known for its bad news. It has given the impression that sin is doing anything fun and enjoyable. This suggests, of course, that God doesn't want us to have any pleasure in life. However, this is a gross misunderstanding of sin and a terrible handling of desire. Many of us think that if only we could control our desire, our problems would be solved. So we use behavioral control methods to deal with desire.

Take heroin addiction. I lived in a slum community of drug addicts for five years. Nestled between the sea and Vancouver is Downtown Eastside. Over six thousand drug-injecting users live within eight city blocks. The area was a containment experiment to limit the spread of infectious diseases. Ninety-two percent of my neighborhood residents had hepatitis C and 64 percent had HIV. The city tried to stop the spread of these infectious diseases by creating the "drug-friendly community." It was a neighborhood of drug addicts for drug addicts. They basically said to the residents, "Live here, use here, and die here. Just don't leave here." It was a lot like an apocalyptic horror film.

Almost everyone in the neighborhood used as much methadone as possible. Methadone is a synthetic drug used as a substitute for heroin in addiction treatment programs. It acts like an anesthetic. When going into surgery, an anesthesiologist puts a mask on the patient, gives them a shot, and tells them to count down from ten. Before they get to one they are out. Well, the vast majority of this neighborhood are somewhere between six and one. They are like the walking dead. Perhaps living in Downtown Eastside opened my mind to the message of shows like *The Walking Dead*. Anyway, the treatments for drug abuse don't work very well in that neighborhood. And there are a bunch of reasons why. But among those one rises above them all: *longing.*

How do you stop desire?

Desire has acquired negative connotation. We all think that if we stopped longing for heroin or sugar or carbs or sex we would be better. But what if desire isn't the problem? What if the real problem is misplaced desire? What if we simply forgot what we were originally longing for?

In the drug-addicted community of Downtown Eastside, the desire was for drugs. Or was it? A study has revealed that over 80 percent of the residents were from the foster-care system. In other words, they were orphans. Maybe the desire fueling their addiction wasn't for drugs. Maybe the drugs were a symptom of a much more basic and fundamental desire: to be loved, to be wanted, to belong.

Many of my addicted friends referred to heroin as a lover or a friend. It used to bug me because of the effects that poison

had in their lives. I often wondered how something so horrible could be considered a friend. But when I considered life with no friends, it made a bit more sense.

What if our desire for connection had been severed or damaged, and we couldn't make any meaningful relationships? Maybe our unfulfilled desire would turn into a thirst to make the feelings of abandonment go away. And maybe the relief we found would be a substitute for what we really desired. The truth lies somewhere therein. Desire is not a bad thing. If we can trace the desire to its origin, it would no doubt reveal the most important thing about us. The desire to be known, to be loved, to feel connected, to matter, to belong—those are all right desires, and they are all found in one place: God. I know, it sounds too good to be true.

A new study is breaking the back of old-fashioned ideas of how addiction works. Basically, the old theories of addiction were based on an experiment with a rat in a cage with two water bottles, one of which was laced with cocaine. Once the rat tried the cocaine-laced water, it would give up all its normal habits to drink from that bottle until it died. The basic idea was that the same thing would happen to humans who tried cocaine. This is addiction.

A Caged Rat

That study informed the way we dealt with addicts for almost an entire generation. But in the 1970s, Bruce Alexander, a professor of psychology, noticed something odd

about this experiment. The rat in the cage was alone. It had nothing to do but take the drugs. What would happen, he wondered, if we tried something different, more realistic? He built a rat park, a lush cage where the rats had colored balls to play with, the best rat food, tunnels to explore, and plenty of friends: everything a rat could want. Alexander also added a water bottle with cocaine. An interesting thing happened. The rats with the good lives tried the drug water a few times but never became addicted. They went on to enjoy their lives.

This gives us an insight that goes much deeper than the need to understand addicts. Professor Peter Cohen argues that human beings have a deep need to bond and form connections. It's how we get our satisfaction. If we can't connect with each other, we will connect with anything we can find—the whir of a roulette wheel or the prick of a syringe. He says we should stop talking about "addiction" altogether and instead call it "bonding." A heroin addict has bonded with heroin because she couldn't bond as fully with anything else.

So the opposite of addiction is not sobriety. It is human connection.[1]

Incredibly, this new study is true about all kinds of addiction. I recently talked to a young man about his porn addiction. He said what he wanted more than anything was to connect with a real woman who actually loved him. Though he was married to a beautiful woman who loved him deeply, his addicted brain was so used to being stimulated by porn

that he couldn't perform in bed with his own wife. The thing he most wanted and longed for was something that he could never get because his addiction has distorted his desire. His journey back from the dead included exposing this distortion and getting back into contact with his real longing—his deeper desire—authentic love.

Hundreds of thousands of people flock to sex shows every year. Millions desiring connection are addicted to porn. Maybe even you. But is that what you really desire? It's more likely a distortion of your authentic desire.

If the true desire of sex addicts is for connection and love, this understanding changes things. The answer is not judgment and fear, but love and acceptance. Addicts can journey through their pain in community.

Perhaps those addicted to power and control desire to be known and valued. If so, the answer might be forgiveness, humility, and reconciliation. Those addicted to money may need to feel that they are enough. The answer might be less work and more intimacy.

What if every addiction was really a desire to be honest and free?

In *The Jesuit Guide to (Almost) Everything* author James Martin discusses desire from a positive perspective. He says that our desire will ultimately lead us to finding God. That if we trace our desires to their source, rather than denying or covering them, we will find we all long for the same thing: God, love, and more. Longing is not bad.

Community for All

There is deep longing in *The Walking Dead*. The community longs to return to normal or to get somewhere safe. They long for a future, human connection, kindness, and children. After all of the bad stuff the characters have been through, you'd think they would give up. Some of them do, to be sure. But most of the group keep on going. They are looking for something. Something else. Something more. They are filled with desire. They have distorted desires, just as we do. But ultimately they are driven by human longing: to find family, to build a new world, to belong to each other, to love and be loved. Finding these connections is not difficult for most of us. But if we are honest, we have the same drive.

The survivors of The Walking Dead *finally arrive at Terminus, the "community for all." And it seems like a dream come true. The people are nice and welcoming. There is food and peace, safety and comfort. Terminus is self-sustaining, which encourages a bright future. But all is not as it seems. Terminus turns into a horrible trap. The people running Terminus are putting on a good show, but they actually are cannibals who trap humans through their desire for community. What follows is a horrifying display of distorted desire. One of the women, as she is dying, explains that they had started out the way they presented. But they were attacked and tortured. They realized that survival in this harsh world could be summed up like this: "You're either the butcher or you're the cattle."*

Sometimes our desire distorts us, making us more like animals. We are content to take and take, but are never satisfied.

This kind of distorted desire leads to death. How can the people at Terminus think they are surviving a zombie disease by eating humans? Isn't it the same thing? Despite our capacity to embrace distortion, at its origin our desire—in our hearts—is a longing for good. We long for love. We long for connection. We long for meaning and beauty and truth. We long to belong. All of those longings are connected to the One who made us. The Bible says God is love, and at creation we were made for community and declared good. No wonder our deepest desire is for love, connection, and belonging.

The Root of Desire

As the team of survivors free themselves from Terminus, chaos ensues. Walkers are everywhere, things are on fire, and Terminus is exploding. They should run for their lives. But Glenn sees other human prisoners and asks the survivors to free them before they leave. They all think Glenn is crazy. And he responds, "It's who we are." They are humans. They are the kind of people who save people. They desire a better world than the one they've just encountered. They can contribute to goodness, belonging, and love by saving people instead of killing them in order to survive themselves. It's a great moment of clarity.

It's a good idea to consider what stops us from getting to the root of our desire, the true longings of our heart. I'm convinced—after working with drug addicts and church leaders, prostituted women and high-powered business executives— that all of us are indeed restless until we find our rest in God. The longings we experience are rooted in a holy calling that

drives all of us to what we long for most, the One who can satisfy our deepest desires.

To get to the root of our longing, we have to be honest about the distortion of our desire. We must trace the source of our desire from deep inside ourselves to our daily actions. And once it becomes clear what the deepest desire of our heart is, we need to seek God in order to fill it. Any other substitute will lead to further distortion. I've found that journaling, prayer, counseling, a spiritual partner, and some good, honest friends help to get to the root of my desire. But once I've uncovered that deep longing that makes me human, asking God to fill it is the most satisfying action. Usually, I find the kind of freedom I seek while I'm on my knees, asking God to fill the deepest longings of my heart with himself. And the longing becomes love, and love overflows.

NO MORE PRIESTS

A friend grew up in an aboriginal community in Canada, a remote village where he was forced to go to a white man's school away from his family. There, he had to speak English. And he was sexually abused by a priest. The first time it happened he ran away in his bare feet in the middle of winter. He told his grandma that he couldn't go to that school anymore because the priest had abused him. His grandma told him to stop talking. She said, "He can't have abused you," shaking her head, "that man represents God." And she sent him back to be abused because she couldn't accept the reality of a priest misrepresenting God.

The man told this story at a Truth and Reconciliation Commission in Edmonton, Canada, last year. As he told it, he wept. And we all wept with him, not only because of his pain but because our pain is shared. Throughout the world we keep discovering that those who are supposed to represent God don't do a very good job. Abuse, scandals, stealing, cheating, lying, cover-ups—I could go on. Even soldiers who have performed some of the most evil atrocities on the planet have done so as "acts of God." It continues to this day.

Where Is God?

In The Walking Dead *Rick isn't sure if he believes in God. There is an ongoing conversation about whether God exists. It's easy to dismiss God in the midst of the chaos. If God were real, would he allow such suffering? Then at one point in the series we are introduced to a priest named Gabriel. When the group moves into the church building for shelter, Father Gabriel says, "This is the Lord's house," and Maggie responds, "No. It's just four walls and a roof." Nothing sacred here. Gabriel is haunted by these people because when they needed him to represent God, he went into survival mode himself.*

Rick questions Gabriel about his sins at the church and quotes the writing scratched into the outside wall of the church, "You'll burn for this."

RICK *That was for you. Why?* (Rick grabs Gabriel by the shirt and screams at him.) *What are you going to burn for, Gabriel? What? What did you do? What did you do?*

GABRIEL *I lock the doors at night. I always lock the doors at night. I always lock the doors at night. They started coming, my congregation. Atlanta was bombed the night before and they were scared. They were looking for a safe place, a place where they felt safe. And it was so early, so early. The doors were still locked. You see . . . it was my choice. There were so many of them, and they were trying to pry the shutters and banging on the sidings, screaming at me. So the dead came for them. Women . . . children.* (Father Gabriel begins to cry.)

Entire families calling my name as they were torn apart, begging me for mercy. Begging me for mercy. Damning me to hell. I buried their bones. I buried it all. The Lord sent

> *you here to finally punish me. I'm damned. I was damned*
> *before. I always lock the doors. I always lock the doors.*

He locked people out of the church, the sanctuary where they might have had a chance to survive, so that he could. The group's response is fascinating. They are surprisingly unimpressed with his sin. He is met with indifference by a group of survivors who have already dealt with their own capacity for evil. They have already seen themselves for who they really are. They have already owned their own brokenness. So, they have very little time for his pretense of righteousness when they know there is no such thing.

In one way the moral failure of priests to represent God is tragic. And in another way it's liberating. God's plan as revealed in the Bible was that a *people* would represent him on earth, not a *priesthood*. The best laid divine plan was for a whole community to live together with mercy, justice, and faith as its foundation. These people, as they lived out of authentic community, would represent him on the earth. But when that community failed, God established a priesthood to represent him. And this system has often been trouble. Over and over again we see that the priests, who were supposed to be special, weren't. They *are* human, after all. They're just people, like you and me, nothing special about them.

The Hercules Myth

I went to see the *Hercules* movie, starring Dwayne Johnson. The idea of the movie is that Hercules is a mere man who

pretends to be mythically strong. He secretly has a team of people help him in his battles, but he emerges from the battles as a lone victor, with his red cape flying. People believe he is invincible.

In one battle Hercules is cut on the shoulder. The captain of Hercules's team sees the wound and rides his horse across the battle front to get to him. When he approaches Hercules, the captain covers Hercules's wounded shoulder with his red cape and whispers in his ear, "Never let them see you bleed."

At this point in the movie, something happened to me. It was strange. As soon as those words were uttered, I had a vision. It was as though God himself changed the image on the movie screen. All I saw was Jesus on the cross, bleeding. Openly, unashamedly, bleeding.

This image of Jesus can be seen throughout the world. Jesus on the cross, bleeding for the whole world, is the opposite of Hercules. Jesus has a different kind of strength, the strength of character to forgive enemies, to challenge power with truth, to take punishment and absorb the hate at the same time. It's the power of love. And as the Scriptures remind us and Jesus shows us, love conquers all.

The Bible says that Jesus is the final priest. He's the priest that every other priest was supposed to be. The kind of priest who lays down his life for his friends. Who serves with vulnerability to usher in a new way of life—a restored humanity. On the cross Jesus is the ultimate example of priesthood. He is the only priest we will ever need.

Most of us are tempted to be Hercules. We are addicted to this narrative. The world loves a good mythical, type-A, red-cape-wearing leader. The trouble is, there is no such thing. We're all human. And until we face that fact, we deny our own humanity and live a fake life. But imagine a world where, like Jesus, we embrace suffering, tell the truth, forgive, welcome strangers, live openly, give extravagantly, and absorb the pain. Imagine that kind of world.

The Walking Dead raises questions about the Hercules myth. In the series, every time we think we run into a hero who has all the answers, it turns out they're just like everyone else. There are no mythical, saving leaders. There are only people who have to discover that their survival depends on each of them bearing up together, using their gifts and skills for the common good. Rick is continually confronted by his own inability to be the leader he needs to be. For example, he and the entire group are saved by Carol, a formerly abused woman who is herself an example of personal transformation. Even though she had been rejected by the group, Carol chooses to save them. But Carol isn't a leader and doesn't want to be. She too is saved by others many times.

Daryl, who would most likely rather live by himself, chooses to go back for his friends, to risk his life for others, to continue to contribute to his new community. Glenn, the former pizza delivery guy, exhibits courage and toughness like no one else. He chooses to see the best in people. They can always count on Glenn to come to the rescue. But he isn't perfect either. None of them are. They're humans.

New People

Jesus reasserts God's original purposes. In an age when religion is a form of power and control, Jesus turns it upside down (or right side up) and ushers in the original idea that *everyone* who is part of his kingdom represents God. They are a new people who would help others see God through the way they treated each other.

God is represented by *all* of his people. Women, slaves, every ethnic background, *everyone* is invited to represent God. We live in an apocalyptic age; people are trying to survive the realities of a dark world. We know how easy it is to succumb to the worst of our humanity as we try to survive, sometimes even against our will. And we also know, because we've learned the truth about ourselves, that we are capable of great evil. We cannot survive this alone, nor can we be the lone hero. We must recognize both our abilities and our limitations. We need other humans. Our relationships, in spite (or even because) of the pain in our lives, give all of us the capacity to change things.

Mother Teresa was once asked by a skeptical reporter how she could believe in God when there was so much poverty around her. She replied simply, "When a poor person dies of hunger, it has happened because neither you nor I wanted to give that person what he or she needed."[1] If there are no more priests—just people trying to build a new humanity based on the new human himself, Jesus—then *we* represent God. Everything we do represents him.

This saves us from pointing a finger at the church and paying no attention to the three pointing back to us. The church doesn't love the poor. Sure. But the question is, do you? The church doesn't pray. Sure. But do you? The church doesn't respond to refugees. Again, do you?

This means that the church is liberated from an institution and is instead embodied in a people. You, if you claim to follow Jesus, represent him in your daily actions. Every act that is loving, kind, forgiving, hopeful, beautiful, and grace-filled is an act of God. And every bitter, unkind, unforgiving, ugly thing we do distorts people's image of God. The responsibility cannot be placed on someone else. It's on us. With great power comes great responsibility. Just ask Rick.

When Maggie told Father Gabriel there was nothing special about his church building, that it was just four walls and a roof, she was right. And she was wrong. The thing that made his church special was what it was for. What it should be: a refuge, a shelter, a place to run to. This is its original purpose.

Church as Refuge

This *Walking Dead* church scene reflects a story from Rwanda, which was the scene of a contemporary apocalypse. The Rwandan genocide took place over a period of one hundred days, from April 6 to July 16, 1994. Hutu extremists attempted to wipe out the entire Tutsi population. Over 800,000 Rwandans were murdered.

At the height of the genocide, in one village a church bell rang, which sounded like a call to refuge. As it rang, the Tutsis,

who were being systematically killed, went there—finally, a place to hide. When the bell stopped, killers emerged, and it became clear to the Tutsis that the bell was used to gather them in order to kill them, not to save them. This is the distortion, a betrayal, of the purpose of the church. And it signals the destruction of God's people. Just as Father Gabriel distorted the purpose of his church, it's the same with us.

The Bible says that the church is not the walls or roof of a special building. It says Jesus' followers are the church. We are his people. When we live as originally intended, we offer refuge, safety, community, belonging, and love. And if the world ever needed this kind of people, this kind of hope and community, it's now.

Far from being closed off and inaccessible, Jesus suffered with us and he offers us a better way to be human. Turning to Jesus, we have determined to live a different way, a better way, to be the humans we were intended to be. And now, by living out this reality in community, we represent God to the world. Jesus' kingdom is a place where forgiveness is possible, where truth is accepted and embraced, where people come as they are, where everyone is in this together.

There are no more priests in the kingdom. God wants to be present in everyone. Everyone is sacred. Everyone is invited. We don't have to try to be someone special. We need to be honest about who we are and willing to work together to build a new world. We can become a new community. A new humanity that represents God together.

THE BRAVEST AND MOST POWERFUL THING YOU CAN DO

We run into some new people in The Walking Dead *story. It's a crew that claims to have the man who can solve the world's problems. His name is Eugene, a scientist who has the capacity to end the apocalypse. His protector is Abraham. Their entire purpose is to get Eugene to a place where he can save the world. But as the episode progresses, Eugene's story takes on a different tone. First he confesses that he is most concerned for himself, not others: "If I don't cure the disease, if I don't save the world, I have no value."*

Then everything goes sideways, as is inevitable, and finally the entire truth comes out. Eugene confesses: "I'm not a scientist. I lied. I don't know how to stop this."

Everyone is speechless. All that hope. All that possibility. A lie.

Is change possible? Can we envision another way of life that isn't just hard and long and horrible, but filled with hope and safety and freedom? Most people think that solving the

world's issues is a pipe dream. This is the subject of much debate in the dialogue of *The Walking Dead*. Is there a cure? Is a new humanity possible?

New Tools of Engagement

I tend to lean toward cynicism. Or perhaps it's realism. Let's get real about what is possible and what is impossible. For over twenty years I've worked with women who have been sexually exploited. Most people suggest this is something we have to learn to live with.

In the discussion regarding prostitution legislation around the world, I've heard debates that sound similar to *The Walking Dead*. Some people say prostitution is the oldest profession and is never going away. Others suggest that prostitution is the oldest oppression and can be done away with like many other social norms that needed to be challenged. After all, in some Western cultures women used to be owned like cows (in some parts of the world they still are). Surely that system was based on ignorance and fear. After it was abolished new possibilities emerged.

Fifteen years ago, Gunilla Ekberg helped usher in a brand-new way of social change. She transformed the way Sweden thought about prostitution. Most people think prostituted women are the culprits or the problem. Gunilla (and others who studied this deeply) understood prostitution to be a form of violence against women. The real culprits are the men who buy the prostitutes' services. So, the Swedes changed the entire system.

They decriminalized prostitution because charging women for being prostituted is like charging a domestic violence victim for being beaten. They made it illegal for people to purchase other people and enforced that new law by arresting men trying to buy sex. Then they offered a way out for women caught in the grip of prostitution—retraining, treatment, and employment. The result? Sweden experienced a transformation. It's the only working model where prostitution has been delivered a fatal blow. In ten years Sweden had halved the number of prostituted women on the streets and virtually stopped human trafficking throughout the country.

When Sweden made the decision to radically alter the prostitution laws in their nation, they announced on their website, "We want the world to know that in Sweden, women and children are not for sale."

How about extreme poverty? For my whole life I've felt that extreme poverty is a reality I should learn to live with. I remember the day I first read that extreme poverty could be beaten. News to me! In *The End of Poverty* economist Jeffrey Sachs says if we applied basic economic principles to extreme poverty, we could end it in thirty years.

A few months later I was watching Muhammad Yunus, a Bangladeshi entrepreneur, banker, and economist, receive a Nobel Peace Prize for his work in creating the Grameen Bank (the world's first microcredit bank for the poorest of the poor). When he received the award, he responded that he couldn't wait for the time in the next decade when he could take his grandchildren to a museum to show them what extreme

poverty was like! Not only does he believe it's possible, he believes it's inevitable! Talk about a mind shift!

This was the most liberating thing I've ever watched. He explains in his book *Banker to the Poor* that he believed it was possible for his country to end poverty, and in order to start that process he went on a year's journey to understand why the poorest of the poor were still poor. After he understood, he created a system to empower them in order to make his dream a reality.

Nelson Mandela was on his way to buy arms when he was arrested. Stuck in the middle of apartheid, a government system of white power and the oppression of anyone of color, he had tried to fight the system as a lawyer and an activist. He finally gave in to despair. He felt that the only way to fight power was with power, so he was on his way to get some when he was arrested.

It took Mandela many years in jail to embrace other forms of power. Violence is not the answer. He knew this deeply. So he started to look at other powerful strategies, but of a different sort. Forgiveness, unity, community, diversity, a shared humanity: these were the weapons he unleashed on an entire nation. It transformed South Africa and is a stunning display of how a better world is possible. Instead of the seemingly inevitable bloody revolution of retributive violence, a bloodless revolution occurred. People emerged with new tools of engagement—forgiveness and truth. It was an incredible thing to behold.

Gunilla Ekberg, Muhammad Yunus, and Nelson Mandela are not alone. Many others are reshaping the world. And

they all have something in common. They are able to envision a different future. Though they frequently meet resistance and are sometimes persecuted, they hold to an unquenchable hope for a new future, a better world, a better humanity. They are unwavering in their commitment to progressive change.

Years ago, I asked Gunilla the secret to actualizing world-changing possibilities, and she told me it was simple. Imagine a better world, she said, and then live out that vision.

Can you imagine a better world?

A Better World

In *The Walking Dead*, it's hard to imagine a better world. It seems the survivors keep looking the nihilist worldview in the face. It becomes difficult, almost painful, to allow yourself to imagine that life can be better, because it's so hard right now. When the survivors encounter a new community, even if it is amazing, they approach it with fear and dread. It can't be what it pretends to be. There must be a sinister truth behind its façade. I find it difficult to watch.

This might be because of my friend Hanna. Hanna's background is a horror story. I've never heard a worse one. After surviving a childhood of trauma and pain she ran away. She found herself, a young teenager, for sale on the streets of a big city. A man walked by her, smiled, and then kept walking. She cursed him under her breath for not stopping. Then she was shocked as he pulled up to the curb where she was standing to offer her a ride to his house. It all seemed quite familiar.

She was expecting the usual tit-for-tat arrangement for the night. But when they got to his house she met his wife and received a home-cooked meal. She was invited to shower and sleep in a nice warm bed. In the morning, over breakfast, the couple offered to let Hanna stay with them until she could sort out her life and future. They told her they had prayed about it and were certain God was telling them to make this offer. God loved her very much, they said, and wanted her to have a home.

I listened to this part of my friend's story with great interest. "What happened?" I asked, like a little kid who can't take the suspense any longer. I knew the story didn't turn out very Disney-like since I had met her in a dark place. She told me she left that house the next night. In the middle of the night, with tears streaming down her face, she exited the home. She couldn't stay there. "Why?" I asked. "Why would you leave?" And that's when she told me something I had never heard before. She couldn't stay there because she couldn't believe it was true. And even if it was true, she couldn't mess up that beautiful family. Staying there would either fulfill her belief that no family is safe or she would make them unsafe by staying. Either way, she had to leave.

Hanna's inability to believe in a better world made a better world impossible.

It's what happens if we allow ourselves to give in to the despair of our current situation. If we give up on the dream to live another day in a better world, what happens becomes self-fulfilling bad news.

Hope-Filled People

As The Walking Dead *series continues, many communities come and go. Perhaps the most significant one, Alexandria, appears in season six. Alexandria is a walled compound virtually untouched by the zombie apocalypse. This self-sustaining community has lost people but hasn't felt the full impact of what seems inevitable. Many of the people living there have never had to kill a zombie. They are unprepared for what lies ahead.*

Rick tries to convince them of their need. But it's very difficult for them to hear. Finally, events happen that make them listen. People die and the residents of Alexandria are unable to protect themselves. The survivors they recently took in, led by Rick, are their best hope. Rick turns them into soldiers and prepares them for a life of survival. In the midst of it all we meet a couple who have drawn plans for the growth of their community: expansion, farming, cultivating new kinds of crops, solar panels, schools. When Rick first hears about it he rolls his eyes at their naiveté.

As we watch the survivors try to settle into a "normal" life, we realize how well-founded his cynicism is. What is happening on the inside of this untouched world feels like a charade, not real living.

The community is attacked and chaos ensues. Most of Alexandria is gone. Carl, Rick's son, has been shot and is unconscious, and walkers are roaming the streets. Everything is unraveling, and we all rehearse the inevitable reality of a world gone mad. But Rick picks this moment to say things that are almost impossible to believe. "I was wrong" is the first. Followed by "It's possible." Talking about rebuilding a community Rick says, "It's all possible. I see that now." Later he says, "I want to show you the new world, Carl. I want to make it a reality for you."

Nelson Mandela aptly observes, "Everything is impossible. Until it's done."

The news media these days tries to convince us building a new world is impossible. Hopelessness and violence seem inevitable. We find ourselves in a post-traumatic state, like the survivors in *The Walking Dead*. Nothing can be done. We are doomed to destruction.

I totally understand how we could give in to these morbid ideas. I've been studying injustice for years, walking with people beaten down by the systemic brutality of slavery in its various forms. I'm tempted to give in to the idea that the future is set, and there is no changing its course. But this is not the gospel. Hope is a major theme of the good news. And this is also true of the zombie gospel—while there is life, there is hope. Change is possible. Truly, this is realized through individual transformations in *The Walking Dead*. Bad guys become nice guys, victimized women become strong warriors, violent people become peaceful. But perhaps the most dangerous reality of *The Walking Dead* is our most dangerous reality too. Despair. The idea that there is no hope of a better world.

Down through the centuries, many people have despaired of a better life, a better world. When Jesus showed up, the Israelites felt this way under the thumb of Rome. Any sort of uprising or public demonstration was met with violent and bloody force. In this context the Jews wanted Jesus to be a military man who would challenge the Romans with revolution. But Jesus wanted to free his people to live outside of

oppression, not just participate in a new cycle of it. So he did things a different way. Much like Ekberg, Yunus, and Mandela, Jesus proves that in the midst of a hopeless culture, we can be a hope-filled people.

Each of us face our own personal cycles of despair. Today, depression, suicide, addiction, and self-harm are reaching epic proportions. We are literally killing ourselves. In the American armed forces, there are more deaths by suicide than by combat.[1] This is what happens when we lose hope, when we lose sight of what we are doing and why we are doing it. We've become pretenders instead of participants—fathers who ignore their children, mothers who lose themselves, spouses who cheat, and employees who steal. We've become the very thing we never wanted. Until we can envision our future differently, we are doomed to repeat it.

This is what is so shocking when Rick declares that his cynicism and hopelessness was wrong. He doesn't admit to being wrong very often! He is a strong and confident leader. But this time he is convinced. Looking at the blueprints of Alexandria, Michonne noticed the Latin phrase *Dolor hic tibi proderit olim*, which means "This pain will be useful to you." Could this be what the survivors are learning?

Believing a Different World Is Possible

It's time to imagine building a new kind of community. This is what the group in *The Walking Dead* stirs inside us. Hope doesn't have to be a denial of pain. It's not forged in the midst of a perfect life. Pain can be useful. It can be a place that helps

us start again. In Rwanda, after the genocide, the people spent years rebuilding their nation. How do you rebuild after experiencing such horror, such inhumanity? First, they said they would always remember. They would never forget how fear, violence, and racism ravaged their country. Every year a whole week is dedicated to remembering and mourning the genocide. The president, with the help of Archbishop Desmond Tutu (the cleric who helped South Africa reconcile after apartheid), called for reconciliation. That meant that the perpetrators of violence, many of whom were getting out of jail, were invited to consider asking to meet with and request the forgiveness of survivors. A *New York Times* reporter recounted the stories of these reconciled people. The following is the story of Dominique Ndahimana, a perpetrator, and Cansilde Munganyinka, a survivor:

NDAHIMANA: The day I thought of asking pardon, I felt unburdened and relieved. I had lost my humanity because of the crime I committed, but now I am like any human being.

MUNGANYINKA: After I was chased from my village and Dominique and others looted it, I became homeless and insane. Later, when he asked my pardon, I said: "I have nothing to feed my children. Are you going to help raise my children? Are you going to build a house for them?" The next week, Dominique came with some survivors and former prisoners who perpetrated genocide. There were more than 50 of them, and they built my

family a house. Ever since then, I have started to feel better. I was like a dry stick; now I feel peaceful in my heart, and I share this peace with my neighbors.[2]

How can anyone have hope for the future when the world is in such a mess? If the answer does not come from outside of us, maybe it's inside. Maybe the pain we've experienced will be useful to us as we build a new world.

This is exactly what Jesus did. His claims about a new way to live shocked some folks, appalled others, and created many scoffers. He set up a new kingdom with a new allegiance (to God alone) and a new system of governance (equality). And those who followed Jesus began to live a new way, which includes forgiveness, sacrificial love, hope, and freedom. It made a big shift in the world. Forever.

When Nelson Mandela launched the Truth and Reconciliation Commission in South Africa, chaired by Archbishop Desmond Tutu, he received a mixed reaction. Most people who were victimized believed it would allow people to literally get away with murder. While others suggested it would teach and do nothing. But everyone watched as things inside and outside of South Africa began to change. Forgiveness and equality have power. Living a different way is the bravest and most powerful thing anyone can do.

Years later when Archbishop Tutu traveled to Rwanda, he had authority to help them deal with the injustice of the past and see signs of hope for a new future. Rwanda has not only recovered from the genocide, they have learned to live

a different way. A seasoned veteran who has done the hard work of learning to forgive as a lifestyle taught them that the answers are never from without but always from within.

Our world is drunk on violence and despair, but we long to live a different way. Why not try it? It starts with believing a different world is possible. My friend Hanna undoubtedly wished she had stayed with that lovely Christian couple who offered her a chance at a new life. You don't have to live with that kind of regret. You can choose to live for a better world by forgiving someone you have held a grudge against. Or helping someone who can never help you back. Or giving when you feel like taking. Or loving people and believing the best for them, even when they haven't been kind to you. You can live a different way from the inside out by receiving God's love to you. Often, we can't live a different way because our internal world is filled with hopelessness and despair. We haven't experienced forgiveness. We don't know inner peace. We have no sense of worth.

But that can change. And as God changes us, it can change what happens around us. Allow God's message of hope to hit you like a crashing wave. Let his love fill you and wash you. Receive his forgiveness and let him fill you with hope for the future. As you receive, then freely give. That's how we build a new world.

BABIES IN THE APOCALYPSE

Maggie and Glenn decide to have a baby. On purpose. They talked about it. Their plan comes out in season six, and it is followed by a conversation between Abraham and Glenn. Abraham just cannot believe that they would intentionally have a baby. He asks Glenn, "When you were pouring the Bisquick, were you trying to make pancakes?" Translation: Glenn, when you and Maggie were making love, were you attempting to conceive a child? Glenn replies yes, they had been hoping to get pregnant. After all, they were trying to build something in this new world. They all were. Abraham can't comprehend this. And for the rest of the season he really can't let it go. He keeps thinking about investing in the future. Being willing to take the risk to hope for a future.

Some things are astonishing. Things that are shocking to hear. The general idea of our wonder-filled, staggering moments are grand, huge, big ideas. Think Grand Canyon. No one can look around at its beauty and bigness and not have their minds blown. It's amazing.

I started listing all the things that have filled me with that incredible feeling. Big things. Like the time I climbed Mount

Sinai at night so I could watch the sunrise over the desert. Or the time I went snorkeling with my son at Australia's Great Barrier Reef and saw the unimaginable depth and diversity of the underwater world. I remember climbing onto the top of a truck with a friend and praying for northern India. Then we drove through the Himalayas together, an exhilarating mix of adrenaline, hope, and freedom. Those instances and many more—sunsets and sunrises, the quiet descent of the snow on a mountain, the breath-holding scene of a doe and her mother in the forest, spotting a whale cresting the ocean—all of them inspire awe.

James Irwin, an astronaut who walked on the moon in 1971, famously said, "God walking on the earth is more important than man walking on the moon."

A Statement of Hope in a Hard World

God walking on earth is amazing. God is bigger and beyond any of our most awestruck moments. And he took all of his majesty and glory and shoved it into the form of a little baby. Like Aladdin once said about being a genie stuck in a bottle, "Phenomenal cosmic powers . . . itty bitty living space." Wow.

And as big as God is, bigger than the universe, I can't help but ponder how small God chooses to get.

It fills me with wonder.

I have witnessed people transformed by allowing the sacredness of life to take them out of survival mode and into something transcendent. The image of God is in all of us. If we could see that every day, we would be altered.

Remember my friend Hanna who was sold into a pedophile ring as a little girl? She was abused and tortured in ways that are traumatizing to hear about let alone live through. I asked her one day how she lived through it. She told me about an incident that had given her the strength to carry on. One day she was locked in a closet because the marks on her body were too obvious for her to go to school. In the closet she called out to God. "Where are you, Jesus?" she cried. The closet was dark and she was afraid and alone. Suddenly, she said, the closet filled with light and God spoke to her. He said, "I'm right here." And she felt him. She felt the presence of peace and comfort. Right in the midst of her darkness and fear, she felt God!

She looked me right in the eyes, with hers full of tears, and told me that on that day everything changed. Not on the outside. Things remained abusive for many years to come. But Hanna now knew that she wasn't alone. God was with her. Surprising, isn't it?

This is what is so truly amazing about God. He can get small enough to show himself to a young girl in a closet. He can get inside of her heart where her true fear lies, and speak truth. That is a wonderful kind of small, isn't it?

So, maybe the big, ostentatious signs from the heavens we are looking for are the wrong ones. Maybe the signs and wonders of God occur in small places.

When Bob, one of the characters in *The Walking Dead* (season 5), is dying from a walker bite, the community says their goodbyes. He then asks Rick to stay with him, along with

Rick's young daughter, Judith. He tells Rick that he never knew if there were any good people left in the world but then the group took him in and he was part of community. Rick and Bob have this conversation:

BOB *Nightmares end. They shouldn't end who you are. And that is just this dead man's opinion.*

RICK (Rick nods) *I'll take it.*

BOB *Just look at her [Judith] and tell me the world isn't gonna change.*

I remember visiting a friend in the hospital after she had her baby. The father of the baby was in prison, and though my friend had lived through her own nightmare, she was excited to welcome this baby into the world. When I showed up to her room with flowers, police guards were outside of the room. My heart started to pound. What was going on?

I went in and discovered that the baby's father had been let out of prison to visit his newborn son. The room was dark, the mother was sleeping, and the crib beside the bed was empty. I started to panic, wondering about the child's whereabouts. Then I heard weeping. Deep cries. I went around the corner and saw this hardened prisoner in an orange jumpsuit kneeling on the floor with a baby in his arms, weeping. He was looking at his baby boy, and was weeping. Between his sobs he said to me, "Have you ever seen anything so beautiful." And the truth was, I hadn't.

All children are born bearing the image of God. Every single life matters to God. He has designed us with his seal—his

image. When we see a baby, we don't merely see a little human, we see the image of our great, big God. That's why babies are so magnificent. Put one in a room and watch everyone gather around. They are a statement of hope in a hard world.

This fact permeates the narrative of *The Walking Dead*. Rick's baby is born. What to do? Logic would tell us to get rid of the baby. That baby is simply fodder in a world gone mad. But is it? The baby represents life and brings hope to many of the show's characters. The survivors begin to recognize the cries of vulnerability, innocence, love, and hope. Hardened and broken people begin to care for someone weaker than themselves. It makes them truly human again.

Remember Michonne, who, after losing her family and her sanity, had lost herself in the effort to survive? She refuses to hold baby Judith, most likely because she didn't trust herself. She can't bring herself to hold a fragile life. But a day came when Judith was thrust on her. Michonne reluctantly holds the baby, first away from herself but then she brings her close. As she holds the fragile life in her hands, Michonne begins to sob. Oh, the wonder that a small, dependent, and innocent baby could bear so much power—so much love.

Made in God's Image

Humanity is sacred. We know this because when we see babies we encounter goodness. Most people can't put it into words, but beauty and hope and life and love exude from an innocent baby. And this truth is sacred. It sure isn't functional. Babies can do very little for themselves. But surely they are a

sign from God that we are not alone. They are a light in the darkness, hope in the midst of despair, a reason to keep going, love that nurtures our best selves. They remind us of not just who that baby is but who we are too. We are sacred. Humanity is sacred. And that is what the babies do in *The Walking Dead*: they wake us up to that reality.

Our reality is almost as harsh as that of the zombie apocalypse. Almost a million children were aborted in the United States in 2014; 19 percent of pregnancies ended in abortion. In our generation, more children than soldiers have been killed as war casualties. And on an average day, ninety-three Americans are killed by guns; that's one every fifteen minutes.[1] When we lose the sacredness of life, we have lost a key to our own humanity. Once that sacredness is covered with fear, despair, or hate, we have lost ourselves. We become the very monsters we are afraid of.

Recently, I was privileged to go to Haiti with Compassion International to visit my sponsor child and his mother. Emerson was born into extreme poverty, and the massive earthquake of 2010, which rocked the fragile infrastructure of that impoverished country, has left them destitute.

Emerson's mother told me she had almost lost hope. She tucked her child into bed hungry every night without knowing how she was going to survive the next day. Someone told her about a church in the city that was helping children. They were giving them a chance in a horribly difficult world. It sounded too good to be true, but just in case she made the long journey into the city to ask about the program. She went

to the church and met people who value life. The church took a look at her and Emerson, and made room for them.

The church looked beyond the despair, dirt, and hunger, and into the eyes of people made in God's own image. People with value, potential, possibility. People with a future and a hope. I managed to play a small part in this unfolding drama. On my trip I not only met the family I had prayed for and supported financially, but I also met hundreds of people who have chosen a life that values every child. People who are at the edges of survival themselves but who choose to value life. It's a powerful reality in a harsh country. It's humbling to see people with few resources share theirs freely. It's encouraging to see folks who have lost everything put the little they have into the lives of children.

While I was there I also met a young pastor who was filled with ability. He spoke several languages and was on the recruitment list of several aid agencies. But he didn't want a lucrative job. He was offered jobs in the United States and many other countries. But he didn't want to leave. He was called to plant a church in the worst area of his city. God had called him there. The area is called "Paradise," almost as a joke. But my friend didn't get it. He thinks it's real. He believes and works and lives for that paradise to become a reality. He told me that if I were to visit, I wouldn't see paradise—not yet. But give him some time. His plan is impressive.

Making Room for Small Things

With a backdrop of pain, destruction, and extreme poverty, we find resilient courage and the power to keep going and

believe for a better future. It takes sheer audacity to make room for the small things of life to emerge. The fragility of beauty and the smell of hope always begin small, small but powerful. We find these small things turning into witnesses of God in a despairing world. It's as if someone turns on a light in the dark. This is, of course, how God comes on the scene of human history. Not as a king, but as a baby—the fragile beauty of vulnerability wrapped in the sacredness of life.

Will we simply go for the well-rehearsed truth that only the strong will survival, or will we dig deeper and experience the true beauty and gift of life? Valuing life, even the most vulnerable kind, takes us from mere survival to becoming part of a beautiful and inevitable future. As Bob said to Rick, "Just look at [a child] and tell me the world isn't gonna change."

The best example I have of this kind of transformation was when I led a small group of people in a shelter. We met once a week to support each other and to pray. To survive, they knew they'd need something beyond themselves to get through. Faith makes perfect sense when you don't have much else to rely on.

In one of our meetings the small group material we used asked us to consider sponsoring a child. I almost skipped that part for obvious reasons. But one of the women in the group said she would like to help a little girl from the other side of the world who had no options. Another person agreed. Someone else suggested they may not be able to do it alone but if they pooled their money maybe it'd be enough every month to support a child. I was floored, thrilled, and convicted at the same time. I couldn't believe it was happening. I told them the

amount that was needed every month to support a child. They agreed it was a great idea to keep them from merely looking after their own needs. Investing in someone else's future was a sacred moment. Caring about a child while they themselves were fighting to survive was extraordinary.

Every week after they made that decision, they would dig deep to support their child. Some brought plastic trash bags full of recycling bottles they had collected, knowing the amount they needed to contribute to this girl's future. Others brought five-dollar bills, knowing their own survival during the week would be more difficult.

It was moving, to say the least. It was like watching survivors in *The Walking Dead* risk their lives scavenging for formula and baby food so that Judith would make it, or Michonne weeping in the company of innocence and thereby restoring her sanity. It reminds me of shepherds bowing before a baby in a manger.

WHY THIS COULD MATTER

Carol is one of the most fascinating characters in The Walking Dead. *When we first meet her she is an abused woman. Weak and frail, she is afraid to make a fuss or stand up for herself lest her husband, Ed, lose his temper. She has mastered the art of avoidance. Rick confronts Ed (with a beating) and soon after Ed dies from a walker attack. We all feel a little relieved for Carol.*

Then Carol loses her daughter. Everything she ever loved has been taken from her. Carol transforms from a weak, pathetic victim to a strong, violent, and sometimes pathological hero. She seems driven to protect the weak, standing up for people when no one else will, and making the hard decisions that no one wants to make (killing the infected but still-living sick, for example).

She hardens her heart and becomes a cold-hearted killer, calculating and a bit scary. When the community settles down in Alexandria, Carol plays her old role. It's fascinating. She pretends to be the person she used to be. And somewhere between pretending and killing, she loses it. She can't figure out who she is. She knows she is no longer the pathetic, weakling that she thought she was. But she also refuses to be a cold-hearted killer.

This all comes to a head when she is confronted by Morgan, who himself was transformed from a vengeful, murderous state to a peaceful man who refuses to kill. Something shifts in her. Something begins to shift in everyone.

Carol and the community are faced with the idea that perhaps their surviving ways don't need to be their destiny. Maybe, instead of simply reacting, they can create. Maybe they can choose not to kill. Perhaps they can live without judgment and contempt. Violence might not be their answer.

Morgan gets busy making a jail cell. Rick tells him that's ridiculous. For Rick, killing people is the only answer. But Morgan is making a truth possible, and the community is forced to confront what it has become.

Eugene has a different transformation. He has been a passive, manipulative, and frightened man. Useless both as a defender and a contributor, Eugene confides in Father Gabriel, who himself has been so afraid he remains paralyzed and cannot help the survivors much at all. Gabriel reorganizes the church in Alexandria and begins by talking about forgiveness, but this time with the kind of depth required to make it sound like truth. Both Eugene and Gabriel have a transformation of courage. They realize that they don't have to live in fear and remain passive cowards in the face of danger. They can confront their fear and move with courage and faith. Both of them embrace their inner capacity to fight.

Like the residents of the imaginary community of Alexandria, our lives move through various forms in different seasons. Some of us have had seasons of our lives when we've checked out or used violence toward others as ways of surviving. Because of fear, some of us have been spectators instead of contributors.

My friend Bob talks about the various stages of his life, which he calls "Bob 1," "Bob 2," and so on. Right now, I think he's on at least "Bob 9." The worst possible thing he could imagine is to be the same Bob his whole life. He wants to give himself permission to adapt, to change, to learn, to grow, to move on. He isn't stuck. When he shared that truth, something resonated deeply within me.

Refusing to Be Stuck

There are times when we all think we are stuck in certain behavioral patterns. We fear that a poor choice we made as a teenager, or our not-so-good marriage, or something horrible we have survived will end up defining us for the rest of our lives. That's not true. It all depends on what we want to learn, how we want to grow, what relationships we pursue, and how much we allow love and the possibility of change to inspire us.

No one can force us to change the way we live, to challenge societal norms, or to commit to creating a new kind of community. That's *our* choice. That's *our* work.

Many people treat their lives like they watch their zombie shows. They get lost in the plot or the characters or the gore. They get stuck on the surface—the makeup, the costumes, the plot twists, how many characters have died—and risk the danger of being a passive spectator to their own lives. They start to believe that life happens to them instead of being something they are creating.

Jay Leno once said that he'd do anything for the perfect body, except diet and exercise. The simple truth is that even though we know the right things to do, we don't do them. In

recovery circles people say that they don't care what we believe, they only care what we do. The Bible puts it like this: "Faith without works is dead." It doesn't matter if we have correct beliefs or what our background is. We do not have to be defined by our past or our ideas; we are defined by what we do.

A woman I was privileged to know spent the last three years of her life loving the poor. She was the oldest person in our mission school and the grandma not only to our group but also to many of the people we helped on the streets. Having lived a hard and wild life, she was dying of liver failure. I'll never forget a conversation we had one day when she expressed how much she wished she would have started this "community living stuff" sooner. She confided that she never realized how fulfilling this way of life could be. Now, she could be friends with people who weren't like her. The fact that she could forgive and be forgiven gave her a new lease on life. Her life mattered to people who needed a friend during a difficult time. She ended our conversation with a sense of regret but also gratitude for the opportunity she had to finish her life for others. Her last years were her best.

Are you living your best life? I have friends who ask themselves, "What would my best self do?" and then they try to do that. Remember when people were asking, "What would Jesus do?" I liked it, but it lacked something. The truth is that our best selves are realized when we allow Jesus to enter our lives. Then we can become the people we long to be. But the other part of this truth is that we have to choose to live the way of Jesus. This is the reality of the situation. The question

isn't "What would Jesus do?" because Jesus already did it. We must ask, "What will I do?" To be our best self, we must follow Jesus' example. It's not too late to change who we are.

I've never witnessed anyone come to the end of their life and suggest they should have paid more attention to surface things. No one ever says they should have redecorated more or spent more time at the office. They express regret for the things they could have done but were too afraid to do, things rooted in truth and relationships, things that resonate with our best selves. They held on to their zombie selves until it was too late to fix or forgive or make changes.

No one wants to live a life of regret. So in the spirit of transformation and the idea that we aren't stuck, let's explore how we can move forward.

Coming Alive

What have we learned from *The Walking Dead* that might change our lives? Let me suggest five things.

1. Embrace your own humanity. Stop pretending that all is okay with the world. If everything in your personal world is okay, you most likely live in a bubble, which won't last long. Inform yourself about the world's crises. People are literally dying while waiting for you to get involved. The first step is to acknowledge your own brokenness. Stop believing that everything is set in concrete and you can't change it. Embrace the truth of your own humanity and how it is intrinsically linked to everyone else on the planet. Little kids are starving to death, and you may not even care. Embrace it. That is the person you are. That is who we all are.

2. *Get the remedy.* Take a long, hard look at Jesus. He is humanity at its best. He is the creator of a new people, the founder of a community that will create a new world. Join us. Join him in his call and mission to restore beauty, truth, hope, and freedom to this world. If you don't understand enough yet, learn more. Take the initiative. Read the Gospels (find a Bible and read the first four books of the New Testament— they're all about him). If you've been pretending to follow Jesus by going to church but not actually living like you know him, why not stop the charade and join the real movement. Get to know the One who will continue the process of world transformation by transforming you.

3. *Join a community.* Find people who want to live this new life together. Don't join a cute club that makes you feel comfortable; be part of a movement of people who believe a better world is coming and are actively involved with Jesus' work toward that end. Join with people who care about the poor, who garden in inner cities and share their food with the hungry, who make room for those the world has rejected. Join a community who asks where their stuff is made and who made it (sweat shops? indentured servants?). It'll bring some tension into your life, but it also will be a sign that you are living.

4. *Start now.* The zombie genre is wrapped in urgency, the sense that time is running out. Don't wait until the apocalypse is here, even if it's simply a personal one that threatens to implode your own life. Don't wait until you are out of choices or are paralyzed by regret for your self-focused life. Start right

now. Live your best life today. This might mean deciding to take some small steps in the right direction. Start volunteering once a week with a group committed to making a better world. Sponsor a child who is barely surviving their own apocalypse. Join a recovery community and get honest about your addictions. Make a difference in the world through your own small acts of kindness. Be the kind of leader you need. Start now.

5. Start the discussion. Maybe your friends have been enjoying *The Walking Dead* but are missing the meaning lying under the surface. Why not have a talk about it, learn some lessons together, discuss your values and the realities of life today? I've made a discussion guide of *The Walking Dead*'s first season to get you started. You can find it at ivpress.com /the-zombie-gospel. Begin to help people enter the deep end of living with intention.

Don't get me wrong. I'm not suggesting you shouldn't be entertained by *The Walking Dead*. I'm simply offering a possibility that the show might be a way for you to have a deeper conversation with others about what really matters in life. In a sense, it's an invitation to prepare yourself for the realities of a harsh and broken world. But it's also much more than that. Rather than thinking of this book as simply a survivors' guide, think of it as a thrivers' guide. Remember, the end of the story is that a new humanity is possible. If you are willing to lose your life, you can find a better one. You no longer need to be afraid. With God's help, it's possible to find your courage, lose your fear, choose a peaceful path, and change your mind. You are part of the plan to help save the human race.

Perhaps more than anything else, the zombie gospel offers us a chance. Before we enter the apocalypse (whether personal or literal), we could choose *now* the new reality, the new kingdom, the new human community. The choice we make will matter forever. Let's start with ourselves and then build relationships with those around us. I believe this resonates deep in our hearts. Listen to the voice calling us to live a different way.

We are sacred. We are special. We are chosen. We can be saved. We can save others. The good news of the zombie gospel—the best news of all—is that we can be human.

ACKNOWLEDGMENTS

My Dad and I had a tradition after we'd watch movies together: we would discuss them. He would quiz me with bothersome questions about what it all meant and whether I believed it and why. It pained me then, but now I'm so grateful. Thanks, Dad. Your example made it possible for me to find God speaking in everything.

NOTES

3 Fighting the Zombie Infection

[1]Melissa Dittman, "Protecting Children from Advertising," *Monitor on Psychology* 35, no. 6 (June 2004): 58, www.apa.org/monitor/jun04/protecting.aspx.

[2]"Ten Things Americans Waste the Most Money On," 24/7 Wall St., February 24, 2011, http://247wallst.com/investing/2011/02/24/ten-things-americans-waste-the-most-money-on. A new tool clocks in real time how much Americans are spending. See "Retail in Real-Time," *Retale*, accessed February 24, 2017, www.retale.com/info/retail-in-real-time.

[3]Quentin Fottrell, "Seven Reasons Americans Are Unhappy," *MarketWatch*, www.marketwatch.com/story/5-reasons-americans-are-unhappy-2015-10-12.

6 The Longing

[1]Johann Hari, "The Likely Cause of Addiction Has Been Discovered, and It Is Not What You Think," *Huffington Post*, January 25, 2016, www.huffingtonpost.com/johann-hari/the-real-cause-of-addicti_b_6506936.html; emphasis added.

7 No More Priests

[1]Mother Teresa and Jose Luis Gonzalez-Balado, *In My Own Words*, (Liguori, MO: Liguori, 1996), 16.

8 The Bravest and Most Powerful Thing You Can Do

[1]Greg Zoroya, "Suicide Surpassed War as the Military's Leading Cause of Death," *USA Today*, October 31, 2014, www.usatoday.com/story /nation/2014/10/31/suicide-deaths-us-military-war-study/18261185.

[2]Susan Dominus, "Portraits of Reconciliation," *New York Times*, accessed February 28, 2017, www.nytimes.com/interactive/2014 /04/06/magazine/06-pieter-hugo-rwanda-portraits.html?_r=0.

9 Babies in the Apocalypse

[1]US abortion statistics: Rachel K. Jones and Jenna Jerman, "Abortion Incidence and Service Availability in the United States, 2014," *Perspectives on Sexual and Reproductive Health* 49, no. 1 (January 2017): 17-27, doi: 10.1363/psrh.12015. Armed conflict and children: Graça Machel, "Impact of Armed Conflict on Children," UNICEF (1996), www.unicef.org/graca. Gun violence: "Gun Violence by the Numbers," Everytown for Gun Safety, accessed March 30, 2017, http://everytownresearch.org/gun-violence-by-the-numbers.

ABOUT THE AUTHOR

Danielle Strickland serves the
Salvation Army in Los Angeles
as the western territorial social
justice secretary. Her books in-
clude *Just Imagine: The Social
Justice Agenda*, *The Liberating
Truth: How Jesus Empowers
Women*, *Boundless: Living Life in
Overflow*, and *A Beautiful Mess:
How God Re-creates Our Lives*.

Originally from Canada,
Danielle has spent over twenty
years serving the marginalized,
bringing hope to those caught up in addictions and prosti-
tution in back alleys, and exerting her influence in the halls of
government to see laws changed and practices transformed
so that people aren't trafficked and children aren't enslaved.
She is also an ambassador for Stop the Traffik (a global anti–
human trafficking campaign) and Compassion International.

Danielle is passionately committed to seeing God's kingdom
come on earth as it is in heaven. She is married and is the mother
of three boys.

COMPASSION SPONSORSHIP
PROVIDES A CHILD WITH

FOOD | EDUCATION

HEALTHCARE | HOPE

**THE OPPORTUNITY
TO KNOW JESUS**

A LITTLE COMPASSION
CHANGES
EVERYTHING

Somewhere in the world a girl is waiting — in some cases for daily food or water. Others have never heard the lifegiving words, "You are special." Sponsoring a child through Compassion for just $38 a month helps provide for her physical, emotional and spiritual needs.

**MAKE A SIGNIFICANT DIFFERENCE
IN A CHILD'S LIFE.**

GO TO: COMPASSION.COM/DANIELLESTRICKLAND

Releasing children from poverty
Compassion®
in Jesus' name

INTO THE LION'S DEN

Sylvia had been a fool to think she could pretend to be a messenger boy to lure the Earl of Greyfalcon from his gaming club. As soon as they were outside, he tore off her cap to let her hair stream free.

Sylvia clapped her left hand to her head, struggling to keep up with him as he dragged her along the flagway. Finally they stopped before an imposing townhouse.

"Please, sir," she gasped. "Where are we?"

Greyfalcon smiled coldly. "Surely you will not refuse to enter my house without a proper chaperon. Not after your little May-game at my club."

"You cannot do this!" she cried.

"Oh, but I can," he retorted . . . and Sylvia realized that her good name and her virtue itself were at the mercy of this man who clearly had none. . . .

AMANDA SCOTT was born and raised in Salinas, California, and graduated from Mills College. She did graduate work at the University of North Carolina, specializing in British history, before obtaining her MA from San Jose State University. She lives with her husband and young son in Sacramento.

SIGNET REGENCY ROMANCE
COMING IN JANUARY 1989

Emma Lange
Brighton Intrigue

Jane Ashford
Meddlesome Miranda

Mary Jo Putney
The Controversial Countess

LORD GREYFALCON'S REWARD

AMANDA SCOTT

A SIGNET BOOK

NEW AMERICAN LIBRARY

Copyright © 1988 by Lynne Scott-Drennan

 SIGNET TRADEMARK U.S.REG. OFF. AND FOREIGN COUNTRIES
REGISTERED TRADEMARK—MARCA REGISTRADA
HECHO EN CHICAGO, U.S.A.

SIGNET, SIGNET CLASSIC, MENTOR, ONYX, PLUME,
MERIDIAN and NAL BOOKS are published by
NAL PENGUIN INC., 1633 Broadway, New York, New York 10019

First Printing, December, 1988

1 2 3 4 5 6 7 8 9

PRINTED IN THE UNITED STATES OF AMERICA

*To the Grey Falcon
His own book
because he is and always will be
an inspiration to us all*

" 'Twas most inconsiderate of Greyfalcon to leave me so suddenly," moaned the dowager countess, reaching with one slim, well-tended hand for her crystal salts bottle but keeping her gaze firmly fixed upon her slender, young companion.

Sandy-haired Sylvia Jensen-Graham hid a smile as she turned away toward the heavily draped windows of the countess's vast, overheated drawingroom. "I am persuaded that his lordship can have had no particular intention of dying, ma'am," she said in rallying tones. From his widow's lachrymose attitude, one might think his lordship had passed away the previous night instead of a full six weeks before. "Do let me open these curtains," Sylvia added. " 'Tis a wonderful bright day outside and I do so admire your view down to the Thames from here. Moreover, I wonder that you can breathe in this stifling atmosphere."

"Oh, no, Sylvia, pray don't!" begged her ladyship. "You know how the sunlight hurts my poor eyes, and I am persuaded that you will let in a draft as well. Straight off the river, too, so it is like to be damp. Just put another log on the fire, if you will be so kind, and light some more wax tapers if it is too dark for you in here." She gestured vaguely. "There are some on the shelf behind me, I believe. And then, dearest, if you will just mix some of my restorative cordial in a glass of water. Doctor Travers prescribed it for me. Such a nice young man, don't you know."

Sylvia's gray eyes twinkled beneath their thick, dark lashes as she moved to obey the last of her hostess's requests, and with no small effort she managed to keep

her voice free of laughter when she replied that Dr.
Travers was a very estimable young man indeed.

"He ought to find himself a good wife," her ladyship
said predictably as she pushed an errant curl of snow-
white hair off her temple and tucked it back into her
intricate coiffure. "A doctor needs a wife, don't you
agree, my dear?"

"Ma'am, really, I've no intention of marrying simply
to provide Dan Travers with a wife, no matter how
skilled a doctor he may be."

"Well, as to that"—her ladyship sighed—"if he were
really good, he might have prevented Greyfalcon's
death and spared me all this distress. Such an awkward
time, you must agree. Why, Mr. MacMusker, our
steward, has never made a single decision on his own,
and Francis hasn't set foot on the place since that
dreadful row he and his papa had after Christopher's
death, and . . . Oh, I'm so sorry, dearest, how thought-
less of me!"

She looked truly distressed, so Sylvia hastened to
reassure her. "You needn't apologize, ma'am. 'Tis all
of three years now since Christopher's death, and as you
must know, there was never anything settled between
us."

"Nonsense, everyone knew from the time Christo-
pher was out of short coats that he meant to marry you
just as soon as you became old enough. And then he
went off to the Continent just to spite his papa for
refusing to purchase him a commission in the Cold
Stream Guards. Too expensive, Greyfalcon said, and
look what it got him—Christopher dead as a common
foot soldier on foreign soil and, not being an officer,
like to be buried there as well, had Francis not inter-
vened."

Sylvia remembered only too well. And she knew, too,
that the quarrel between Sir Francis Conlan and his
irascible sire had sprung from the fact that Sir Francis
had "wasted his blunt" bringing his younger brother's
body home for burial in the family graveyard deep in

the beech wood at Greyfalcon Park. "Damn-fool non-sense" was what the old earl had called Sir Francis's action, and remembering the stories she had heard of Sir Francis's brutal observations to his sire on that occasion, Sylvia could only marvel that the earl hadn't suffered an apoplectic seizure then and there, rather than waiting three years to do so.

She gave Lady Greyfalcon's cordial a final stir and stepped to the settee to hand it to her. "When does Sir Francis mean to return to Greyfalcon Park, ma'am?"

"I'm sure I couldn't say." The tone was long-suffering, but her ladyship straightened a little in order to drink her cordial.

"Can't say? But surely you must have written to inform him of his father's death." Sylvia stared at her in dismay. "I never thought to ask before, for it simply never occurred to me that you might not have done so."

"Well, of course I did, directly after it happened," replied her ladyship with a touch of asperity. "And even if I had not, your father must certainly have done so."

"Papa? Why on earth would you suppose any such thing as that, ma'am? You of all people must know that Papa rarely raises his nose from his books—except to sit for the Assizes, of course, or to shout for his supper or his pipe."

"Don't be disrespectful, Sylvia. Your father is a very great scholar. Of that I make no doubt. Why, even Greyfalcon respected his vast learning."

Knowing that the old earl had gone in awe of anyone with patience enough to read an entire book, Sylvia made no comment. Instead she repeated her question. "But why should Papa have written to Sir Francis?"

"Because Lord Arthur is his chief trustee, of course," the countess said impatiently. "Surely, you knew."

Sylvia shook her head. It occurred to her then that the man they had been discussing ought no longer to be styled as Sir Francis Conlan. He was now eleventh Earl of Greyfalcon. And her father was his principal trustee?

"Who are the others, ma'am?"

Lady Greyfalcon sighed again. "Myself, of course, and my brother, Yardley, though we are mere ciphers, as you might guess. Nothing can be done without Lord Arthur's say-so. Greyfalcon wrapped it up tight. Told me so at the time. Said I'd be too easily swayed by Francis's glib tongue, and called Yardley an old woman —which he is, of course," she added with another sigh. "Really, Sylvia, this conversation is making my head ache abominably."

Sylvia apologized but persisted. "Did you receive no reply at all to your letter, ma'am?"

"Merely a brief note, declining my invitation and expressing his apologies."

"How rude! He did not come for the funeral, either. I did wonder about that, but of course you were in no fit condition to be cross-questioned at the time."

"No, I was utterly prostrated," admitted her ladyship complacently. "Anyone would have been, to be sure. The shock—"

"Of course, ma'am, but surely you must have been distressed by his absence."

For the first time, the countess's pale-blue eyes shifted and she failed to meet her companion's gaze directly. "As to that, my dear, I was not really very surprised."

"Ma'am?"

"Well, you see, I had felt it necessary to explain in my letter to Francis that he had caused his papa's death, don't you know, so I could scarcely be amazed when he did not show himself at the funeral." In the face of Sylvia's clear astonishment, her ladyship's final words trailed into an uncomfortable silence.

When Sylvia found her voice at last, she said faintly, "Surely, ma'am, you never told him he was to blame."

"But he was, my dear, and someone else would have told him so if I had not."

"Do you mean to say it was true that his lordship suffered an apoplectic fit merely because he learned that Sir Francis had got into debt again?"

"Heard he lost over twelve thousand pounds in one sitting at Brooks's, that is what he heard, and from an unimpeachable source." Lady Greyfalcon sat up straighter and carefully adjusted her paisley shawl to sit more firmly upon her shoulders. Then, looking more directly at Sylvia, she added, "He also heard tales of one or two young women, no better than they should be, if you must know the worst."

"Well, Sir Francis has certainly never been called a saint, ma'am."

"No, but one of them has designs, Yardley said. An actress, he said, and a high-flyer, though I'm sure he oughtn't to write such stuff to me, nor should he insinuate that my sole surviving son is a rake."

"No, that he oughtn't, nor should he have written as much to his lordship, which I'll be bound he did, for if Lord Yardley is not your unimpeachable source, ma'am, I shall be much surprised." When Lady Greyfalcon only looked selfconscious, she added gently, "Sir Francis ought to have been left to deal with his own business in his own way."

The countess tossed her head. "I daresay Greyfalcon would have heard about the twelve thousand pounds, you know, without Yardley to tell him, and that was what sent him off, poor man. And what I am to do now, I'm sure I cannot say, with so little money of my own and no gentleman to look after things except Lord Arthur, for I am persuaded that, learned though he might be, he will forget to see to things more often than not."

Since Sylvia could not, in good conscience, disagree with this sentiment or, with propriety, agree with it, she changed the subject to one better calculated to cheer her hostess. Having with no small effort succeeded in this endeavor, she waited only until she had got the lady settled with a new gothic romance to read before gathering her gloves, her hat, and her riding whip and taking herself off to home. As she let her dappled mare pick her own route home through the water meadows

along the gently flowing Thames, she looked back for a last glimpse of the magnificent Elizabethan chimneys that stretched above the beech trees surrounding the great stone house, and wondered whether her father even remembered that he had responsibilities toward Lord Greyfalcon. She discovered over supper that she had wronged him.

"Well, of course I have attended to all that," said Lord Arthur Jensen-Graham as he peered suspiciously through his silver-rimmed spectacles at a platter of grilled sole being presented for his inspection. "Just a morsel," he added for the maid's benefit.

"Do you mean to say you've written to Greyfalcon?"

"Of course not. Thought he'd be home long since, demanding pocket money. Since he ain't here, daresay he'll come when he's of a mind to. In the meantime, I've set matters in train for probate. Dashed nuisance, too, I can tell you. Can't think why that old scoundrel didn't leave all this to his own man of affairs. Have to work with the fellow anyway. And I'll tell you this, my girl, 'tis just as well young Francis ain't about. Like as not he'd only complicate matters."

"His debts will be paid, will they not?"

Her father blinked at her. "Has he got debts?"

"His mother said he lost twelve thousand pounds in a single sitting at Brooks's."

"Good God. Well, the estate can stand it, if it must, but he ain't asked for the money, and I don't propose to go looking for debts to pay. The usual notices will appear in the papers, of course."

"Papa, I think you ought to write to him and tell him to come home."

"By and by, perhaps, if it appears he's needed."

"But I have been looking after his mama for six weeks now, and I can tell you he *is* needed. He simply must come home and take control of that place before she falls into a decline or burns the house down through ordering too many wax tapers lit or too large a fire kindled in her drawing room."

He peered at her over his spectacles. "I daresay the woman has little sense, but surely she can't burn that huge stone house to the ground through mere carelessness."

"Well, no, perhaps not, but I can tell you this, Papa, I am in a fine way to dwindling into an unpaid nurse companion, and I don't believe such a career will suit me at all for very long."

He grinned at her, the expression lighting his long, rather narrow face. "Then, the solution is clear, daughter. *You* write to him."

Sylvia opened her mouth to expostulate with him, but she saw at once that it would do no good. Though he certainly knew as well as she did that it would be thoroughly improper for her to write to Greyfalcon, he had said all he meant to say on the subject. Indeed, he had opened his book and propped it against a fruit bowl, and was paying her no further heed at all.

An hour later she sat at the little mahogany desk in her sitting room, nibbling the end of her pen thoughtfully. She could not, in propriety, write to a single gentleman to whom she was quite unrelated. Despite the fact that her father treated her as an unpaid housekeeper and Greyfalcon's mother treated her as a nurse-companion, she was still an unmarried lady and, at twenty-one, not altogether upon the shelf. It would be most unbecoming for her to write the sort of letter she wanted to write to the new Lord Greyfalcon. It would not, however, be improper for her to pen a simple request for his return on behalf of the dowager countess.

Accordingly, in the very elegant copperplate so painfully learned at Miss Pennyfarthing's Seminary for Young Gentlewomen in Oxford, she composed a graceful letter, explaining that she was doing so only at his mama's most earnest request and asking him to come home at his earliest convenience. Since her father's title was the honorary one bestowed upon the younger son of a marquess—for he was the late Marquess of Lechlade's

fourth son—he could not frank her letter for her, so she entrusted it to the post with some misgivings, lest Greyfalcon begrudge the expense of a few pennies to receive it.

Since any reply would quite naturally be sent to Greyfalcon Park, it was necessary to inform the countess of what she had done, and this was accomplished the very next day. Her ladyship chose for the moment to be grateful, but when her son's reply arrived less than a week later, the attitude she displayed to Sylvia was a long-suffering one.

"You did your best, my dear," she said, languishing against a pile of soft pillows on her drawing-room settee and looking very elegant in a lace cap and a robe of pink gauze, "but no one could have expected more than that he would say what he has said. Francis has no regard for anyone other than himself, just as his papa always said."

Suppressing a surge of annoyance, the strength of which surprised her, Sylvia adjusted the little petit-point footstool beneath her ladyship's pink-sandaled feet and said with forced calm, "Would you like me to ring for tea, ma'am?"

"That would be pleasant," agreed the countess, sniffing at her vinaigrette. "One must keep up one's strength, after all. Although I don't expect anyone will hear the bell. Imagine his writing that I am surrounded by doting servants. If only he knew."

Biting her lip, Sylvia moved to pull the bell. She was not in the least surprised when it was promptly answered by a tall young footman, neatly attired in the Greyfalcon blue-and-scarlet livery. The fact was that, much as the countess complained of her lot, her staff was an excellent one, well-trained under her temperamental husband and managed to a nicety by Merrill, the Greyfalcon butler. Greyfalcon had not concerned himself with the niggling details of household management as he had those of his estate, but he had certainly expected everything to run smoothly, nonetheless.

Sylvia had seen the new earl's reply to her letter, and while she could not but deplore his having written that he had no intention of returning to the country for some months because country life bored him, she could accept as typically masculine his belief that his mother, with a houseful of doting servants, had little need of his company. What angered her was his lordship's casual postscript, noting that now that there were funds at his disposal, he intended to enjoy himself. A man who could drop twelve thousand at a sitting at Brooks's, she thought, could no doubt bring an abbey to a grange in less than a year if he were not stopped.

Back at home that evening, she tried to bring the subject up tactfully over supper; however, her first efforts eliciting no more than a series of grunts from her father, whose nose was, as always, in a book, she tried a more direct approach.

"Papa, I am speaking to you. I wish to know more about Greyfalcon's fortune."

Lord Arthur, his attention dragged at last from the book beside his plate, blinked at her through his spectacles. "What is that you say, my dear?"

"Papa, do you not control Greyfalcon's fortune? You are his chief trustee, are you not?"

Lord Arthur frowned at her. "This is scarcely a fit subject for the table, Sylvia, nor one for discussion with a delicate female, come to that."

She wrinkled her nose at him. "Pooh. You cannot expect me to run this house for you, sir, nor to look after Lady Greyfalcon as I do, and still profess to be a fan-fluttering damsel unable to comprehend matters of finance. Where would we be, I wonder, if I had to have every such matter explained to me and then shook my head and batted my lashes and professed a lack of understanding of such complicated stuff? Do be sensible, Papa. This is important."

Lord Arthur grimaced. "I am perfectly sensible, thank you, and the fact of the matter is that I have been plagued with that man's affairs for several weeks now,

and I have no wish to be plagued with them over my supper tonight. I didn't like his father. I cannot imagine what possessed the man to dump his posthumous minutiae in my lap, unless it was merely to annoy me. And as for his wife, all I can say is that it takes a stronger man than I am to stomach her whining and her megrims."

Sylvia lowered her lashes demurely. "Lady Greyfalcon said his lordship admired your vast intelligence, sir."

"Stuff," replied her sire, unimpressed.

She chuckled. "Yes, no doubt, sir, but you do not answer my question, and while I promise not to subject you to whining or megrims, I can also promise to give you no peace until you satisfy my curiosity."

"Sylvia," he growled, "such curiosity is most illfavored in a young woman of quality."

"Papa, you are wasting your breath." She waved to the maidservant to begin clearing the first course, then made a tent of her fingers beneath her pointed chin, waiting only until the servant had left the room before continuing. "Now, tell me, sir, does he control his fortune or do you?"

Lord Arthur sighed but gave her his full attention at last, pushing the book aside. "I have discretionary control until he turns thirty, more's the pity. I believe he is turned twenty-nine, however, so it will be for less than a year." When Sylvia allowed herself a small grunt of satisfaction, her father glared at her. "I hope you haven't got some maggot in your head, girl, because I don't intend to play nursemaid to that young man. The faster I can turn his affairs over to him, the better I shall like it. If he then chooses to play at ducks and drakes with his fortune, that's his own lookout."

"But surely," she protested, "you have a duty to protect the estate."

"Never asked for it," he told her. "Don't intend to let it bedevil me."

He pulled his book forward again as the maid entered

to begin serving the second course, and Sylvia knew it would do no good to attempt to discuss the matter further. Clearly, her father had no intention of exerting his power over the new Lord Greyfalcon. His lordship's mother had no influence with him at all, so if anyone was going to bring him to his senses, she would have to do it herself.

Retiring to her sitting room, she gathered her materials at her desk. Then, this time carefully altering her own elegant hand to more nearly resemble her father's broad-nibbed scrawl, she set to work, entrusting the result the following morning to the postman, who promised faithfully to see it on its way to London at once.

Intercepting the reply when it came posed no problem, for Lord Arthur paid no heed to the post unless he was expecting a new book to add to his vast collection, and then he looked only for parcels. Greyfalcon's letter, though it came with commendable promptitude, was both disappointing and infuriating.

In bold black letters upon expensive gray paper, his lordship regretted that he had appointments that would preclude his waiting upon Lord Arthur in Oxfordshire. He further hoped that Lord Arthur would understand that such a meeting could serve no purpose and assured him that he placed every confidence in him to look after his affairs at home until such time as the trust might be concluded. Greyfalcon trusted, moreover, that he might depend upon Lord Arthur to see it that a generous draft was deposited quarterly in his London bank.

Sylvia scanned the letter in rising fury. Not one word about his mother, merely that arrogant assumption that Lord Arthur would make all tidy. Just who did Greyfalcon think he was? Did he actually think Lord Arthur had nothing better to do than to attend to Greyfalcon's affairs?

Briefly, she considered the possibility of writing him once more, more forcefully, but less than a moment's reflection was necessary before she discarded the

notion. Greyfalcon would at best merely refuse again to come into Oxfordshire, and she would be where she was right now. More positive action was required.

Not for the first time she wished she had a friend or relative nearby to whom she could unburden her feelings. But there was no one. There had been no one since Christopher's death. Of course, she mused, she could write to Joan. Lady Joan Whitely had been her bosom bow at Miss Pennyfarthing's, and although she was now Lady Joan Gregg, Countess of Reston, she had been at that time quite as much a madcap as Sylvia.

Joan would appreciate her feelings. She had met Sir Francis Conlan only once, but had promptly dubbed him arrogant and unfeeling for the simple reason that when he had learned that his brother, Christopher, then a student at Christ College, Oxford, had been caught in the act of assisting two young ladies to sneak back into their seminary after midnight, Sir Francis had traveled all the way from London to Oxford himself in no pleasant temper to put a stop to such goings-on. They had all three of them suffered the rough side of his tongue on that occasion. Yes, Joan would understand. But Sylvia had no wish to entrust her feelings in the matter to a letter. It would be much the better plan to discuss the matter with Joan personally.

No sooner had the thought entered her head than she began to take action. There were arrangements to be made, of course, for she had no chaperon to travel with her and she could scarcely leave without seeing to her father's comfort and to Lady Greyfalcon's as well. But by the time she had dispatched a message to Lady Joan and received an enthusiastic invitation to come to London at once and to stay as long as she liked, she had discovered that the vicar's housekeeper, Mrs. Weatherly, had formed the intention of visiting her brother in London and would be glad of Miss Jensen-Graham's company on the trip. She had also arranged for the vicar's wife, Mrs. Mayfield, and their daughter, Lavender, to visit the countess daily.

Though Lavender was well-known to be the silliest young woman in the neighborhood, Mrs. Mayfield was a calm lady who could be depended upon not to fidget her ladyship unduly. More important, they were the best Sylvia could do on short notice. By the end of the week her cases were packed and she was ready to set out for London.

Sylvia's fifty-mile journey to London was wearing but uneventful. The vicar's elderly traveling coach had little to recommend itself by way of comfort, but it was clean and Mrs. Weatherly was a restful companion in that she rarely spoke except to comment upon the cool weather, the lack of sunshine, and—when they stopped overnight at the Greyhound in Maidenhead—to condemn the hostess's housekeeping methods. Since the inn had retained an excellent reputation from before the day when on his way to the block Charles I had taken leave of his family there, Sylvia saw no reason to enter into debate over the issue, and had gratefully sought her pillow without examining the sheets.

They entered London via Kensington by late morning of the second day, and it was with relief that Sylvia bade her companion good-bye when the coachman let her down before the tall, imposing house in Berkeley Square that was the London residence of the Earl of Reston, Joan's esteemed husband. Her cases were swung down by the obliging, middle-aged coachman, who also offered to run up the steep, stone steps to knock on the door for her.

Sylvia, aware that the earl, known to be a stickler, might be at home, agreed at once, awarding the man a brilliant smile. Moments later, a footman in the Reston gray livery ran down the steps to collect her cases, and within ten minutes she was in the charming first-floor saloon that was Lady Joan's favorite room, watching her friend toss aside a newspaper in order to leap to her feet to greet her.

Attired in a sea-green silk afternoon gown, Lady Joan

Gregg was nearly as slender of build but several inches taller than Sylvia. Her bright golden eyes sparkled and her cinnamon-colored curls, arranged in a thick mop that had been cropped in the latest style, bounced erratically as she hurried forward.

"Sylvia, what a pleasure this is," she exclaimed, grinning. "Do sit down at once and tell me everything you left out of your letter. I shall order refreshments for you, in case you are starving, but I hope you do not mean to retire until supper to rest, like Aunt Ermintrude always does."

Sylvia chuckled. "How is Lady Ermintrude?"

"Better than she would have one believe," replied Joan with a wide grin. "She is here with us, you know."

"No, I didn't know," Sylvia replied. "How could I? You wrote nothing about her in your brief letter. Please don't say that we shall be expected to cosset her and tend to her needs. I promise you I have had all I can take in that direction from Lady Greyfalcon."

"So that is your reason for fleeing Oxfordshire! I might have known it would be something like that. Have I not been attempting unsuccessfully to get you to spend a Season in town these past two years and more?"

"I could not leave Papa," Sylvia said calmly.

Lady Joan wrinkled her button nose but made no comment, and just then the footman returned with their refreshment. Waiting only until her guest was served, Lady Joan dismissed the servant and demanded to know precisely what was going forward. "For I don't believe you mean to stay very long, my dear, much though we should like to keep you here with us."

"I doubt that Harry would be so quick to agree with you," Sylvia said with a teasing smile. "Confess now, when you told him I was coming, he nearly suffered a seizure."

"Not quite so bad as that," Joan said with a responding smile. "You and I are several years older now, you know, so he cannot expect us to get into the same sort of mischief we got into as girls. And he scarcely

knows the half even of that, for I have never described any but the mildest of our transgressions to him.''

''Perhaps not, but he was able to see one or two things for himself, after all, during our come-out Season. Remember his reaction when we held our Venetian breakfast in your mama's garden and swore to him that all the ladies and gentlemen were going to wear Roman costumes?''

Lady Joan gurgled with laughter. ''He wore a toga! Oh, Sylvie, that was indeed too bad of us. Harry was livid.'' Her golden eyes widened as a thought occurred to her. ''I do hope you don't mean to tease him about that. He truly made no fuss at all when I told him you were coming to us, but if you were to be so tactless as to remind him of that, I cannot answer for the consequences. He is a most obliging husband, but he does still have a bit of a temper.''

Sylvia shook her head. ''Never fear. I shall be as close as an oyster. Indeed, I shall be as sympathetic to Lady Ermintrude as it is possible for me to be, and I promise to be ever the obedient, respectful guest when Harry is present. But, Joan, you are quite right. I am in town for a purpose, and I doubt I shall remain for long. Papa will fret if I am away for more than a week. He has grown to depend on me, you see, and though he pays little heed to what goes on around him in the normal course of things, he becomes like a bear with a sore head when he is uncomfortable. I shouldn't like to go home to find that the servants have fled.''

''Then why are you here? You mentioned that it was a matter of great importance, but you went into no detail. And why on earth,'' she added as another thought crossed through her mind, ''are you fussing over Lady Greyfalcon? I know they are your neighbors, and I know that his lordship died some weeks ago, for there were notices in all of the papers, but surely she still has family to look after her and a host of servants. Don't forget, I have seen that monstrous pile of stone they live in and noted the great number of servants they employ.''

Sylvia grimaced. "That is precisely why I am in town. She has always been more than kind to me, in her fashion, so I quite naturally made a point of visiting her often after his lordship's death, with the result that she has come to depend upon me. Do you know that Sir Francis—or Greyfalcon, as we should now style him—has not set foot on the place since his father died? His mama has had no more than the briefest civil note from him. Well, no, that is not precisely true," she added conscientiously. "He did respond to a letter I wrote in her name, informing her most politely that the country bored him and that he would rather remain in town."

"No, Sylvie, you are jesting."

Sylvia explained the matter in rather more detail, and when she had finished, Lady Joan frowned, saying, "I cannot say I like Greyfalcon very much, for I cannot help but recall, whenever I hear his name, that very dreadful scene at school after Christopher helped us get back into the grounds that night and we were all caught by Miss Pennyfarthing herself."

"Greyfalcon was scarcely responsible for our mischief," Sylvia said with a grin.

Lady Joan was indignant. "Of course he was not, but it was he who made Christopher apologize to Miss Pennyfarthing, which gave her the notion that we ought to apologize to him—to Sir Francis, that is—for being the cause of his being called up to Oxford. And say what you might, he had no right to scold us, whatever he might have chosen to say to Christopher. And the whole, moreover, was Christopher's fault, for he sent for Sir Francis in the first place."

Sylvia shivered, for Lady Joan's words brought Francis Conlan's image to mind as clearly as though she had conjured the tall, dark-haired, broad-shouldered man into the room. She remembered his quick, restless movements and sweeping gestures. Indeed, she could almost hear his voice, as deep as the bottom of a well and nearly as cold, for he had not been in a pleasant frame of mind that day.

"Christopher didn't have enough money to pay his fine after Miss Pennyfarthing complained to his bagwig," she said. "He knew it would be useless to apply to his papa, and so he wrote to Sir Francis to ask him to send the money under his seal. Instead, Sir Francis came in person. Christopher hadn't written the details to him, but of course his brother had them out of him in a trice once he was there at Oxford." She was silent for a moment, remembering, then she said rather more quietly than was her custom, "I wish you had not mentioned that episode, Joan. I had forgotten Greyfalcon's temper."

Joan's eyes suddenly narrowed in suspicion, and Sylvia could almost see the thoughts organizing themselves in her quick mind. Thus, knowing of old that it was rare that one needed to explain details to her friend, she was not surprised when that young lady said sharply, "You have come to drag Greyfalcon back to Oxfordshire! Sylvie, are you mad?"

"Not mad, merely angry. And do not fly up into the boughs, for I have no intention of doing anything idiotish. I meant at first only to write to him again, to ask him to call so that we might discuss the matter. I thought that if I could see the man face to face, I might convince him that he is needed at home."

"But you cannot write to him. Harry would have a fit. Perhaps—"

"No, Joan," Sylvia cut in, seeing where her friend's thoughts were taking her, "I shall not ask Harry to speak to Greyfalcon for me. Harry is several years younger than he is, for one thing, and will likely be intimidated by him. And though I am sure Harry will make his mark one day, I do not think he would carry much influence with Greyfalcon now."

"And you will?" Lady Joan's skepticism was clear in her tone.

Sylvia grinned again. "He could scarcely ignore me if I were standing before him, and I am certainly not afraid of him." A small chill raced up her spine as she said the final words, for the vision she had had earlier

leapt back into her mind, and it was hard to see Grey-falcon as anything but one of the adults who had so often been annoyed by the pranks that she and Christopher had played as children. Though she attempted to ignore both vision and chill, telling herself firmly that she was *not* afraid of him, that he was, after all, a man who had no authority over her and one, moreover, who was merely eight years her senior, she was not altogether successful.

Lady Joan had not shot her entire bolt, either. "The fact remains that he wouldn't need to face you, my dear. Since he would no doubt feel he is not obliged to reply to so improper a letter, he would only ignore it. Then where would you be?"

"I did not mean to write in my own name, idiot, but in Papa's. I did so once before, after Greyfalcon's mama had received his reply—the one I told you about—and Greyfalcon never suspected that the letter I wrote him did not come from Papa himself. Never mind," she added hastily when her friend's mouth opened in amazed protest, "I thought better of that notion before ever I left for London. Despite what I said a moment ago, I know full well that even if he agreed to meet with Papa here at Reston House, his reaction when he discovered me in Papa's place . . ." She shivered. "Well, it doesn't bear thinking of. But do look at his reply to what he thought was Papa's letter, Joan, and tell me if you have ever known such arrogance?"

Reluctantly Lady Joan perused the letter, then returned it with a small shake of her head. "He certainly seems determined to avoid Oxfordshire, does he not?"

"Well, he has reckoned without me," said Sylvia grimly. "I told you I had devised a new plan—and a much better plan at that, Joan, one that cannot fail."

Lady Joan stared at her for a long moment, but when Sylvia said nothing further, she gave a little gesture of defeat, and her pretty features relaxed into an acquiescent smile. "Tell me what you mean to do, dearest."

But Sylvia shook her head. "First, I must think out a

few more of the details of my plan. I know, however, that you will help me in any way that you can."

Lady Joan nodded dubiously, biting her lip. "Harry won't like this, Sylvie."

"Then don't tell him anything about it. I must say the reason I don't tell you the whole at once is not merely that I have not yet thought out all the details but also that I don't trust you to keep a still tongue in your head. I remember how hard it is for you to keep secrets from your husband, my dear, for which reason I do hope you never decide to play him false. You would make a poor job of it."

"Sylvie! As though I would do such a thing!"

"No, of course you wouldn't," Sylvia said placatingly. "Certainly not before you present him with an heir."

"Sylvia!"

Noting the unmistakable glint of anger in her friend's eyes and remembering that it was one of the great sorrows of Joan's life that she had failed, after three years of marriage, to present her spouse with a child, she capitulated at once, saying remorsefully, "I beg your pardon. It was a dreadful thing to say. Don't be angry, dearest, I beg you."

"Oh, I am not angry," Joan said. "I know your foolish tongue of old."

"Here," Sylvia said, reaching for the teapot, "let me pour you a second cup." She glanced at her friend, noted with relief the disappearance of the storm signals, and then her eye was caught by sight of the newspaper that had been cast aside upon her entrance. Deciding a change of subject was very much in order, she asked quickly, "What news is there? I shall depend upon you, you know, for all the latest *on-dits*."

Lady Joan chuckled, clearly not deceived for a moment. "You never change, Sylvie. But there is not so much to tell as you might think, for we are very thin of company this early in the spring. I should still be in Somerset had Harry not been utterly determined to be

present for the opening of Parliament. As it is, I am doing little other than ordering new gowns and planning our first rout party. I do wish you were staying at least that long, but perhaps you will come back for it. 'Tis to be held the second week of April.''

"Perhaps," Sylvia agreed, unwilling to commit herself. "But surely there must be some titbit to discuss. I cannot believe London to be altogether devoid of gossip.''

"No, of course not, but about all one hears about presently, aside from Prinny's usual demands and shortcomings, is Prime Minister Perceval's wish to lay his hands upon some books that have gone missing. Would you credit it, Sylvie? He is said to have paid as much as five thousand pounds for a single copy.''

"Goodness, whatever is the book?''

"Here, let me find the article," Lady Joan said obligingly, reaching for the copy of the London *Times* that lay beside her. Rustling through the pages, she came to what she was looking for. "Here it is. 'It is rumored that our esteemed Prime Minister has been reduced to paying large sums of money (as much as five thousand pounds) for the return of several copies of *The Delicate Investigation*, purported to be a collection of the evidence gathered by his agents several years ago against the Princess of Wales. Most copies were retained by Mr. Perceval; however, several were given at the time to certain friends. It is said now that Mr. Perceval never intended the book to be made public and reportedly had burned most of the existing volumes in his own back garden. There are at least six copies, however, the whereabouts of which are unknown.' Imagine, Sylvie," Lady Joan said, looking up and shaking her head, "Five thousand pounds for one single book. 'Tis prodigiously hard to believe.''

"I don't believe it," Sylvia said flatly. "No one would pay so much for a single book.''

"Well, I should certainly like to find a copy of that book upon my own bookshelf," Lady Joan retorted.

"I'd take it to Mr. Perceval at once, and if he insisted upon paying me such a sum, I can tell you, my dear, I shouldn't refuse to accept it."

"No, neither should I," admitted Sylvia, thinking of all that one might accomplish with five thousand pounds in hand.

The conversation continued along such desultory terms as these until Lord Reston returned from the House and it was time to change for dinner. Sylvia changed quickly and spent the remaining time preparing her assault against Greyfalcon. Her plan required the writing of two letters, one professing to be an open letter to both the *Times* and the *Gazette*, the other a cover note explaining the first. Carefully imitating her father's hand again, she wrote them both before joining her host and hostess for dinner. Afterward, leaving her host to enjoy his postprandial port in solitude, she retired with her hostess to the saloon again.

Seating herself on a green brocade Kent chair, Sylvia smoothed the skirts of her somewhat outdated cream-colored evening gown and leaned toward her hostess, seated nearer the cheerful fire. "I believe I am ready to deal with Greyfalcon," she confided.

"Dear me, how on earth?" Lady Joan's eyes were wide. "And so quickly, too."

" 'Tis simple. I mean to tell him he gets no money unless he returns to Oxfordshire."

"But you said your papa has no intention of exerting his power," Lady Joan pointed out.

"What Papa intends and what Greyfalcon shall be made to think he intends are two separate matters," Sylvia said loftily. "I mean him to think that Papa intends to place a notice in the *Gazette*, informing Greyfalcon's creditors that his trustees will not be responsible for his debts and that his lordship will have no access to his inheritance until he achieves his thirtieth birthday."

Joan gasped. "Sylvie, you couldn't do such a thing."

"Yes, of course I could. I did. One sees such notices

often, you know, and I copied the wording from one that was in that copy of the *Times* we were looking at earlier. Such a ruse cannot fail to bring him to Oxfordshire, you know, and once he is actually there, surely he must see how greatly his presence is needed."

"Sylvie, he will be livid."

"No matter." Her tone was airy now. "I shall deal with his temper when I must. His mother needs him, his estate needs him, and if no one else will make a push to make him see that, then I must. And you will help me."

"I?" Lady Joan showed no sign of enthusiasm.

"Yes, you. You said you would not two hours ago in this very room, and surely you have not become such a staid creature as to miss such a lark as this one. Moreover, I shall not require anything more of you than your moral support—and one other small item."

"What item is that?" inquired Lady Joan warily.

"Only a footman's uniform, so that I might deliver my message to his lordship in person."

Lady Joan burst into laughter. "A mighty fine spectacle you'd make, my dear. Have you not looked at our footmen? There is not a single specimen under six feet tall. You are a full foot shorter than that."

Sylvia frowned. "I forgot. But we must come about, for I am determined to know his reaction, and I cannot trust such an order to one of your people even if I might trust any of them to describe Greyfalcon's reaction accurately afterward."

Lady Joan opened her mouth to speak, then bit her lip and kept silent instead, but the movement caught Sylvia's eye. "What is it? Come, Joan, you have thought of something."

"Only that I do have a page's uniform that might well fit you, though the page himself is stouter of build then you are. But, Sylvie, you cannot do this. Harry would cut my heart out if I let you."

"Oh, pooh, Harry knows us both well enough to know where to lay blame if he should by some misfortunate chance discover this plot. He might scold you,

but if you do not yet know how to bring that man around your thumb, Joan, then I never knew you at all.''

Lady Joan looked self-conscious for a moment, then grinned. ''All right, I daresay I can manage Harry. After all, there is no need for him to know anything at all about it, but I still think it would be better to send whatever message you mean to send to Greyfalcon by footman. Each one of them may be trusted not to read the contents of your message.''

''Perhaps, but I do not mean to take that chance, for only think of the dust that would be raised if such rumors got around London. In truth, Joan,'' she added when her friend continued to look mulish, ''I cannot bear simply to go back home and wait to see if my plan has succeeded. I shall know by looking at him, but that is the only way. Don't worry, the man hasn't laid eyes upon me in several years. Even if he recognizes your livery, he will never suspect a page of being anything but what he appears to be.''

''I suppose not, but if you haven't seen him in so long, how can you be certain you will recognize him?''

''Well, I shall take the message to his house, of course. He lives in Curzon Street.''

''But he will most likely be out during the day, Sylvie. You would then have to seek him at his club.''

''Well, I shall go there. And never fear, Joan. He was a man grown when last I saw him. He cannot have changed as much as I have.''

The arguments did not rest there, of course, but Sylvia's determination carried the day, and two o'clock the following afternoon found her upon Greyfalcon's doorstep, her slender form attired in a loose-fitting gray page's uniform, her long silky hair tucked mostly into the cap but cunningly arranged to look like boy's hair tied back at the nape of the neck with a black silk ribbon. The cap itself was pulled low over her forehead, nearly to her eyes, its white feather curling near her right cheek.

True to Lady Joan's prediction, his lordship was found to be from home, but his man displayed no reservation about confiding his whereabouts. Having had the forethought to retain her hackney coach in the street, Sylvia gave the coachman instructions to set her down next at Brooks's Club in St. James's Street.

"I'll not be able to keep me 'orses standin' 'ere in all this traffic, me lad," the jarvey said when they had reached their destination. "'Sides, there be 'acks aplenty all about."

Sylvia nodded, paid him, and climbed the steps to the front door of the famous club with only a slight pang of trepidation. Her primary emotion was excitement. She was doing the unthinkable. No woman of quality would be caught anywhere on St. James's Street except in a closed coach with a proper escort. Certainly no lady of quality would stride—in breeches, yet—up the front steps of Brooks's Club and expect to gain entrance. A liveried servant pulled open the door for her and nodded toward the porter's room.

"May I be of service to you, lad?" inquired the stately gentleman behind the window there.

"I've a message for Greyfalcon," Sylvia muttered, keeping her voice as much of a growl as possible, lest he detect feminine notes in it.

But the porter had other thoughts in his mind. "The Earl of Greyfalcon to you, my lad. I'll take the message." He raised his hand to signal one of several page boys standing against the opposite wall.

"No! That is," she added more carefully, "my orders are to see the message personally delivered into his lordship's hand."

The porter grimaced and said in strong British accents, "A *billet doux*, no doubt. 'Tis only the ladies who insist upon such nonsense. Very well, here is a salver, for you'll not hand it to him more personally than that upon my premises." He handed her a small silver salver and nodded to the young page who had answered his summons. "Take this lad to the Sub-

scription Room. He has a message for Lord
Greyfalcon."

Sylvia followed the page, content now that she need
worry no longer about anyone's suspecting she was
other than she appeared to be. As she crossed the black-
and-white tiled floor of the front hall toward the green-
carpeted marble staircase that swept up the right wall
and then, from a corner landing, continued along the
rear wall, she glanced about, paying little heed to the
famous portrait of Charles James Fox that hung over
the fireplace like a tutelary deity, but approving of the
general atmosphere of the place. She had often
wondered what a gentleman's club would be like, and
Brooks's appeared to be elegant yet friendly and casual,
much like her Uncle Lechlade's country house.

They reached the first floor, and a low murmur of
masculine voices drifted to her ears before the page
stepped aside to allow her to pass through the tall
arched entrance into the Great Subscription Room.

"Over yonder," the boy said tersely with a small
gesture when she hesitated upon the threshold.

But Sylvia had already spotted Greyfalcon, sitting at
a table toward the rear of the room. Though she had
told Lady Joan that she had no fear of failing to
recognize her quarry, she had indeed experienced a
qualm or two on her way to the club, for she had not
seen the man in several years, but she knew now there
had been no cause for such worry. Greyfalcon looked
precisely as she remembered him.

He was not built like Christopher, which had always
surprised people who had met first one and then the
other. Christopher had been of no more than medium
height with very broad shoulders and the narrow waist
but muscular thighs of the sporting man. He had been a
bruising rider to hounds and a consistently merry
companion, with the devil of mischief lurking always in
his azure eyes. His hair had been blond and curly, his
complexion fair and ruddy.

Greyfalcon was taller, just over six feet, and although

he had the same broad shoulders, his frame was sparer, almost lanky. His hands were particularly long and slender, elegant and graceful in their movement. Sylvia watched them now as he placed several chips out on the table before him. When his signet flashed in the light from the room's hundreds of candles, her gaze moved to his face. There, too, the resemblance of Christopher was slight. Greyfalcon's complexion, like his hair, was darker and his eyes seemed always hooded, as though he feared they might give away his thoughts. She knew they were darker than Christopher's had been, indigo rather than azure, and she remembered suddenly that while Christopher's had seemed always to be filled with warmth and laughter, his brother's eyes could change in an instant from the ordinary to the dangerously chilling.

The page behind her suddenly murmured his impatience to be gone; so, swallowing carefully, she placed the small packet she had so carefully prepared at Reston House upon the silver salver. Then, noting few of the famous room's attributes other than the high, barrel-vaulted ceiling, the glitter of a thousand candles, and the gray-and-black herringbone carpet beneath her reluctant feet, she pulled her cap a little more firmly down over her eyes and made her way across the room, wondering for the first time since leaving Oxfordshire if she was being very wise.

3

Only too soon did Sylvia find herself at Greyfalcon's table. The five men seated there were in the midst of a hand, and she knew at once that she would have to wait a few moments before daring to interrupt.

The table was covered with green baize upon which had been painted a pattern of thirteen numbers, representing the value of the cards in each suit. An assortment of colored chips had been placed upon these numbers, and several of those chips had been "coppered," which is to say that a penny had been placed upon each of them. In front of Greyfalcon, who held the bank, was an open-framed box from which, as Sylvia came to a halt at his elbow, he drew a card faceup and laid it beside the box. It was the nine of spades.

"Aha, nine the loser!" exclaimed the gentleman to Greyfalcon's right, a dapper young man attired in a bright-green coat with tight red armbands. Perched atop his carroty hair was the most astonishingly beribboned straw hat Sylvia had ever clapped eyes upon. It was all she could do not to stare. The gentleman continued gleefully, "And my copper sitting right on my number-nine chip. Pay up, old man."

"Contain your soul in patience, Lacey," recommended another of the gentlemen, this one older and more conservatively dressed. "The turn is incomplete and there might yet be a split."

"Aye," put in a third dryly, "and if there is, 'twill be the best luck Greyfalcon's had today. The devil's in his cards, and no mistake." He regarded the dealer with wary amusement, drawing Sylvia's attention back to the man she had come to see.

The Earl of Greyfalcon drank deeply from the glass near his left hand, and Sylvia was certain from the look of him that it was not the first glass that had been served him that afternoon. His dark hair was tousled, a lock falling over his forehead, and there were lines in his face that made him look older than his twenty-nine years. As he drew the next card and placed it beside the first, he grimaced and young Lacey let out a crow of delight.

"Look, Lancombe, the winner is your ace. He owes us both now. No split this turn. Too bad, Franny, me lad."

The older man grunted as he shot an oblique look at the dealer, then said quietly to Lacey, "It would behoove you to learn to take your winnings gracefully, sir, not to chortle over them."

Abashed, the younger man offered a hasty apology, adding, "No doubt the luck will change when you pass the deal, Fran."

"Perhaps." Greyfalcon drew the next card, and Sylvia shifted impatiently, causing him to glance up at her. "You want me, boy?"

"Aye," she muttered, carefully keeping the right side of her face, that which the feather concealed, toward him. "I've a message fer ye, m'lord."

Scarcely glancing at the salver, Greyfalcon scooped up the packet and shoved it inside his coat, tossing several chips from the pile before him upon the salver in the packet's place. "The porter will change those for you."

"Thank 'e, sir, but I'm t' see ye open the packet," Sylvia muttered.

Greyfalcon drew the next card without looking at it as, with a sigh, he extracted the packet once more from his coat, ripped it open, and dumped the contents, both sealed letter and folded note, onto the table. "You've seen. Now go."

"Ye're t' read at least the note, an it please ye, sir." A hint of desperation crept into her voice.

He glanced at her then, but she kept her face carefully

averted and breathed a small sigh of relief when he said
nothing further and began to unfold the note. Since it
explained merely that Lord Arthur was doing Grey-
falcon the courtesy of showing him the accompanying
letter before having it printed in both the *Times* and the
Gazette, Sylvia was not the least bit surprised when,
having scanned it rapidly, he tossed it down with an
angry oath and snatched up the letter, breaking its seal
without comment.

She watched him carefully now, determined to know
his every thought by the changing display of expressions
that flitted across his face. He read the whole letter
much more rapidly than she expected, however, and
thus was she caught off guard when his head suddenly
snapped up and she found herself looking directly into a
pair of steel-blue eyes aglint with fury.

With an involuntary shiver of fear, Sylvia jerked a
bow and began hastily to turn away, but Greyfalcon's
hand shot out with even greater speed to clamp around
her upper arm, none too gently.

"Please, my lord, I have done only as I was com-
manded to do." Again she muttered the words and kept
her face averted, but she had glimpsed a fleeting look of
astonishment in his eyes during that brief moment when
her gaze had collided with his, and she very much feared
that he had recognized her.

A moment later she was sure of it when Greyfalcon
pushed back his chair and got to his feet. He seemed
suddenly much bigger than she remembered, for al-
though in her memory he was taller than Christopher,
she had not remembered that he was so tall as he seemed
now, looming beside her, his hand tightly gripping her
arm. Casually he waved his other hand toward the small
pile of chips on the table before him. "Look after this
paltry lot for me, Lacey."

A chorus of protest arose from his gaming com-
panions, but he ignored it, retaining his grip on Sylvia's
arm and turning toward the door. When the protests
became more voluble, he glanced back over his
shoulder. "You cannot complain, my friends, for you

had nearly cleaned me out. Moreover, 'tis not as though I were quitting as winner, nor as though you will not have more from me before the day is done. Don't forget you are all coming to dine with me this evening.''

There was laughter then, and several ribald comments regarding both the nature and the importance of any message that could spur Greyfalcon to such a hasty exit, comments that sent flames of color shooting up Sylvia's cheeks. A moment later the comments were forgotten as Greyfalcon propelled her down the wide, carpeted stair to the main hall and, scarcely giving one of the pages time to reach the front door and open it for him, out and down onto the flagway that bordered St. James's Street.

Certain that she would retain bruises upon her arm for weeks, Sylvia began as soon as they reached the pavement to protest his rough treatment. "Unhand me, my lord. You have no right—''

"Not another word," he snapped, tightening his grip. "Not unless you have a wish to find yourself sprawled facedown across my knee right here and now. You deserve no less.''

Gasping with indignation, she glared up at him defiantly, opening her mouth to dare him to do any such thing. But one look at his angry countenance deterred her. In the past she had thought him no more than aloof, a trifle cold, and rather distant. At worst he had figured merely as one more exasperated adult when she and Christopher had had to face the consequences of one or another of their pranks. Now it was at one and the same time as though she had never known Greyfalcon and as though she knew him through and through. She could not doubt that he meant what he had said, yet she still could not believe he had said such a thing to her. With relief she heard one of the club's footmen call to ask if his lordship required a carriage.

"No."

Sylvia protested as he began to drag her beside him along the pavement. "You can't mean—''

"I told you to hold your tongue. And don't," he

added, raking her with a burning glance, "lose that
damned cap."

Sylvia clapped her left hand to her head, struggling to
keep up with him as he strode along the flagway. By the
time they had crossed Piccadilly, she was breathing
heavily and finding it necessary to concentrate upon
every step in order to avoid stumbling. She had a strong
belief that Greyfalcon would merely drag her along
behind him if she did miss her step. It seemed to take
forever, but at last they reached Curzon Street, and at
last his pace began to slow. At the third house from the
corner, one that was a good deal larger than most of the
others in the street, he turned to mount the steep stone
steps.

"Please, sir," she gasped, pulling back at last.
"Where are we?"

Greyfalcon stopped and looked down at her, looming
taller than ever, since he stood a step above her. His
mouth twisted into a wry grimace. "Surely you will not
refuse to enter my house without a proper chaperon,
Miss Jensen-Graham. Not after your little May-game at
Brooks's."

"You cannot do this!" she cried.

"Oh, but I can," he retorted, turning back toward
the door. He did not lift the knocker, but merely turned
the latch and pushed the heavy door open. A moment
later, she stood beside him in the middle of a broad,
two-story hall.

A neatly dressed manservant hurried forward to meet
them. "My lord?" His quick gaze took in Sylvia's dis-
heveled appearance before he looked again at his
master.

"Bring a bottle of the madeira to the library in ten
minutes' time, Wigan, but do not disturb us until then."

"Aye, m'lord." The manservant effaced himself.

Greyfalcon hustled Sylvia through a pair of tall doors
on the left side of the hall, releasing her arm at last. She
found herself in a comfortably appointed room, lined
with shelves full of well-worn books and boasting rather

shabby but comfortable-looking furniture. A fire
burned with what she thought to be rather tactless cheer
in the small black marble fireplace. She had little time to
savor the comforts of the room had she wished to do so,
however, for with the snap of the doors shutting behind
her, a cold shiver raced up and down her spine that not
all the warmth in the room could dispell.

"Look at me."

She had no wish to obey that particular command,
but neither did she wish to make him any angrier than
he was already. To do so, she was certain, would be
nothing short of folly. Slowly, rubbing her aching arm
and drawing a long breath to steady her nerves, she
turned to face him.

"Whatever possessed you to do such a foolish
thing?" he demanded.

"I—"

But he had not asked the question in expectation of a
response. He had asked it merely to give himself a
starting point. Without allowing her so much as a
moment's time in which to reply, he continued with a
scathing description of her character that spared
nothing for her sensibilities, nothing for her pride. His
words seemed to hammer at her, and when he informed
her in chilling tones that even Christopher would have
been disgusted by such a prank, her eyes filled with tears
and she had all she could do to keep them from spilling
down her cheeks. Never in her life had anyone shredded
her character so finely as Greyfalcon was doing now.
She had had her share of reprimands and punishments
from her parents as a child, and more of the same at
school. But even Greyfalcon's scolding at Miss Penny-
farthing's had been as nothing compared to what he was
saying to her today.

"Just what business," he said now, "did you have
risking your good reputation by storming the bastions
of Brooks's so thinly disguised as a page? Pray tell me,
for I should like very much to know."

A moment of tense silence fell as Sylvia just stared at

him, her breast heaving beneath the loose gray jacket, her hands trembling as she attempted to wipe the sweat from her palms on the gray breeches she wore. It was as though she could still hear him shouting at her, as though she still waited for him to run out of words. His anger was so patent that she seemed to hear him even when he was silent.

"I asked a question, Sylvia," he said finally, grimly. "I expect an answer. And take off that damned cap."

At last the words penetrated the dense fog in her mind, and she looked up at him. His brow was furrowed, his eyes narrowed, and his lips were pressed together as though he were forcing himself with great effort to keep silent, to allow her to respond. He looked so angry, so damned righteous. The last thought cleared the pain from her eyes, brought anger in its stead. She looked at him directly now and drew herself up, pulling off the cap and wishing, not for the first time in her life, that she were at least three or four inches taller, and also that she had the nerve to tell him she had never given him leave to address her so informally.

She could not bring herself to do so much as that, but she could give him what he had asked for. "You wish an answer, my lord?" He nodded, still grim. "Very well, sir, though I doubt you will like it much. I dared search for you at Brooks's, because the message I bore was important, because you have ignored your duty until your mother is well nigh frantic, until your estates are in peril of their future, and because you have ignored all pleas for your return. I wanted to see for myself that you actually received that message and that you would pay proper heed to it. No doubt you will think me presumptuous, and no doubt you are in the right of it in many ways, but you do most certainly have a duty, my lord, and I mean to do my part to see that you attend to it."

Greyfalcon grunted. "That duty, as you call it, Miss Jensen-Graham, is not yet mine but that of my trustees. Thanks to my father's whim, I shall not be my own

master for nearly a year yet. I've not the slightest intention of attempting to take reins that will not be willingly relinquished into my hands."

So bleak did he look as he said those words that Sylvia nearly blurted out the truth, that his primary trustee would be only too happy not merely to relinquish but to thrust those reins into Greyfalcon's hands at the earliest opportunity. She held her tongue, however, for the simple reason that she was not by any means sure the truth would get him to Oxfordshire. He was still angry. That much was only too easy to see. But his tirade was over, for the moment at least, and she had no wish to start it up again. And she could not think he would take her confession lightly. Not now. Once he was safe in Oxfordshire, perhaps. So long as he believed Lord Arthur meant to publish the humiliating letter, he would go home to stop him. And home was where she wanted him. She kept her gaze fixed upon his face with difficulty. "Your mother needs you, sir." That much was true at any rate.

He grimaced. "My mother needs a shoulder to cry upon, that is all."

"Well, I have been that shoulder for six weeks, and I do not wish to retain the position indefinitely," she said more tartly. "Though it may come as a shock to you to hear it said, she is your responsibility, sir, not mine."

The corners of his lips twitched, surprising her. It looked as though she had almost made him smile. The look disappeared, however, when the doors opened behind him to reveal the manservant with a tray of refreshments. Sylvia looked at it appreciatively. There was not only the madeira that Greyfalcon had ordered but also a platter of little sandwiches and cakes. Suddenly she realized she was hungry. She beamed at the manservant, then turned to draw up a nearby chair as the man set the tray down upon the library table.

Greyfalcon dismissed the manservant with a brief order to send the housekeeper to him at once. Noting that Sylvia had begun to help herself from the tray, he

said then with a touch of that unpleasant chill in his voice, "Don't get too comfortable, my girl. I've still a thing or two left to say to you."

"Well, I'm hungry, and I intend to eat," she informed him with a saucy smile, no longer frightened of him despite his tone. "Say what you will, my lord. By the by, how did you come to recognize me?"

" 'Tis a wonder everyone did not recognize you," he said in a near growl. "That flimsy disguise—"

"It wasn't flimsy—it isn't." She looked down at herself, pushing hair out of her face and brushing a crumb from the borrowed jacket. "No one recognized me but you."

"Most fortunately for you, that is true. I should like to say I would have recognized you as a female in any case, but that is not true. I recognized your face. I have, after all, watched you grow from a toddling child into a young woman. Slight as you are, I doubt anyone who had not known you so long would realize you were not a boy. Still, it was a foolhardy and dangerous thing to do. Your reputation might have been damaged irreparably."

She shrugged. "Much I care for that. What should I miss, living in the depths of Oxfordshire as I do, flirting with all the eligible gentlemen at Almack's? With your drunken friend Lacey, perhaps?"

"You would do well to keep silent on that head," he warned. "I made a threat to you earlier that I shall be pleased to turn into a reality if you do not set a guard upon that impulsive tongue of yours." He watched her for a long moment, but when she applied her attention to the sandwich in her hand, he continued, his tone still grim. "Who else knows of this little escapade of yours?"

"No one," she replied hastily, nearly choking.

"Don't mistake me for an utter fool, Sylvia. You did not come to London alone, and you are not staying at some inn in Cheapside. Nor do I believe you contrived all this without assistance."

"Well, I did contrive the whole," she protested.

When he looked ready to take up his reading of her character where he had left off, she added hastily, "I'm not lying, I swear it. Not that *no* one knows, precisely, but only one other person does, and she does not count, for she would never breathe a word of it to anyone."

"Your maid?"

"No, of course not. I don't even have a maid. What servants we have are mostly for Papa's comfort, not mine. Have you been away from Oxfordshire so long as that, my lord?"

"Sylvia." He said no more than that, but the warning was clear.

She sighed. "I came to London with Mrs. Weatherly, the Mayfields' housekeeper, who has come up to visit her brother."

"Mayfield? Ah, yes, the vicar with the rather pretty daughter. Good family, that. The chit came out last year, I believe. Their housekeeper, you say? Did you expect to return with her?"

She paid no heed to his use of the past tense. "No, of course not, for she has a fortnight's holiday, and Papa expects me to return long before that. And before you leap into the boughs again, Greyfalcon, let me tell you that Joan would never let me return to Oxfordshire without a maidservant, nor would Harry."

"Joan? Lady Joan Whitely?"

"Yes, of course, although she is Lady Joan Gregg now, for she married Reston but kept her own title. Only think of dearest Joan a countess. She has been married for nearly three years now, and I still find it difficult. Surely you knew."

"I daresay I did, but Reston does not number among my closer friends, so I had forgotten."

Sylvia chuckled. "I daresay he doesn't," she replied, mimicking his tone as well as his phrasing. "Harry is younger than you but a good deal more skilled at dealing with responsibility than you are. And he hasn't got any actresses dangling after him."

A moment later she could have bitten her tongue out,

so much did she wish the words unsaid. The look on his face made her fear for a moment that he intended to carry out his earlier threat. Indeed, he took two steps toward her, making her glad that the library table stood between them. Had it not—had she been close enough for him to grab her before he thought better of it, she thought he might very well have given his temper full rein.

As it was, Greyfalcon contained his temper with difficulty. When he spoke, his words were carefully measured. "You will write at once to Lady Joan, informing her that your mission has been successful and that we will depart for Oxfordshire at once. You will request that she entrust your things to the messenger who will deliver your letter."

"I shall do no such thing," Sylvia said fiercely.

"Oh, but you will," he retorted. "If you do not, I shall go alone to Oxfordshire, where my first deed will be to inform your father about your visit to Brooks's. I am not generally one to carry tales, but I am persuaded that Lord Arthur never intended for you to deliver his letters personally, certainly not to a gentleman's club. Indeed, under any circumstance, I am certain that he expected you to employ a courier, if he even knows that you came to London at all."

"Of course he knows," Sylvia said indignantly. But she knew Greyfalcon had won the hand. She had no wish for him to discuss the matter with her father—not ever, if she could prevent it. Capitulation was definitely in order. "I'll do as you ask," she said quietly. "How soon must we leave?"

"You may tell Lady Joan that we mean to leave the city at once," he said.

"Very well." She watched while he strode to the large, leather-topped desk that occupied nearly the entire space under the tall, street-facing windows, opened a drawer, and extracted a sheet of gray letter paper. There was an inkstand upon the table. The quill, when she attempted to use it, appeared to be split, and

she handed it to him wordlessly to mend for her. It was the work of but a moment before he returned the little penknife to his pocket and handed her the pen. There could be no more delay. Reluctantly, she began to write, keeping the letter as brief as possible, admitting nothing, saying only what he had told her to say. Joan would no doubt guess the rest, but that would not be nearly so bad as having to tell her.

She had written no more than a line or two when the doors opened again to admit a short, round little woman, whom Greyfalcon greeted as Mrs. Wigan.

"Wigan did say ye'd sent fer me, m'lord." She gazed curiously at Sylvia, who looked up at her and then, catching Greyfalcon's eye, returned to her task.

"I did send for you," he agreed. "We've a guest for the night." Sylvia looked up in protest at that, but he went on smoothly, "As you see by her attire, Miss Jensen-Graham enjoys masquerading as a servant, and I have agreed to indulge her fancies before I return her to her father in Oxfordshire. You did mention earlier today that you are short a scullery maid, I believe?"

Sylvia gasped. "You'd not dare!"

He did not so much as look at her. "You will put her to work, Mrs. Wigan, and I shall hold you personally responsible for her safety. She is to sleep the night in the housekeeper's room, if you please, and it will be much the worse for you if she not still there come morning."

"Greyfalcon!"

"My lord, do you be tellin' me that there is a young lady?"

"A young woman, certainly. As for whether she qualifies as a lady at the moment, I leave you to judge for yourself."

" 'Tisn't fittin', m'lord," Mrs. Wigan began firmly, speaking as one who had known him and served his family for a good many years. "Ye ought not to be doin' this, truly ye ought not. What would yer lady mother be sayin', I ask ye that."

"My mother would certainly prefer that I keep Miss

Jensen-Graham safe from harm. She would certainly say I ought not to allow her to go about in public dressed as she is.''

"Considering that you dragged me down I don't know how many public streets, that's a bit thick, my lord,'' said Miss Jensen-Graham sarcastically.

He looked at her. "I don't recall asking for your opinion.'' He turned away then, before she could inform him that whether he wanted it or not, he would certainly hear her opinion of his despicable plan. Taking Mrs. Wigan by the arm, he led her nearer the desk, speaking now in urgent, low tones. A moment later, the housekeeper turned back to Sylvia.

"When yer finished wi' yer letter, miss, I'll be just outside the door.'' Her tone was stiff but resigned.

Sylvia waited only until the door had shut behind her before leaping to her feet to launch her attack. "How dare you!'' she cried. "Do you forget who I am, sir? Do you forget that my uncle is none other than the Marquess of Lechlade, friend to many in high places, including the prime minister himself? How do you suppose he would respond to the information that you had kept his niece captive overnight, that you had forced her to serve in your house as a scullery maid?''

Greyfalcon regarded her quizzically. "I don't know,'' he said slowly, letting his gaze move slowly from her tousled hair down her body to her feet. "I do know that he is in town, however. Shall we go to Lechlade House and ask him what he thinks of it? I can take you there at once, if you like.''

Sylvia suddenly wanted nothing so much as to throw the inkstand at him. He knew perfectly well what her stuffy uncle would say if he were to hale her into his presence dressed as she was. Speechlessly, helplessly, she stared at him, telling herself that if it was the last thing she ever did, she would be revenged upon him for this day.

Greyfalcon's features relaxed at last and his blue eyes

twinkled as he read the intent in her expression. "You might just as well give in gracefully, you know. There is nothing you can do about the situation at the moment, except to obey me. Later, perhaps, you may get your revenge."

It was as though he spoke to humor a child, and it was almost the last straw. The inkstand stood rather too near her right hand, and her hand fairly itched to pick it up. But even as the thought crossed her mind, she saw the expression in his eyes begin to harden and she knew she did not dare. Instead, she said with as much calm as she could muster, "You said we were to leave the city immediately."

"You also heard me say, at Brooks's, that I am expecting company to dine. I can scarcely change that arrangement without giving rise to just the sort of chatter I'd prefer to avoid. I shall have my dinner party, and we will make the trip into Oxfordshire tomorrow in a single day. If we were to leave at once, we shouldn't get much farther than Colnbrook before dark, and I've not the slightest intention of racking up at an inn with you, my girl."

"Goodness, my lord, you are mighty concerned with the proprieties for a gentleman who has just insisted that I spend the night at your house."

"Mind the sarcasm, miss. You will be under the eye of Mrs. Wigan, who is the soul of respectability. And, Sylvia," he said, returning to that warning tone she had already learned to detest, "remember that I shall hold her responsible for your actions. Be certain before you act that you wish the consequences of your actions to be visited upon an innocent woman."

"I don't believe you would do such a thing," she said stoutly.

"Believe it. Have you finished with that letter?"

She swallowed hard, for his tone had left nothing to doubt. "No."

"Do so. Then get you to the kitchens. I daresay Mrs.

Wigan can find you something more suitable to wear than that rig.''

Sylvia glared at him, but he turned away toward his desk and she had nothing to do but to sit back down and finish her letter to Joan.

With every plate and pot she scrubbed that night, Sylvia cursed the Earl of Greyfalcon and plotted ways to be revenged upon him. Mrs. Wigan had suggested rather diffidently that Miss Jensen-Graham might prefer to spend the evening in the housekeeper's room rather than up to her elbows in soapsuds in the scullery, but Sylvia had refused, not trusting Greyfalcon for a moment and believing her doubts fully justified when he appeared in the kitchen at half-past ten o'clock, smiling and jesting as though he had merely come to thank the kitchen staff for a job well done and not to check up on his reluctant guest.

"I thank ye, miss," the plump housekeeper said in an undertone when the earl had gone back to his friends upstairs. "I did not think he would come."

"Well, I did not doubt it. I know you think he is doing what is necessary, Mrs. Wigan, but your master is a tyrant, and that's all there is about it." She shook lukewarm, sudsy water from her hands and reached for a cloth to dry them.

" 'Tain't fittin', a young lady like you in a scullery," said the housekeeper, "that's certain sure. But wi' 's lordship in 'is cups, as 'e was t'day, there be no gainsaying 'im, and wi' all them gentlemen and who knows what else upstairs, I daren't leave the kitchen, fer there be no certainty they'll stay put wi' 'is lordship in the dining room, when all be said and done, though the rest of the 'ouse be mostly wrapped up in 'olland covers. Ah, what 'er ladyship would think of the goings-on in this house nowadays. It don't bear thinkin' of, miss, and that's a fact."

"I believe you," Sylvia said dryly. "Look here, Mrs. Wigan," she added, intending to tell the woman she would be even safer at the Earl of Reston's house. But she bit the words off unsaid, remembering that Greyfalcon had said he would hold the housekeeper responsible for her presence in the morning. In his cups, the woman had said, and no doubt she was right. He had certainly been drinking when she had seen him at Brooks's, and she remembered thinking the drink she saw was not his first. And he certainly would be drinking more tonight with his guests. If he were sober, she could not believe him so unfair as to take his anger at her out on the innocent housekeeper. But if he were to waken with a sore head the next morning, he might be capable of anything. She dared not take the chance. " 'Twas nothing of importance," she said at last. "Are there any more of these awful pots?"

"Never ye mind, miss. Now 'e's been an' gone, 'e's not like t' show 'is face again. We'll leave the rest fer Sally t' look after. She'll not mind." Their voices were pitched low, for it had been Mrs. Wigan's suggestion that it would be best to keep Sylvia's identity a secret from the kitchen help, and Sylvia had heartily agreed with her. She knew she needn't worry about any of them recognizing her in future, assuming she should ever again, by any mischance, find herself at Greyfalcon House and they should see her in her own clothes. Dressed as she was now, in one of Mrs. Wigan's own dresses, it had proved necessary to bunch the excess material at the waist and to tie it around and around with her apron strings. Thus, she looked rather thick-waisted—square, in fact—for there was an over-abundance of material everywhere, and the light-gray color of the dress made her own complexion look sallow. Add to all that the fact that her hair was bundled into a mob cap and that the lighting in the kitchen left much to be desired by anyone who wished to see what she was doing, let alone to recognize her at a later date, and Sylvia was quite certain she had nothing to fear in that regard.

She agreed at once and without regret with Mrs. Wigan's suggestion that they retire to the housekeeper's room, but when she discovered that Greyfalcon's cavalier suggestion that she spend the night there meant sharing a bed with the housekeeper, she balked again. "I couldn't, Mrs. Wigan. Whatever would your husband think?"

" 'Tisn't what Wigan thinks as counts, miss," the housekeeper replied with dignity. " 'Tis what 'is lordship thinks. Wigan 'as slept on the wee sofa more than once. 'E'll not mind doin' so again."

"But I could just as well sleep on the sofa," Sylvia protested, keeping laughter at bay with difficulty.

"That ye'll not, miss. I'm ter keep ye safe wi' me, and there's no sayin' them young lads won't be burstin' into my sittin' room as well as any other room in the 'ouse."

"Goodness."

"Ye might well say so. I didn't be meanin' t' tell ye this, but they've women with 'em, Wigan says, and that be when they behave the worst, a'chasin' of each other up and down the stairs, like as not. 'Tis no fit place fer ye t' be."

Sylvia agreed, but at the same time she wished she had sufficient courage to creep out into the corridor to see what she might see. She had never before passed the night in a rake's house, and she thought that perhaps her education had been sadly neglected. Men chasing women, and perhaps the other way around as well, from what Mrs. Wigan said. She longed to question the woman further, but she knew it would be of no use. Mrs. Wigan, just as Greyfalcon had said, was the soul of propriety, and was already looking self-conscious at having revealed so much. A moment later, she was pointing to Sylvia's cases, standing in a neat row beside the high patchwork-covered bed.

"Ye'll be wanting yer own things now, miss."

Sylvia thanked her, did no more than what was absolutely necessary by way of preparing for bed, and made no further argument about where she would spend the night. It occurred to her as she pulled the thick

patchwork quilt up to her chin that she was more tired than she could remember ever being before. It was the last thought that passed through her mind that night. The next conscious thought she had was one of annoyance. Someone was calling her name, and she wished they would stop.

"Miss, miss, 'tis time ye were up and about. 'Is lordship done called fer 'is horses and chaise already. If ye be wishful ter break yer fast, ye'd best bustle about."

Sylvia groaned, stretched, and turned over to find Mrs. Wigan, fully dressed, leaning over her with a candle in hand. "Go away," she said sleepily. "It isn't morning yet."

"Aye, that it is, and no mistake, though 'tis earlier than I'd expected 'is lordship t' be about. Now, ye just stir yerself, miss, else 'e says 'e'll come t' fetch ye 'imself. I've told 'im I'll not be allowin' no such of a thing, but 'e's in no frame of mind t' be withstood, an 'e takes the notion into 'is 'ead, an' so I'm warnin' ye."

Sylvia sighed but did as she was told, donning her tan traveling dress and a pair of dark-brown kid boots and tidying her hair into a neat bun at the nape at her neck. It appeared that she was meant to break her fast in the housekeeper's room, for there was bread and cheese laid out upon the table in the sitting room, and a pot of tea besides. She seated herself and did ample justice to the simple meal, looking up when the housekeeper returned.

"I am ready, Mrs. Wigan. When does his lordship intend to depart?"

"At once, miss. Wigan'll fetch yer cases."

"Who is to go with us?"

"What's that, miss?" Mrs. Wigan looked confused by the question.

"I assume that Greyfalcon has arranged for a maidservant to accompany me," Sylvia said patiently.

Mrs. Wigan shook her head. "There be no maidservants, miss, only Wigan and me, the boots, and me nephew, who comes in ter oblige when 'is lordship entertains."

"Well, what about Sally, then, or Cook?"

"Cook don't travel, miss, not if it was ever so, and Sally lives out. Don't be many young wenches willing ter work in a bachelor's 'ouse, lessin' they lives nearby and not in. And I doubt Sally'd be wantin' ter go into Oxfordshire, when all is said and done, miss. That be why the master be wishful ter make the journey in one day, don't you know."

Sylvia nodded, but she wasn't by any means certain that she wanted to spend the entire day shut up in a traveling coach with Greyfalcon. She discovered when she met him upon the doorstep that she needn't have worried. He had no wish to share such accommodations with her either. A light traveling chaise stood waiting at the curbside, drawn by a team of magnificent black horses. A fifth horse—this one a large, handsome bay—stood waiting patiently behind the chaise. A pair of uniformed postboys were already mounted on the offside horses, and Wigan himself was tying the last of her cases into the boot.

"Good," Greyfalcon said when he saw her. "I am in no mood to be kept waiting."

"You look like a bear with a sore head," said Sylvia sweetly. "Ape drunk, were you?"

"That, my child, is none of your affair."

She appeared to consider his words for a moment, then said, "Well, do you know, I think it is very much my concern if you are to be my sole protection on this long and no doubt perilous journey."

"It will be perilous, indeed, if you mean to bait me," he replied with equal sweetness. There was a glitter in his indigo eyes that told her he meant what he said, so she nodded submissively and placed her hand gently upon his arm.

"I am at your command, my lord."

"That will be the day," he muttered under his breath.

She looked up at him from beneath her dark lashes but said nothing further until she was seated in the chaise. It was light outside now, though the sun still lingered below the horizon, and she could see his grim

expression quite clearly as he turned away. "Moderation begets its own rewards, my lord," she said softly through the open chaise window to his back.

He looked over his shoulder. "You'd best put up that window, Miss Jensen-Graham. You don't want to take a chill."

No sooner had she obeyed him than the chaise began to move. The cobbles beneath made the carriage sway, but the feeling was not an uncomfortable one, and she was almost sorry when the pavement became smoother after they passed through the Kensington turnpike.

The chaise moved with greater speed now, through Hammersmith, across Turnham Green, through Brentford, Smallbury Green, and across Hounslow Heath. An hour and a half after they left London they were crossing the River Coln at Longford. They had traveled more than thirteen miles. Sylvia glanced out the window at Greyfalcon, who had brought his mount alongside the chaise and was moving up to talk to the postboys. She lowered the window in time to hear him shout that they would not change horses before Slough.

The chaise slowed somewhat after that, although the road was flat and free of traffic, and Sylvia realized that the postboys had decided to spare the horses. They must, she thought, have expected to change rather sooner. Slough was, after all, some twenty miles from London, more than two normal stages.

When they reached Slough, the change was accomplished with speed at the White Hart, where it was clear that Greyfalcon was known. He changed his own mount for a dappled gray at the same time, and Sylvia saw that the bay's sides were heaving. Greyfalcon didn't, she thought, look much better himself. His complexion was gray, his eyes dull. Really, men were so foolish. It was not as though he had not known he had a long ride ahead of him today. To have allowed himself to drink so much and stay up so late was the action of a man more foolish than she had ever believed Greyfalcon

to be. What if Christopher, who had idolized him, could see him now?

Some of her thoughts must have shown in her face, for Greyfalcon, turning to catch her eye, flushed slightly and turned away without speaking, despite the fact that the window was down again.

The landlord stepped up to talk to him, and Greyfalcon smiled at the man but made no effort to pay him. When the earl was mounted again, the innkeeper waved and called out to him to have a good journey, his familiarity making it clear to Sylvia that Greyfalcon was a familiar customer, one moreover who was allowed to travel on tick.

They crossed the Thames at Salt Hill and made good speed once more through Maidenhead, where they crossed the river again and entered Oxfordshire. The team they had now was slower, but the postboys (still Greyfalcon's own, for he had not scrupled to leave his horses to the Slough innkeeper's care) managed to hold them together until just before Assington Cross. By the time they reached that village, however, their pace had long since slowed to a walk and the offside wheeler was showing lame. The hour was nearly half-past two. Sylvia was famished.

She let the window down as they drew into the innyard of the Bell and Castle. "I hope you mean to seek refreshment, my lord," she called, "for I swear I shall faint from hunger if you do not." Not to mention boredom, she thought, watching him. He was looking at the ostlers, however, and not at her. They unhitched the team rapidly and led another four horses from the stable adjoining the inn. Greyfalcon grimaced expressively and turned his own mount toward the chaise. Leaning down, he muttered, "Bonesetters, the lot of them. No doubt touched in the wind, as well. I do apologize. I had hoped to make Nettlebed before we made the change, for I know the inn there to be as trustworthy as the inn in Slough, but the last pair simply wasn't good for a full two stages. We ought to have changed them in Maiden-

head, I suppose, since there isn't another posting house between there and Henley.''

"Why didn't we stop in Henley, then?" she asked reasonably.

"For the same reason I didn't stop in Maidenhead," he said. "Thought you'd receive less attention in a smaller place. Public room here is like to be less crowded at this hour, too."

"I am accustomed to a private parlor, my lord," she said provocatively.

"I don't doubt it, but you'll not get one while you're in my company, my girl. We're like to set tongues wagging enough as it is. I'd prefer it if you'd take a bite in the chaise, actually, but I suppose that is too much to hope for."

"Indeed it is," she retorted with asperity. "I have been cooped up in this vehicle for far too long already, and if you do not wish to hand me over to my father's keeping in a demented state, you will certainly not ask such a thing of me."

"Well, it goes against my better judgment, but I should detest being confined for so long, myself, so come along." He dismounted, handed his reins to an ostler, and opened the chaise door for her. She stood, waiting for him to let down the steps, but instead, he merely grasped her lightly under the arms and swung her to the cobbled pavement.

Her breath seemed to catch in her throat as she looked up into his face, but he had already turned his attention to the inn, and catching her hand, he tucked it into the crook of his elbow and began moving toward the front steps. She had no choice but to move with him, though she could still feel warmth where his hands had grasped her waist and could feel, too, an extraordinary awareness of his body so near her own.

Inside, her senses returned to normal. The coffee-room proved to be empty, and the innkeeper's wife bustled about them, providing bread, a hearty beef-and-vegetable soup, and a whole roasted chicken. Grey-

falcon ordered tea for Sylvia and ale for himself; then, before taking a single bite, he got suddenly to his feet again.

"I ought to give orders to the boys," he said, a shadow of guilt passing across his face. "They'll not see to their own needs, otherwise."

Sylvia also knew a pang of guilt. She had not so much as thought about the fact that the postboys must be as hungry as she was herself. They deserved at the very least to have some bread and meat and some ale, if not a full meal.

She looked up to find the innkeeper smiling obsequiously down at her, and she smiled back.

"We didn't hear his lordship had got married," the man said, watching her rather narrowly.

Without thinking, she responded, "He hasn't." Then, noting the man's look of blatant disapproval, she said evenly, "He is my cousin. I had word of an emergency at home, and he very kindly offered to escort me there."

"Home?"

"Near his own, about five miles upriver from Iffley," she said.

"I don't know his lordship personally, only by reputation," the man said. He seemed to wrestle with himself for a moment before he murmured more to himself than to Sylvia, "I daresay he's good for what he puts on tick."

Sylvia opened her mouth to assure the man that Greyfalcon was a man of honor, but before the words came, her evil genius intervened. "He is not going to pay you at once?" She raised her eyebrows, then looked away quickly as though she had said too much. Indeed, she had.

The innkeeper regarded her suspiciously. "He be an earl, right enough, if he be who he says."

"Oh, yes, he is Greyfalcon. Only—"

"Only what, miss?"

"Well, I really should say no more," she began, then

bit her lip sharply when Greyfalcon himself loomed up
behind the innkeeper.

"That's taken care of," he said on a note of
satisfaction. "Bring me another mug of ale,
innkeeper."

"As to that, my lord, I fear I'll need to see the color
of your money first," the man said stoutly.

"What? I thought we had already made our arrange-
ments. You'll be paid, man, and soon enough."

"I'd as lief be paid now, sir, no offense intended."

"Well, offense *is* taken," Greyfalcon said sharply.
"What the devil is this, then?" He glanced at Sylvia,
who looked quickly away, unable to meet his gaze. "I
see," he said slowly. "Very well, man, what's the
damage?"

The innkeeper named a sum that seemed vast to
Sylvia. Indeed, it seemed just as vast to Greyfalcon,
especially when the innkeeper informed him that either
the inn's own lads would go along to look after the
team, or there would be no team provided. That meant
either hiring extra mounts for his own postboys or
putting them up at the inn until they might be sent for.
Greyfalcon opted for the latter, suggesting that the full
amount owed might be paid when his coach came back
to collect the boys.

"I don't think so, my lord," the man said evenly,
more determined now than ever. "For a man so certain
he can pay, you appear downright slow to do so."

"Well, the fact of the matter is that I didn't expect to
have to lay out much blunt on this journey," Grey-
falcon told him. "The decision to make the trip at all
was made at short notice, and I had no time to provide
myself with any great amount of cash. Moreover, I've
always been able to travel on tick before. I just haven't
come this way in some time, and a good many houses
appear to have changed ownership in the meantime."

"I don't doubt it, my lord, but I'll have my money, if
you please."

"Look here, we've still a full stage and more ahead of

us. I can't give you every cent I have. What if your horses pull up lame?''

"My lads'll look after 'em," the man retorted. He said no more, merely gazing expectantly at the earl.

Glancing at Sylvia again with a look that boded no good for her immediate future, Greyfalcon said tightly, "Very well, but I shall not want another horse. I shall ride in the chaise from here on. I haven't enough on me to cover the whole amount, and I've no wish to be without any money at all, but I can leave my watch with you if you'll take it." He drew a large, gold watch on an intricate gold chain from his waistcoat pocket. "The chain alone is worth your charges, but I'll leave the watch as well. Will that suit you?"

"Indeed, sir, and I'll keep it safe by until you are able to redeem it. I'm an honest man, I am, and I can see that the watch is valuable.''

Indeed, he was so impressed by the earl's gesture that Sylvia half-expected him to relent. Clearly Greyfalcon expected the same thing, and when the man simply turned away to go about his business, he released his breath in a sigh of angry frustration.

In the chaise, Sylvia waited breathlessly and somewhat fearfully for him to vent his anger, but beyond giving her another angry look, Greyfalcon said nothing, merely climbing in behind her and sitting beside her in silence. That silence continued most uncomfortably for the last twelve miles of their journey.

As the chaise turned onto the tree-lined gravel drive leading up to her father's house, she drew a long breath of relief. Her mission was accomplished. She had brought Greyfalcon home, and now that he was here, he would see how greatly he was needed. His mother would be delighted to see him, and his tenants would be even more so. No doubt the worthy MacMusker would greet his arrival with unmixed joy, grateful to have a master home again at last. She let down the window and leaned out a little to watch for the first view of her father's house.

Moments later the thick growth of beech trees on either side of the road seemed to part, giving view of the tall stone manor house. The arched, sixteenth-century gateway, with its central oriel and porter's lodge above, seemed to be set off by the red-tiled roof of the house behind.

Greyfalcon spoke for the first time since leaving the Assington Cross innyard. "The approach to this house always seems to take one back in time. One almost expects to be met by men at arms."

His tone was not particularly friendly. It was more as though he merely muttered his thoughts aloud.

Sylvia answered just as evenly, "I doubt there were many men at arms here at any time, sir. The original house was erected by one of our ancestors, Sir Robert Jensen, during a brief lull in the Wars of the Roses. Since there is no record, despite his knighthood, of his ever having served either York or Lancaster, one must assume that he kept himself to himself as much as it was possible at that time to do so. There were extensive alterations made during the time of Elizabeth and James the First, so one must assume that Sir Thomas Jensen, whose badge is to be seen above the arch of the gateway, must have been in royal favor then. But that was a peaceful time in Oxfordshire, so—"

"I did not request a history lesson, Miss Jensen-Graham," Greyfalcon said absently. He was watching now out his own window as the chaise drew into the courtyard and pulled up before the narrow stone stairway leading into the hall. One side of the courtyard was occupied by a row of buildings built by Sir Thomas to connect the gatehouse with the parlor, but the other side was occupied primarily by her father's library, and she knew that he would most likely be disturbed by the noise of their arrival and look out his window, so she took no exception to Greyfalcon's tone; indeed, she wished only that he would open the chaise door, so that she might get into the house before her father took it into his head to come to greet them.

Instead, to her dismay, when the front door opened, Lord Arthur himself appeared upon the threshold.

Greyfalcon did open the door then, opened it and jumped down, letting down the steps himself, then reaching to take her hand. His eyes gleamed a little as his gaze met hers, and Sylvia knew at once that trouble loomed ahead.

"Hallo, Sylvia, pleasant journey?" Lord Arthur called out as he moved down the steps to greet them. "Greyfalcon, that you? Never thought she'd do the thing."

Greyfalcon's teeth grated together as he replied, "I'd like a word with you, Lord Arthur. At once, if you please."

"To be sure, lad. I suppose you'll be wanting to know just how things are fixed. Thought I'd be hearing from you long before this, if you want the truth of the matter."

"Oh, I want the truth, all right," Greyfalcon said grimly, with a look at Sylvia, who still waited with one foot on the step of the carriage for him to help her down. "I want to hear from your own lips just how you had the impudence to think you might address public letters to my creditors and how you dared to send copies of those letters to me by your daughter's hand."

"Eh, what's this? Letters?" Lord Arthur looked hard at his daughter, who suddenly wished she were the type of young woman who could faint dead away at a gentleman's feet. "What letters, Sylvia? What is Greyfalcon talking about?"

Greyfalcon, too, looked at Sylvia, and the look in his eyes gave her to understand that fainting would not be good enough, that the only thing that would save her now was a magic wand, one that would transport her to another land, a land where gentlemen did not exist and could not enter.

She swallowed carefully, holding Greyfalcon's gaze with her own. "His lordship is tired, Papa. We have had a long journey, and I am persuaded that he is longing

for his dinner and his bed. You can discuss all this with him another time. Thank you so much, my lord," she added, holding out her hand to him, "for seeing me safely home again."

"Why, you're most welcome, Miss Jensen-Graham," said Greyfalcon suavely, ignoring her hand as he grasped her firmly about the waist and lifted her down from the chaise to stand beside him, "but I am in no great hurry. Indeed, I believe that your father and I have much to discuss."

"No, please, you must—"

"Don't be daft, Sylvia," cut in Lord Arthur sharply. "You can't just send the man off dry, and if I'm not mistaken, there is something very much amiss here. What was that you said about a letter to your creditors, lad? I'll swear an oath I know not what your meaning may be."

"Oh, I've no doubt of that now, sir," said Greyfalcon, his words sounding to Sylvia much like the cracks of a whip. When his arm came around her shoulders, pressing her forward toward her father, she found herself most reluctant to obey but forced to do so whether she would or not. His voice went on, over her head, and she knew this words were creating more trouble for her than she had ever thought possible. "You must ask your daughter, sir, about her trip to London, about the letters she brought from you, supposedly written in your hand, to be delivered to the *Times* and the *Gazette*. I must thank you for your courtesy in sending them to me first, and for your warning that they would be published unless I returned at once to Oxfordshire."

Lord Arthur glanced over at the interested postboys. "Have your rig sent 'round to the stables, lad, and come you inside. We've much to discuss."

Sylvia found her voice at last and stepped forward. "Papa, do not be angry. I only did what I—"

"Enough," Lord Arthur said in a tone she could not remember having heard from him before. "You will

retire to your bedchamber at once, daughter. Your apologies can be made at a more appropriate time.''

"But, Papa—"

"Not another word," he said, standing aside and pointing toward the open door. "Bid his lordship good night and go, at once.''

His tone this time brooked no further argument. Muttering "Good night, sir," Sylvia fled past her father and up the great-hall stairs to her bedchamber.

Alone in her bedchamber, Sylvia lit the three candles in the silver holder on her dressing table and sat down to peer at her reflection, noting that the flames of the candles were as nothing to the flames in her cheeks. Sent to her room like a child . . . and with Greyfalcon as a witness. How could her father do such a thing to her?

As the question flashed through her mind, however, she had difficulty meeting her own eyes in the looking glass. Her father had done nothing, really, and considering that Greyfalcon had roused Lord Arthur's temper to a greater heat than she could remember ever having done herself, Lord Arthur had acted with great restraint in simply dismissing her. He might just as well have reprimanded her severely right there in front of Greyfalcon. This was all Greyfalcon's fault.

Again, she had difficulty meeting her own gaze in the mirror, for her innate honesty forbade blaming the earl alone. Greyfalcon had done no more than she had provoked him into doing. And, she decided, despite, or perhaps in view of, everything, she would give a great deal to know what was taking place in the library at this very moment.

She could not doubt that the two men had retired to Lord Arthur's favorite room. The hall, with its magnificent chimneypiece, was an impressive chamber and the one they used whenever they entertained formally at the manor house, but the library was where Lord Arthur spent nearly every hour of every day that he was not sleeping, and even a certain number of those hours. He enjoyed a comfortable doze before the roaring fire with his book lying open on his lap and one of his dogs curled

at his feet. Picturing him in that familiar pose, Sylvia smiled. Then the smile faded as she pictured him standing instead by his great desk, stiffly listening while Greyfalcon, no doubt having taken a place before the great fire to warm himself, told him of her perfidy in no doubt painstaking detail.

Would he tell Lord Arthur about keeping her overnight in his house on Curzon Street? She doubted it. But she did not doubt for a moment that he would describe her visit to Brooks's down to the numbers on the cards she had seen, and the ribald comments that had followed them from the Great Subscription Room, or that he would describe those damning letters right down to the last flourish of Lord Arthur's forged signature. Indeed, he might well have brought the letters with him. The more she considered the possibility, the more she was certain he must have done so. How could she have neglected to foresee what would happen and to plan in order to avoid this distressing outcome?

Sighing, and unwilling any longer to gaze at any portion of her reflection—such a stupid girl, really there was no accounting for her stupidity—she turned away, swiveling her body on the dressing stool to face the chamber, a pleasant room, decorated in green and white, with a floral carpet on the polished hardwood floor and green curtains at the single, large, stone-mullioned window. Now, with little light coming through the window and only the candles' glow within, the colors were grayed, but the scent of potpourri from the jugs near the tall, carved door was familiar, and the sense of being at home helped her to relax. If only the thought of her stupidity would cease whirling through her mind.

It was not as though she had never fallen into a trap of her own making before. Her most brilliant ideas had almost always been edited by Christopher, and when they had not been, the pair of them had nearly always come to grief.

She remembered the time she had been moved, at the

age of eight, while awaiting Christopher in the kitchen
hall at Greyfalcon Park, to replace a bowl of hard-
boiled eggs destined for the supper table with newly laid
eggs from the henhouse basket left temptingly upon a
sideboard. She had said nothing to Christopher until
they were both well away from the house, so it had been
impossible for him to warn her that company was
expected that afternoon. By the time they learned that
none other than the haughty Lady Milford, a most
intimidating acquaintance of Lady Greyfalcon's, had
been the first person to attempt to crack open an egg, it
was too late. Christopher had taken the blame, insisting
that he and he alone had been responsible for the prank,
and Sylvia had suffered no more than a boxed ear,
Christopher's retaliation for the whipping he had taken
on her behalf.

She had attempted to explain to him on that occasion
that she had intended the first egg to be his brother's,
for Christopher had complained that Francis, home
from school as he was himself then for some holiday or
other, had been lording it over him that he was allowed
to take supper with the family and not in the school-
room with a housemaid in attendance as Christopher
still did. She had been sure, she insisted, that Francis,
greedy as Christopher was always telling her he was,
would certainly take the first egg. Christopher had been
sadly unsympathetic, telling her then as he had on other,
similar occasions that she simply didn't think matters
through, that she must learn to think out all the possible
results of a plan before executing that plan. Otherwise, he
warned, she would more often come to grief than not.
That had not been the only occasion of the sort, of course,
because although she did try to think everything through,
it was when her ideas were most brilliant that she found it
most difficult to think beyond their brilliance to their
possibly unpleasant consequences.

Surely, she thought now, it was hard to conceive of
how she could ever have thought Greyfalcon would say
nothing to Lord Arthur about what she had done,

particularly since she had done everything in Lord
Arthur's name. Of course, she had anticipated neither
that Greyfalcon would escort her to her very doorstep
nor that Lord Arthur would be the first person he would
clap eyes upon when he did so. She had thought no
further than forcing Greyfalcon's return to Oxford-
shire, and that was the nut with no bark on it. Her goal
had been to get him home. That goal she had achieved.

This last thought cheered her a little, and she got up
from the stool and moved toward the window to look
out upon the darkness. A pair of tall Jacobean cup-
boards flanked the window with a padded bench
between. The window curtains hung from a rod con-
nected to the corners of the cupboards, forming an
alcove and hiding the bench from view when the cur-
tains were drawn. As a small child, Sylvia had often
curled up on the bench with the curtains drawn, shutting
out the rest of the world. It had been her secret place,
her haven, and she had confidently imagined that no
one would find her there. Indeed, when she was eleven,
after her mother had died, she had spent many hours
there, curled up alone with her grief.

She had no wish tonight to draw the curtains around
her, for she was older now and knew she could not with-
draw with such ease from the world or from the con-
sequences awaiting her. But she sat down on the padded
bench and drew her knees up, clasping her arms around
them and leaning back against the side of one of the
cupboards to look out upon the landscape.

The moon was rising over the Chilterns behind her,
casting its silvery glow upon the Thames and lighting the
sky above the Berkshire Downs beyond, making those
hills seem black by contrast. Despite the low rise upon
which the house sat, the trees blocked most of her view
of the river. She could see only a wide, silvery bend to
the southwest, the bend where Greyfalcon's Island was
located. The island itself looked from here to be only a
black bulge in the silvery river. She could not see the
narrow arched bridge that connected it with Greyfalcon

Park, the bridge she and Christopher had run over so many times as children, seeking a magic land on the tree-shrouded island. In daylight she would be able to see the tall chimneys of the great stone house above the trees, but not the house itself.

She pulled open the window and for a moment imagined that she could hear masculine voices drifting up from the library below. There were Jacobean cupboards there, too, ornately carved, two pair of them, flanking the huge stone chimneypiece. And each pair was connected by a padded bench like the one she sat upon. If either pair of windows was open . . . But she knew in a moment that she had heard nothing, that it was only her imagination, that the windows there would be shut tight against the night's chill. And she knew, too, that it was just as well she could not hear. The two men in the library were angry with her. And, she admitted frankly to herself at last, both had excellent reason to be.

After a time, she heard the rattle of chaise wheels on the gravel drive, and though she could not see the drive from where she sat, she had no doubt that Greyfalcon was departing. Muscles tightened at the base of her spine as she realized that her father might come in search of her now. He was not, and never had been, a harsh parent, but neither had he ever failed to do his duty when called to notice that there was duty to be done. And tonight Greyfalcon had no doubt made Lord Arthur's duty plain to him. She did not relish the thought of the interview that was to come.

Having seen the grim look in Lord Arthur's eyes as he ordered her to seek her bedchamber, she could not but be certain that he was angrier with her than he had ever been before. Still, she did not think he would feel called upon to beat her. Fathers did beat their daughters, of course, even grown-up daughters. It was expected of them when the daughters misbehaved. Just as it was expected of husbands with misbehaving wives. The days of chivalry were dead, long since, those days one read

about when knights worshiped their ladies and forbore to lift a finger to hurt them.

Not that Sylvia truly believed in a knight who never raised a hand to wife or child. She had read enough, both at school and under her father's tutelage, to know that men had forever been held responsible for the behavior of their kith and kin, most particularly for that of their females. The rule of thumb, her father had explained to her, dated from a time long ago, when a man was forbidden to beat his wife with a stick that was of greater circumference than his own thumb. That law, he had said, held true even now, and Sylvia remembered feeling sorry for any woman whose husband had fat hands.

Pushing these unwelcome thoughts aside at last, she looked over at the candles on her dressing table, noting that they had burned nearly to stubs. He would not come to her tonight. Noting, too, that her basin had not been filled, she realized that unless she wished to chance running into him on the stair or in the lower hall, she would have to go to bed in her travel dirt. The decision was not, under the circumstances and in view of her earlier thoughts, a difficult one to make.

Accustomed as she was to waiting upon herself, it was but a matter of a few moments before she was ready for bed. She had blown out her candles and climbed under her quilts before she heard Lord Arthur's step in the narrow corridor outside her door. He did not hesitate but passed by on his way to his own bedchamber, and not until all sound of his footsteps had receded into the distance did she realize she had been holding her breath. Letting it out in a long sigh of relief, she turned over onto her side and fell quickly asleep.

So tired was she that the morning light might well have passed unnoticed had the maid, one of four who came daily to attend to the housework and serve the meals, not come in and flung the curtains wide with a clatter of rings against rod. Sylvia sat bolt upright, startled, then rubbed her eyes and said with a wry grin,

"You're like to give a person an apoplexy, Sadie, coming in with a racket like that."

The young woman grinned back at her. " 'Tis glad we be t' have ye back, Miss Sylvie. Cook was sayin' only yesterday that she be plumb out o' ideas fer 'is lordship's dinner, 'im decidin' of a sudden that 'e don't fancy chicken or fish no more, 'n all."

"Oh, has he, indeed?"

"Aye, miss. An' partridges be not so plentiful lessin' someone be willin' ter hunt fer 'em. An' 'is lordship don't be much of a gennelmun fer takin' 'is gun out."

"No, that he isn't, and I cannot even say for certain that this is a good season for partridges. I daresay Papa doesn't know either. He'll just have to make do. What about a nice pork roast?"

They discussed the possibilities for tempting Lord Arthur's palate while Sylvia got out of bed and washed her face and hands at last with the water Sadie had brought her. But when she had allowed the maidservant to do up the back buttons of her sprig-muslin frock, she turned at last to the subject that had been filling her mind ever since she had wakened.

"Is the master down yet, Sadie?"

Sadie clapped a plump hand to her head, pushing her mob cap sadly askew. "If that don't beat all, miss. Here he says I'm ter tell ye ter stir yer stumps, that he's awaitin' ter speak wi' ye, and I go and plumb fergit ter tell ye atall. He'll be wantin' me 'ead on a platter, that 'e will."

"It isn't your head he wants," said Sylvia with a grimace. "Where is he?"

"In the breakfast parlor, miss." Sadie's tone was subdued now, as though she sensed more from her mistress's attitude than she had sensed earlier from her master's. "He didn't seem put out," she said a moment later, as though she would soothe Sylvia's worries. "Only said he wished to speak with ye."

Sylvia smiled at her. "You needn't fret, Sadie. He would never show his temper to you unless he felt you

deserved to see it. I am the one who has distressed him."

"But how, Miss Sylvie? Yer always so kind."

"Thank you, Sadie." Sylvia smiled but dismissed the maid, unwilling to say any more to her. When Sadie had gone, she took a last look at herself in the looking glass, smoothed a strand of hair back from her cheek, and then straightened, feeling a little as though she imagined the Christians must have felt before entering the arena to face the lions.

Her father's mild appearance when she entered the breakfast parlor might have put this last fantasy to flight rather quickly had she not noted the steely glint in his eye when he looked up to bid her good morning.

"Good morning, Papa." She smiled again at Sadie, who had bustled in behind her to see if there was anything she needed that was not immediately at hand. "Never mind, Sadie, I'll serve myself. Is there hot tea in that pot?"

"Indeed, there is, miss, and toasted muffins in yon basket."

"Then you may go and help Cook in the kitchens or see that one of the others has dusted the library, if you please."

"Never mind the library," Lord Arthur put in sharply as he scraped his chair back and stood up. "I've told you before I don't want those women messing about in there. Besides, I'm going there myself now, and you're to come along when you've finished your breakfast, Sylvia. I've a deal to say to you."

"Yes, Papa," she said meekly, exchanging a speaking look with Sadie.

The maid's attitude was sympathetic in the extreme, and she scarcely waited until her master had gone from the room before saying, "Poor lamb, 'e do be in a fine temper, just like ye said 'e were."

"That will be all, Sadie," Sylvia said firmly.

"Aye, miss. Are ye sure ye'll not want anything else?"

"I'm sure."

Indeed, she thought, when the maid had left, she would be doing well if she would manage to swallow a morsel of toast, now that she knew her father was impatiently awaiting her arrival in the library. She tried, piling her plate with toasted muffins, jam, and sliced apples, and filling her cup from the teapot. But it was no use. After nibbling halfheartedly at a muffin and sipping a mere two sips of tea, she could stand it no longer. She simply had to get the interview over with. Accordingly, she pushed the dishes away, rang for someone to clear, and left the room, striding across the great hall to the library door, then coming to an abrupt halt outside as her courage deserted her.

Swallowing hard, she lifted her hand to knock, then thought better of it and merely opened the door. He was seated behind his huge desk, piles of books on either side of him nearly obscuring him from her view. But as the door swung open, he came to his feet.

"Come in, Sylvia." His tone was grim, putting her courage to flight again. "Close the door behind you."

She obeyed and began to step toward the desk, halting when he moved around it, her eyes widening at the look of anger on his face. She backed a pace toward the hearth, one hand rising involuntarily as though she would need to defend herself, her words spilling forth. "Papa, I'm sorry. What I did was thoughtless—"

"Aye, it was that," he said curtly. But he stopped moving toward her, gestured instead toward a pair of chairs near the fireplace. "Sit down, daughter."

She obeyed him quickly, expecting him to take the other chair. He did not. Instead, he moved to stand in front of the cold hearth, and the look he gave her brought no warmth to the room. Sylvia felt very small.

"What you did," he began in measured tones, "was not merely thoughtless, as you say, but in defiance of the king's law as well. You could be prosecuted and imprisoned for writing letters in another person's hand, my girl, if anyone chose to bring charges against you."

"Papa, you wouldn't!"

"No, of course I wouldn't," he replied, seemingly

angrier than ever that she might suggest such a thing. "You are my daughter, though I'm ashamed at the moment to admit it to anyone, least of all to Greyfalcon."

Her throat seemed to close, making it nearly impossible to force the next words out. "Will Greyfalcon—"

"No, he won't, but you put me in a dashed humiliating position, my girl," said her father. He said a great deal more, not mincing his words in the least, and though Sylvia had thought she could not possibly feel worse than she felt already, she soon discovered that she was wrong.

There seemed to be nothing at all to say in her own defense. To try to explain to him now that she had felt as though no one would help her, that no one else was making the slightest push to get Greyfalcon to see sense, to come into Oxfordshire and tend to his business, seemed utterly pointless. Indeed, such excuses were beside the point altogether. What had seemed to be such a brilliant plan now showed itself to be not only despicable but unforgivable as well.

"You will apologize to Greyfalcon before the day is done," Lord Arthur said at last, "and to the countess as well, for having the impertinence to interfere in her private affairs."

She nodded, her countenance paling at the thought of having to face Greyfalcon again. But she knew there was no getting around it. She would have to do as Lord Arthur commanded, not so much because he commanded it as because she knew now that she owed as much to the earl.

With all her father had said to her, he had mentioned nothing of her visit to Brooks's, which could mean only one thing: Greyfalcon had not told him. That he had said nothing of her visit to the house on Curzon Street was just as clear, but she had not expected him to mention that. Regardless of what his reasons might have been, it was scarcely the thing to keep a young woman of good family captive overnight in one's bachelor

establishment. But there had been nothing to stop him
from telling Lord Arthur about her visit to Brooks's,
and if Lord Arthur knew about that . . . Sylvia
shuddered, unable to convince herself that in that case
he would merely have a few more harsh things to say to
her.

"Well, Sylvia?" he said now, and she realized he had
been waiting for her reply.

"I will do as you bid, sir," she said quietly. "I will
ride over to the park at once. And, Papa"—he regarded
her grimly—"I-I'm sorry, Papa. Truly, I am."

He nodded, gave a little wave of dismissal, and turned
away. She knew then that he would not forgive her
easily, that she would be in disgrace for some time to
come. The tears that had not come while he scolded her
flooded her eyes now, but she blinked them away and
managed to retain what little dignity she had left as she
arose from her chair and took her leave.

Upstairs, as she changed from her muslin frock to her
fawn-colored riding habit, she was forced more than
once to blink back the tears, until finally, thoroughly
disgusted with herself, she dampened a cloth with water
from the ewer and washed her face, scrubbing until her
cheeks were red in an attempt to wash the desire for
tears away. Sylvia did not cry. It was a point of pride
with her, just as it had been a point of pride with the
youthful Christopher, from whom she had learned most
of what she knew about pride and honor. Not crying
meant being in control, and being in control of oneself
and one's emotions was of paramount importance.

At last, her whip and dark leather gloves in hand, she
made her way to the big barn behind the manor house
that served as its stable. There she found the stableboy,
Tad, willing to saddle her mare, Sunshine, and minutes
later, she and the mare were ready. Allowing Tad to give
her a hand up, she tucked her right leg securely into the
saddle's leg rest and her left foot in the stirrup, gathered
her reins, and settled her feathered hat more firmly onto
her head. Then, with a cheerful wave at the stableboy,
she touched Sunshine with her spur and guided her out

of the stableyard onto the hedge-lined path that led toward the water meadows.

The two miles between the manor house and the park took less than half an hour to cover, although Sylvia made no attempt at all to hurry the mare. At last, however, the gates of Greyfalcon Park loomed ahead of her. They were open, as always, so there was nothing to delay her. Fifteen minutes later she was dismounting in the drive before the broad stone steps of the great house and handing her reins to a stableboy whose sole task seemed to be to await visitors there. Moments after that the footman, Thomas, was ushering her into Lady Greyfalcon's saloon. The curtains were open today, letting the bright sunshine flood the room, and her ladyship sat upright upon an upholstered Kent chair, plying her needle. Spread across her lap was a piece of fancywork that looked as though it were intended to be a chair cover. Whatever it was, Sylvia thought, it looked very cheerful, as did her ladyship.

She put down her needle as Sylvia entered and said in her cultivated tones, "My dearest child, do come in. We will have tea, Thomas."

"At once, m'lady."

The footman closed the doors behind him, and Sylvia advanced to greet her hostess. "You are looking very well, ma'am," she said, smiling.

"Indeed, I am feeling very well, and it is all your doing, my dear, dear girl."

"Then you will perhaps be surprised to learn that I have come to apologize for interfering in your affairs," Sylvia said with a slight flush upon her cheeks.

"Apologize? Whatever for? Why, you have brought dearest Francis home when I had quite despaired of him."

Dearest Francis, Sylvia thought, keeping her face blank with great effort, for it was difficult not to think of her hostess's last description of her oldest son, as inconsiderate as his father had always said he was. But Sylvia put this thought firmly from her mind. Though the countess seemed to be delighted, she had still

promised her father that she would carry out his orders.

"I am glad you are pleased to have him home again," she said carefully, approaching to stand directly before the countess, her hands folded together, "but I fear I got him here under false pretenses. He is very angry with me, ma'am, as is my father. And I did interfere where I should not, you know. 'Twas no affair of mine."

"Fiddlesticks," replied her ladyship, setting aside her needlework altogether and gesturing toward the chair facing her own. "Do sit down, child, and pull your chin up from the floor. I make no doubt that Francis is displeased. Indeed, I know he is, for he told me so himself, having got it into his head somehow that I had put the notion of fetching him home into yours. Which I did not."

"No, ma'am," Sylvia said, taking the chair to which she had been directed. "I take full credit, or blame, for the entire business. And whether you agree or not, I do know that I owe you an apology for bringing him to you in such a state. He is furious with me."

The door opened to admit the footman once more, and Lady Greyfalcon waited until he had served them and departed before she said with unusual candor, "What you did, my dear, you did do for me, whether I put the notion in your head or not, for it was my megrims and complaints that stirred you to action. I make no apology myself, for I have indeed been most grievously put upon. You cannot deny that, though Francis does so. He cannot know how difficult it has been for me." She sighed. "One must forgive him. He is rarely unwell himself, so he simply has no understanding of my complaints."

"Where is he, ma'am? Though I should much prefer to sit quietly with you and drink my tea, I must find him, for I have promised Papa that I will apologize to him as well."

"Goodness," said her ladyship, diverted. "Did Lord Arthur command your apology to me?"

"He did, and whether you agree or not, rightly so, ma'am."

"Well, I never . . ." But she seemed pleased, rather than otherwise.

"Ma'am," Sylvia said, attempting to recall her hostess's attention, "his lordship?"

"Oh, heavens, I don't know where he is, my dear. I haven't seen him all day. I had breakfast in my boudoir, and by the time I came downstairs, he was nowhere to be seen."

"Perhaps one of the footmen—"

"Of course, just pull the bell, won't you?" Her ladyship's pale-blue eyes twinkled as she added, "If you are quite certain you wish to find him."

Sylvia was by no means certain. If she had seen him immediately, perhaps, she might have been able to extend her apology with dignity and decorum. But this delay, the countess's clear approval of what she had done—it was all very difficult. Reluctantly she pulled the bell and even more reluctantly did she make her wishes known to Thomas when he answered her summons.

"His lordship be in the garden, Miss Sylvia. Shall I send one of the lads to fetch him in?"

"No, that will be quite all right," Sylvia said hastily when her ladyship opened her mouth to answer in the affirmative. "Where in the gardens, Thomas?"

"Down near the little temple, miss, by the rose garden. Shall I accompany you?"

"That won't be necessary," Sylvia said, forestalling her ladyship once again. And when the footman had gone and the countess looked ready to remonstrate with her, she added, "Truly, ma'am, I should much prefer to speak to his lordship alone, and the garden is practically the only place where that can be accomplished with any propriety."

"Very well, my dear," agreed the countess. "I am persuaded that you will manage to put Francis into a better frame of mind if anyone can do so."

Sylvia nodded, hoping that the countess was right.

Leaving the house by way of a side door, Sylvia made her way quickly to the sweeping lawn that covered the hillside all the way to the river, creating a vista that seemed even greater than it was. The beech wood to her left was in fact a deer park, separated from the magnificent lawn by a nearly invisible ha-ha. No fences could be seen from where she stood. Indeed, the only thing to break the view was the flower garden designed by the famous poet-gardener William Mason and the little marble Temple of Aeolus that it surrounded.

The gardens at Greyfalcon Park, Sylvia knew, had been designed by Capability Brown during the last four years of his life. Brown, known for three particular characteristics—his sweeping lawns, his belts of trees, and his lakes—had had a great deal of help here from Mother Nature, who had provided the Thames at the doorstep and the magnificent beeches surrounding the house. The sweeping lawn, Sylvia knew, had once covered the hillside all the way up to the front steps, until a prominent visitor—no less a personage than Mr. Horace Wapole himself—had complained of stepping down from his carriage into wet grass.

As she approached the flower garden with its neat boxwood hedges, she saw that there was already a great deal of color there, though the famous roses would not begin to bloom for some weeks yet. The temple in the center of the garden was no more than a circle of columns upon a marble platform, supporting an arched dome topped by a golden ball. A breeze was blowing, and she could hear the melodic humming of the Aeolian

harp that hung within, cleverly angled so as to catch the slightest whisper of wind drifting between the columns. She did not see Greyfalcon until she had walked into the garden and followed the curving path around to the front of the structure, for the earl was sitting on the topmost of the four curved marble steps that led up to the entrance, gazing down at the river, apparently in a brown study. He did not notice her approach until she cleared her throat.

At first when he looked up and saw her, she thought she surprised a gleam of welcome in his eyes, but a moment later he was frowning, and she decided she had been mistaken. "I am sorry to disturb you, sir," she said quietly.

"There is no need to apologize," he said in the same quiet tone as he got to his feet.

She grimaced wryly. "I wish that were so, my lord, but it is not. It is for the purpose of apologizing to you that I have come in search of you this morning."

"Then you have accomplished your purpose," he said gently.

"You know I have not." She looked up at him, trying to see if he was teasing her, but the indigo eyes were half-shut, their lids and thick lashes hiding his expression. Funny, she thought, that she had never noticed before what thick, dark lashes he had. Why were ladies never so blessed? He came down a step, his movement breaking her brief flight of fancy and bringing a flush of color to her cheeks. Flustered, she said the first thing that came into her head. "Why did you not tell Papa about my visit to Brooks's?"

"Did you wish me to do so?"

"Odious man." She grinned at him, surprised that he did indeed seem to wish to tease her, but not displeased by the fact. "No doubt you feared I would reciprocate, for you must know you used me abominably in London."

"I did no such thing. 'Twas to prevent your being

used abominably that I gave you into my housekeeper's care."

"You might have accomplished the same purpose by returning me to Reston House," she pointed out.

"Indeed, I might, your host and hostess having already shown how very competently they were able to look after you." His eyes were open now, and their expression challenged her.

"You had no right, sir."

"Is this your apology, Miss Jensen-Graham?"

The color in her cheeks deepened, and she said defensively, "Must you tower over a person like that, Greyfalcon? It is most distracting."

The amusement in his eyes were unmistakable now. "Would you like to trade places? Then, perhaps, you might look down upon me while you offer your apology, if indeed you truly mean to offer one."

She regarded him doubtfully, knowing he was still baiting her, yet thinking at the same time that she would need to stand on the top step at least before she might look down at him. Life could be most unfair. She gathered her dignity. "You choose to jest with me, my lord, but I assure you this is most difficult for me."

"I am sure of it," he murmured.

"Damn your eyes, Greyfalcon, you are no gentleman."

"Oh, but I am, Miss Jensen-Graham, or I should very likely have told your father all about your visit to Brooks's. And may I take leave to point out that your language is vastly unbecoming? Not at all what one expects to hear from a lady."

She could scarcely debate that fact with him. He was right. Suddenly she wanted no more to do with this conversation. She wanted only to get away from him, to go somewhere where she could be all by herself, where no one would find her, ever. Her cheeks were in flames. She could feel the heat in them. And her dignity was in shreds again. It would have been better had he roared at her, had he at least shown some of his earlier temper.

This steady teasing, refusing to take her seriously—this was much more difficult to deal with. In fact, she couldn't deal with it at all.

She had turned, taken a step away from him, but his hand on her arm prevented her going any farther. It was not, fortunately, the same arm he had grabbed two days before. That one still showed bruises. His touch was gentle now.

"I must be the one to apologize now," he said in a low voice, standing quite close to her. "I have behaved very badly, and indeed I never meant to. Just as I never meant to expose your misdeeds to your father."

She looked directly up at him then, her eyes wide. "You told him the minute you clapped eyes upon him."

"I know. I was angry. I had meant to deal with you myself. I had pretty well decided, you know, before ever I mentioned the letter to Lord Arthur, that you had been responsible for the whole business, start to finish. I had a long time along the road yesterday to think about the matter, and there were a number of things that didn't make sense. There was no reason, you see, for him to have sent those letters with you to London. The post would have done, just as it did for his earlier—"

He broke off, looking at her, for she had gasped guiltily and turned away from him again at his last words. There was a heavy silence, lasting a full half-minute, before he turned her back again. "Look at me, Sylvia."

She faced his broad chest, but she could not meet the stern look in his eyes.

"You sent the first letter as well, didn't you?"

She nodded, then waited for the explosion.

"You must have wanted me home very badly."

She looked up at him then. "Your mother . . . She wasn't well. She—"

"She was driving you to distraction. You needn't mince words with me. I won't take offense. I know my mother, have known her all my life. She fancies herself put upon by every least little setback in life. She wishes

to be toadied to and sheltered from everything, and she does not wish to be imposed upon by anyone else's needs.''

"You are too harsh, sir. Lady Greyfalcon is merely bored, I think, and depressed. Why, your very presence here has cheered her enormously. Moreover, I did not mean to give you the impression that I dislike her, for indeed I do not. She has always been very kind to me.''

"Kind? Is that why you nearly ruined yourself to find me, child?''

"I am not a child, Greyfalcon, and I wish you would not call me so.''

"No, young Sylvia, you are not a child. You were one when I left this place, and in my mind's eye you are one still, but when I look upon you with the wind blowing your hair like a golden cloud, and the sunlight making silver highlights in your lovely eyes, I can see quite clearly that, though you are still mighty small, you are not a child any longer.''

Shaken, she stepped away from him, and the look he gave her then was cynical. "Do my words distress you? I speak no more than the truth.''

"Please, sir, I came only to apologize to you for the letters and for interfering where I had no right. It was very wrong of me to behave as I did, and you were right to be angry with me. I hope that with the passage of time you will find it in your heart to forgive me.''

"Very pretty. Did you learn that off by heart?''

"Greyfalcon—''

"Damn my eyes again, and I'll teach you better manners, my girl. No, enough.'' He laughed then and held up his hand in the signal men made to acknowledge a hit in dueling. "Don't you wish to know if your efforts have been successful?''

More than anything she wished she could tell him she didn't care a whisker, but she could not. Not only did she care very much but curiosity was her besetting sin. "You are needed here, sir, and not just by your mother," she said quietly. "I hope you mean to stay.''

"You know," he said, "you need not have gone to such great pains to achieve your purpose. All you had to do was to tell me your father had no intention of keeping a tight rein."

Her eyes widened. "That's all? I feared you would not believe me."

"Perhaps not at first, but I would have looked into it. He tells me he has no wish to be saddled with my cares, that he'd just as soon leave all in my hands entirely."

"But what of your other trustees?"

"You didn't pay them much heed before. No," he added when she looked defensive, "you had no need. I can handle my Uncle Yardley and Mama without any trouble. My father knew that, which is why he named Lord Arthur as primary trustee. I never really knew your father, just assumed that he would be the sort my father expected him to be. Had you informed me that he was not, I should have been down here in a flash."

"But I could scarcely write such a letter as that to you," she protested, adding demurely, "for surely you could not expect me to write to any man saying that my father didn't wish to be saddled with his affairs."

Greyfalcon laughed aloud then. "What I expect, my girl, is that you will prove to be a rare handful to any man foolish enough to marry you. Why on earth, though, has no man done so?" When she flushed again and turned away, he said remorsefully, "I should never have said such a thing. Forgive me." And then before she could question his meaning or the remorse in his deep voice, he had taken her elbow and was urging her toward the house. "You will catch cold standing in the wind like this. Let me escort you back to my mother."

"I-I really must get back home," she said then, allowing him to guide her from the garden onto the lawn. Spring was not yet so far advanced that the grass had begun to grow shaggy fro neglect, but there were already dandelions, daisies, and blue speedwell blossoms blooming among the greening blades of grass. "You will need to set men to scything soon," she said after a moment's silence.

He said, "I'll see to it, along with a number of other things. I have already spoken with MacMusker."

"Then you truly do mean to stay."

"For a time," he replied. His tone was expressionless, even perhaps a little aloof, the tone she was accustomed to hearing from him. The note of laughter was gone, and she was sorry. She had wanted to ask him what he had meant earlier, why for the first time he had sounded as though he had truly meant his apology, but now she felt as she nearly always felt in his presence, young and rather as though she had done something wrong.

He escorted her around to the front entrance of the great stone house, where the stableboy waited, and it was Greyfalcon who sent the lad scurrying to fetch Sunshine. While they waited, their conversation was desultory, the topics such comfortable ones as the day's unseasonable warmth, the beauty of Capability Brown's vista, and Greyfalcon's decision to grant one of his mother's latest whims.

"She wants some marble urns to mark the ha-ha," he said. "My father would never have allowed her to do such a thing, of course, but I can see no harm, and she insists that some poor unsuspecting visitor is like to fall into the thing, though no one ever has that I know about."

"I thought the point of a ha-ha was to separate parkland from gardens without the necessity of breaking the view with a fence," Sylvia said, looking up at him. "Won't the urns—"

"Be a blot upon the landscape?" he finished for her. "Of course they will, but if I can give into her on something trivial like this, perhaps I can hold my own in more important battles. She has likewise taken it into her head that the tenants' cottages are uninteresting— 'such dull little rows,' she says, 'not picturesque at all.' Now, I ask you—"

Sylvia chuckled. "I can remember when she made that same suggestion to your father. He roared. Told her the tenants should be grateful to have sound roofs

over their heads. But she has seen pictures of Milton Abbey and Blaise Hamlet, you see, and she imagines that something similar might be arranged here."

"I daresay she does, but if she thinks I'll waste my blunt on such nonsense, she's another thing coming."

"Now you sound just like your papa," Sylvia told him.

He glared at her, but whatever he might have been going to say in reply he swallowed, for the stableboy came around the side of the house just then with Sunshine. Greyfalcon tossed her into the saddle and watched while she settled her skirts and gathered her reins.

"I hope my presence here won't keep you from visiting my mother," he said rather stiffly. "She enjoys your company."

"Tell her I will come tomorrow," Sylvia said.

He nodded and stepped back, and she touched the mare with her spur, feeling a sense of relief to be away from him again. Something about him overwhelmed her senses. It was clear that he hadn't forgiven her yet, that he meant to punish her just a little more. Or was that it at all? Was it perhaps merely that he had little to say to her? She was not of his world, after all. Oh, her breeding was perfectly acceptable—the niece of a marquess might go where she liked—but she was not well-acquainted with rakes, and Greyfalcon was clearly that. How long would his duties at Greyfalcon Park hold his interest? How long would it be before he felt the pull of the London gaming tables again, the pull of the light-skirts, the wine, and the friends who bore him company in such pursuits?

There were splashes of orange and yellow where marsh marigolds bloomed in the water meadows along the Thames. The sunlight on the water was particularly cheerful today, and a pair of lapwings, taking flight from a nearby hay meadow, showed their bright white undersides like flags flying on the breeze. Following the path between two hedgerows, tall enough in some places

to block most of the view to either side, she rode in peaceful solitude with only the sounds of nature to keep her company. Birds called to one another, and in the distance she could hear the low murmuring of a herd of sheep. It was a fine day.

All too soon she reached the manor house, its yellow-stone walls and red-tiled roof looming at her out of a grove of beech trees as she approached it from the southwest. There was no long view here, no lake, and no great sweeping lawn, but there was charm and much history. For a time, the house had served as a dower house to the Marchionesses of Lechlade. The third marchioness had not got on well with her daughter-in-law, and the fourth marquess had caused the house to be built many miles from Lechlade Abbey, his principal seat, in order to bring peace into his life. The property was unentailed, and the seventh marquess had deeded it to his fourth son upon the occasion of his marriage. Sylvia had known no other home.

Sunshine needed no urging to seek her stable, and after giving the mare a handful of oats, Sylvia knew she could delay no longer. There were duties to be attended to, and although she had been away but two days, she knew her absence had been felt.

Changing back into her frock, she hurried to the kitchen to confer with Mrs. Hardy, better known as Cook, who informed her that she had come by a nice bit of lemon sole for the master's supper. Since Lord Arthur would have considered more than one course to be sinfully extravagant, Sylvia felt she could leave that matter in Cook's hands, and she went to oversee the turning out of the linen cupboards on the upper floors, with Sadie and one of the other maids to assist her.

She did not see her father until suppertime, for Lord Arthur took no luncheon and preferred the solitude of his library and the company of his books to any other. At table he greeted her politely, but his attitude was still stiff, and when she told him she had been to Greyfalcon Park, he merely nodded, as though he had expected

nothing less. Hesitantly, she mentioned that Greyfalcon had decided to stay to look after the estates, but if she had expected to gain anything by this gambit, she found she had mistaken her man. He only grunted.

"Papa, please, can you not forgive me? He is back, and he is taking his responsibilities in hand. Is that not worth something?"

"Something, maybe, but it hardly serves as vindication for your behavior, daughter."

She gave it up and finished the meal in silence. Regardless of his opinion, she felt justified now in what she had done. She had accomplished what she had set out to accomplish, and if the consequences were more than she had expected them to be, well, one took the rough with the smooth.

In the days that followed, she visited often at the park, for the one person who could be counted upon to express approval of her actions was Lady Greyfalcon. The dowager countess was very grateful to have her son at home again, and if she still did not see as much of him as she felt was her due, at least he was not off in London, gambling away the family fortune. And if he could not be wound around her finger, at least he was seeing to the estate, and it was to him that her tenants now took their complaints.

"For that, if for no other reason, one must be thankful for his presence," she told Sylvia one afternoon during the following week. "I am not strong enough to listen to complaint after complaint, and MacMusker *would* send them to me rather than deal with them himself."

"That was too bad of him," said Sylvia dutifully.

"Well, it was scarcely his fault, you know, for Greyfalcon's papa would never let him make a single decision. He has not got the habit of it, don't you see?"

Sylvia nodded. No one at Greyfalcon Park had got the habit of it while old Greyfalcon had lived, for the old earl had made all the decisions himself, and although the roofs were indeed kept in good repair and

fences were mended, he had begrudged every penny spent and had made no secret of the fact. Indeed, he and Lord Arthur had that much in common, although Lord Arthur could be depended upon not to stint himself when it came to his books. Both men were notoriously parsimonious where it concerned others. Perhaps, she thought now, that trait, rather than her father's intellectual capacities, had been what had caused the late earl to name him trustee for his son's interests.

"I am sorry Francis is not here today," said the countess, breaking into this train of thought. "He has ridden out to look over the northern fields and may even ride as far as Oxford, he said, for old times' sake."

" 'Tis of no consequence, ma'am. I came merely to visit with you." If she felt a pang of disappointment, Sylvia ignored it. She had seen Greyfalcon rather often over the past week, and there had been moments when she had thought they might become friendly, but each time she had decided afterward that it was mere wishful thinking on her part, for he had continued to be aloof and even a touch disapproving in his manner toward her. And, to her great disgust, he still managed from time to time to treat her as though she were still a child. More than once she had thought she would like to teach him a lesson for that alone, teach him to treat her with more respect, but she had not been able to think of any way in which this might be accomplished.

Taking her leave of the countess a half-hour later, she mounted Sunshine at the front steps and took her usual route along the water meadows. The late afternoon was golden after a day of fog, and the change cheered her. Indeed, she felt like giving Sunshine her head. She could not do so, of course, for the way was uncertain unless she kept to the path, and this she did not wish to do. Accordingly, she turned the mare into the meadow itself, and Sunshine responded with a gay skip and broke into a trot, seeming to like the feel of the marshy ground beneath her hooves. There had been no rain for more than a week, and the footing was not as slushy as

it could be. After a time, enjoying the splashing and squishing as much as the mare seemed to, Sylvia urged her to greater speed, keeping near enough to the higher ground of the path not to worry overmuch about unseen holes or tangling weeds that could trip an unwary mount.

When she drew the mare up several moments later, just before the point where she would pass through the gate and into the hedgerow, she paused to wave to two men on a passing barge, and heard her name called out before she turned again.

Greyfalcon was riding toward her on a large chestnut gelding. She waited politely for him to draw up alongside of her, wondering what she had done now to bring such a frown to his face.

"Good afternoon, my lord."

He drew his watch from his pocket and made a point of opening the case and looking at the time. "Rather late for you to be out riding, is it not?"

"I often ride at this hour," she said. "I see you retrieved your watch." Maybe that was why he was out of sorts, she thought, the watch no doubt bringing back memories that annoyed him.

He ignored her second statement, however. "I thought you visited my mother only in the mornings."

"I visit when I have time to visit, sir. We have begun our spring cleaning at the manor house, and today was the buttery. We had to do it in the morning so as to have it done before Cook began preparations for supper. There was naught but a cold collation to serve as a nuncheon, since Papa does not eat at noon, so I came to your mama, knowing I should get tea if I did. Your people serve an excellent tea."

"I daresay." He glanced around as though searching for words, and his gaze was caught by the barge drifting downstream with the current. "Do you know those men?"

She looked at the barge. "No, of course not. Why should you think so?"

"Are you accustomed to waving at strangers?"

"We have always waved at the river people. You did so yourself, as I remember."

He shrugged. "You were a child then. It was not so unseemly. You ought not to be out by yourself, Sylvia. Don't you have a groom?"

"No, and if I did, I certainly shouldn't drag him to Greyfalcon Park and back whenever I choose to visit your mama. How absurd, sir. Whatever will you think of next?"

"I shall visit your father this evening, I think. There are matters I wish to discuss with him. Though he has given the reins into my hands, there are still papers he must sign."

"Look here, my lord," she said hastily, "you are not thinking of telling Papa he must restrict my movements. He would never do such a thing, I assure you, and he would wonder what business it is of yours to suggest that he do so."

She wished she could be as certain as she sounded. In her father's present mood, he might listen to anything Greyfalcon suggested to him. She was not a child who needed looking after. She was a grown woman with responsibilities and good sense. She wouldn't allow anyone to dictate her movements.

Greyfalcon met her glare with a bland look, saying evenly, "I should prefer to have your word that you will not be so foolish in future, that you will have a care for your safety and your reputation. It would be better, I think, if you were to be sure to leave the park soon enough that you not run the risk of being out after dark."

"After dark! For heaven's sake, sir, 'tis no later than half-past four, and the days are getting longer, not shorter."

"Nonetheless, if your mare were to come up lame, you might well be caught by darkness. I mean it, Sylvia. You will make me this promise or I shall speak to Lord Arthur."

"I cannot believe you would behave so shabbily," she muttered, still glaring at him. He did not look away, but he did smile then, making her angrier than ever. "Oh, very well, so you would behave so. I shall do as you say, sir, but not because I believe you would convince my father. I do so only to save you an embarrassing confrontation with him."

"You are very kind," he said sweetly, "and for that, I shall escort you home."

"It is not at all necessary, sir, I assure you."

"Oh, but it is. I have delayed you now, and you might well be overtaken by darkness. Besides, I can as well speak to your father now as later. I do," he added when she opened her mouth in protest, "have several matters of business to lay before him."

There was nothing more to be said after that, and if she hoped he would meet with rebuff from her father, she was disappointed. So long as Greyfalcon was willing to lift the burden of responsibility from Lord Arthur's shoulders, Lord Arthur was quite willing to place himself at the younger man's disposal whenever he wished. Indeed, he magnanimously invited his guest to remain for supper.

At table, Sylvia watched the earl carefully for signs of displeasure at being served only one course, and only fish and a platter of spring vegetables at that, but again she was disappointed. Greyfalcon complimented the cooking in the manner of the very best guest, and when she left the men to indulge themselves in a glass of port afterward, they both seemed mellow and content.

Their mood did nothing to improve her own. Greyfalcon had behaved like a doting uncle from the moment of their arrival, and his attitude had galled her throughout the meal. Her father treated her like one of the servants, though he was somewhat more polite to her than it was his wont to be with them. Between the two of them, she had been brought to the screaming point. Something simply must be done to teach his lordship, at least, a lesson.

The following day her opportunity arrived. At first Sylvia did not recognize it as such and was mildly annoyed when Sadie informed her that Miss Mayfield had come to call. She was in the midst of turning out the gabled bedrooms on the upper floor, and her apron and mob cap made her look more like a servant than the mistress. Moreover, she felt dusty and hot.

"Tell her I shall be with her in just a few moments," she told Sadie, pulling the mob cap from her hair with one hand while undoing her apron strings with the other. Clean water and a hairbrush achieved all that civility would allow on such short notice, and she joined her guest in the parlor less than ten minutes later.

Miss Lavender Mayfield was buxom of person but only two inches taller than Sylvia. Today she was charmingly attired in a violet afternoon gown, with a chip-straw hat perched becomingly upon her auburn curls, its violet ribbons tied in a frivolous bow beneath her right ear. As she rose to greet her hostess, she pulled off her white net gloves and held out both plump hands to clasp Sylvia's tightly. Managing to conceal her dislike of such effusiveness, Sylvia allowed herself to be kissed upon both cheeks as Miss Mayfield gushed her greeting.

"We expected you to be longer in London," that young lady added, taking her seat again. "Such a fast trip, and I hear you returned with Greyfalcon himself. How very romantic that must have been!"

"We made the journey in a single day, Lavvie, so tiresome is a more exact description. I felt bruised and battered and filthy when we arrived. Not the least bit romantic, I'm sorry to say."

"Oh, but it must have been. He is so handsome. Mama and I paid a call upon the countess yesterday morning and chanced to meet him riding out upon that magnificent chestnut of his. Oh, I did think he looked exactly like a knight of old. Just the thought of driving in a carriage with him sends me over at the knees and makes my inside all shaky."

"The onset of dyspepsia, I assure you," said Sylvia unsympathetically. "No, really, Lavvie, the journey took hours, and Greyfalcon rode most of the way. When he did finally take a seat in the chaise, he didn't speak a word to me, just stared out the window or dozed, I promise you."

"Then you must have done something to displease him," Lavender said bluntly, "for I can assure you that when I was in London for the Season last year, he was said to be all that is charming. Why, everyone who knew him sang his praises."

Sylvia stared at her. "Lavvie, you are making that up. I know for a fact that Greyfalcon has the reputation of a rake. I doubt you ever heard his name."

"Well, I did," retorted her friend shortly, "and if he is a rake, all the better, for such men must practice their charm all the time in order to warrant the name. Don't you find it most exciting? Only imagine what one's friends would think. They would stare to see me dancing with him, and only fancy being thought beautiful enough to attract his notice."

Sylvia opened her mouth to point out the difference in their ages and station, and thus the very unlikelihood of such a thing ever coming to pass, but her evil genius intervened before a single word was uttered. Instead, she lowered her lashes and said, gently, "Do you know, Lavvie, you may very well be in the right of it. Greyfalcon mentioned your name to me once. As I recall he said you were a very pretty girl."

"Nonsense, he wouldn't remember me. You were the one who spent all her time at the park, not I."

"Oh, I didn't get the impression that he was

remembering you as a child, Lavvie, not at all." She frowned as she attempted to bring that very brief conversation to mind. "I am quite sure he mentioned seeing you in London during your come-out last year. Surely, you met him at least once."

"Well, yes we did, at a rout at Lady Heathcote's, but only in passing, you know, and only because Mama practically snatched at his coat sleeve as he made to pass us by. I am persuaded that he can scarcely have noticed me."

"But I cannot think of any other reason for him to have mentioned your beauty, Lavvie."

The other girl's eyes sparkled. "Sylvia, do you really think he remembers me?"

"Why, yes, of course he must." Sylvia salved her conscience by telling herself that that at least was true. Even if, as was perfectly possible, Greyfalcon retained no memory of that conversation, he would know the vicar's entire family, just as he knew all his neighbors. And if she had exaggerated just how well he remembered Lavender, well, that young lady was pleased as punch to think she had drawn such attention, and Greyfalcon was certainly experienced enough to keep her at bay if she attempted to throw herself at him.

Miss Mayfield would no doubt attempt to do just that by the look of her, but since she had been known in her eighteen years to have fallen madly in love with everyone from a lowly bootboy to the Duke of Devonshire with no ill effects, Sylvia could not feel that love of Greyfalcon would affect her any more powerfully or painfully than love for any of the others had done. And it might well teach his lordship a lesson.

Accordingly, she encouraged Lavender to believe that Greyfalcon, having seen her in London, had been unable to dismiss the thought of her beauty and charm from his mind, and when, predictably, Miss Mayfield arrived less than ten minutes thereafter at the point of wondering if he had come into Oxfordshire for no other purpose than to worship at her feet, Sylvia merely

shrugged. However, it then became necessary, if she was
not to give way to the mirth bubbling up within her, to
note he passage of time and to wonder if Lavender's
mama might not be growing a trifle worried over her
daughter's long absence from home. Miss Mayfield ex-
claimed at the time, and adieux were made. As Sylvia
watched the gig disappearing down the drive, she bit her
bottom lip, wondering just where this latest mischief of
hers might lead.

Two days later, declaring a holiday for herself, she
packed a book that the countess had lent her, some
apples and cheese, and some bread and beef into a
satchel that she tied, along with a thick blanket, to her
saddle. Accepting Tad's assistance, she mounted,
touched Sunshine with the tip of her whip, and cantered
off through the beech wood until she came to the drive
that bordered Greyfalcon Park. There was a fence here,
but it was cunningly concealed in a belt of elm trees,
beeches, and a yew hedge, and when she came to an
opening into the deer park, there was only a swinging
gate that could be easily unlatched and opened with the
end of her whip. She was now on the far side of the ha-
ha from the house, and there was a path leading through
the thick growth of trees down to the river. She had
come this way so as not to be seen from the house, for
she did not wish the countess to wonder why she did not
call. Today, she wanted to be on her own.

She came at last to the river, to the narrow arched
stone bridge leading to Greyfalcon's Island. Sunshine
was not particularly pleased to be asked to carry her
across the bridge, for there was a weir beneath, and the
low parapet enabled even pedestrians to watch the
silvery flashes of leaping salmon. The view and the noise
of the water rushing across rocks and between boulders
made the mare nervous, but Sylvia was content to let her
pick her way without haste.

On the island, she wended her way through the trees
to the far side, where she dismounted and spread her
blanket under a tree, from which vantage point she

could watch the river traffic from time to time when she looked up from her book and while she ate her meal. It was a special place, one to which she had come many times before to seek privacy. She could see but not be seen unless someone rowed a boat right up to the island and peered through the reeds and shrubbery, for here the landscape had been allowed to grow freely. The river plants were kept rigorously under control—which is to say they were customarily kept from growing at all—in front of Greyfalcon House, where the lawn was king and must grow right to the water's edge. But here the bur-reeds and butterbur grew, and already there were marsh marigolds and mace, and the water crowfoot had begun to bloom, its tiny white blossoms hugging the damp earth near the shore, peeping brightly from between the sword-shaped yellow-flag leaves and the slimmer though thicker-growing rushes and reeds. Soon there would be fluffy white wild angelica, and huge yellow-flag blossoms would wave cheerfully above the swordlike leaves.

She read for an hour or so, then gave one apple to Sunshine and helped herself to the other, munching as she watched the river traffic. There wasn't much today, only some boys in a rowboat and a couple of barges, but the river itself was mesmerizing. She leaned against the tree, her book open against her knees, and watched the gently flowing water. Coots and moorhens splashed nearby, and once she was rewarded by the sight of a tiny, elusive dabchick, startled by the noise of oars, diving and then appearing quite near her in a patch of reeds. She smiled, relaxing against her tree, then bowed her head to read some more.

"Trespassing, Miss Jensen-Graham?"

His voice startled her so that she knocked the book from her lap. He bent to retrieve it for her, but held it when he straightened, looking at the title, engraved in gold on the blue leather cover. "*A Short Residence in Sweden*? That scarcely has the ring of a gothic romance. You surprise me."

"Well, it is hardly thought by most men to be an improving work, so you should not be all that surprised," she retorted. " 'Tis written by the author of *The Rights of Women*."

"I ought to have realized that you would be interested in the first Mrs. Godwin's odd notions, but where came you by this? I doubt your father gave it to you."

"Why not? He encourages me to read anything that interests me."

"Nonetheless, I doubt he would provide you with a work that encourages young women to forsake their traditional roles in life. He would not wish himself to be made uncomfortable."

She smiled at that. "You are quite right in that, sir. But you seem to have read Mary Wollstonecroft's work yourself, and that does surprise me."

He shrugged. "I have heard about her from one source or another, I expect. I cannot pretend to agree with her notions, but then she did not hold true to them herself when it came to her well-known opposition to marriage. Nor did Mr. Godwin. Most disappointing."

"But what else could they do when she found she was with child? That must have changed things considerably."

"Perhaps, but you have not answered my question. Where came you by this book?"

She grinned saucily. "Your mama lent it to me."

He stared then. "Giving me my own back, Sylvia? I don't believe you."

"Well, you are out then, for she did. You needn't fret, though. I know for a fact that she has not read a word of it, and I daresay she would be shocked to know the content. If you must know, I believe my father sent it to her. His notion of a joke, I should think, though I dare not ask him just now."

Greyfalcon handed the book back to her, and she set it down as he pulled out a corner of her blanket and sat down upon it. His nearness made her oddly nervous, but she could scarcely ask him to sit upon the damp

ground. Instead, she asked how he had found her.

"I didn't hear you approach, sir, and Sunshine didn't so much as whicker."

"She's dozing in a patch of sunlight. I walked over. My gelding doesn't like that bridge. I saw you earlier from the hay meadow, riding across, and didn't see you ride back. Thought I'd just see if you were all right." He grinned then, and there was a guilty twinkle in his eyes that she could remember having often seen in Christopher's in the past. He said, "Actually, if you'd prefer the truth of the matter, Mama has callers, and I thought I'd disappear for a bit."

"Dear me," she said, opening the satchel again and offering him his choice of the contents, "who is it who sends you seeking shelter, sir?"

"Mrs. Mayfield and her charming daughter, though I pray you'll not let it be known that I'm such a coward."

Sylvia nearly choked, and reached quickly inside the satchel for some bread and meat for herself in order to cover her confusion. "I can't think why you would fear Mrs. Mayfield," she said. "She has always seemed very kind."

"Perhaps, but her daughter is a predatory creature if ever I've seen one. Though scarcely past eighteen, she gushes, she simpers, and she clings to one's lapels like a river leech."

"Greyfalcon, what an unhandsome thing to say!"

"Yes, isn't it? You see to what ignoble behavior I am reduced." He rolled a thick chunk of beef up in a slice of bread and munched for a moment. "They called yesterday, too, you see, and the day before as well and it has rapidly been made clear to me that Miss Mayfield does not find my person displeasing. Indeed, it has been made so clear that today, when by the greatest good fortune I chanced to pass through the stableyard on my way into the house and saw the Mayfield gig standing there, I made my escape rather than chance repeating my previous experience."

Feeling the need to change the subject before she

found herself in the briars, Sylvia asked him how his work was progressing. "Are you finding a great deal to do, sir?"

He shook his head. "Not really. MacMusker is a good steward, just hesitant about doing things without clearing them first. My father kept rather a heavy hand on the reins, you know, and an even heavier hand on his money. I've told the man I have every faith in his capabilities, and since my father neither spared any time to teach me my duties here nor ever gave me a free hand to make my own mistakes and profit by them, MacMusker has taught me a great deal in just over a week. I have dutifully visited all my tenants and listened to their complaints and have done all I can, with his help, to redress their grievances. Fortunately there are not too many, so I am able to apepar magnanimous. They seem to like me."

She smiled at him. "It sounds to me as though you have been very busy."

His eyebrows lifted. "Surprised?"

"Well, I did not think you would be much amused by such duties, sir. Your life in London is rather different from what it is here. I had thought you would be yearning to get back there as quickly as possible."

"London looks more favorable every day," he said with a speaking glance in the direction of the house and a wry twist of his lips.

Not wishing to encourage that train of thought, Sylvia spoke without thinking. "Have you paid all your debts?"

"Debts? What can you have been hearing about me, my dear girl?" His tone was not so much one of annoyance as one of long-suffering.

She grinned at him. "Perhaps I ought not to have mentioned such a distasteful subject. 'Tis another of those things about which young ladies are supposed to be ignorant. However, it transpires that I have heard about a certain night at Brooks's."

His brow wrinkled. "Only one night? Dear me, I had

thought the line of communications between town and country to have been far more efficient than that."

He said no more, and somehow she was suddenly loath to press him for more information. He seemed relaxed, more at ease and younger than she had seen him before. Indeed, it appeared that his duties in Oxfordshire had agreed with him. If it was not that, then perhaps it was merely the effects of good fresh air and exercise. The deep creases near his eyes and the dark circles beneath them had nearly disappeared. He looked rested, alert, and really quite as handsome as Miss Mayfield had described him.

The last thought caught her unawares and she turned away, feeling sudden, unwelcome warmth in her cheeks.

"You have not told me what you are doing here," he said quietly after a long moment of silence. "I trust you are not still so deep in disgrace with Lord Arthur that you must seek sanctuary."

"No, at least I do not think so. He received a parcel of books from my Uncle Lechlade three days ago, and I have scarcely seen him since. He even brings his books to the table, you know. Thank heaven the Assize court convenes soon. He will have to come up for air then."

"He was very angry with you."

She nodded. "So were you." When he didn't say anything, she looked up at him to discover that his thoughts seemed to have taken him far away. "Greyfalcon?"

He blinked, turned to face her, then gave his head a little shake as though to clear it. "Sorry, I was thinking only that you have not changed much since the old days."

"That is nearly as unhandsome as what you said about Miss Mayfield, my lord. I am quite grown up now, no longer have braids flying when I ride or teeth missing when I smile. Indeed, I am very nearly a spinster lady."

He made a rude noise. "That's the most ridiculous thing you've said to me yet. You cannot be above one-and-twenty, if that. In fact, if I am not very much

mistaken, the anniversary of your birthday is not long past."

"I turned one-and-twenty last month, actually," she said, exceedingly pleased that he should remember. "But truly, sir, there is not much scope for husband-hunting in Oxfordshire. What little social life there is revolves around Mrs. Mayfield's supper parties or Lady Milford's receptions now that your mama no longer entertains. Oh, there are occasional invitations to house parties during the hunting season, but I rarely go to those anymore. I expect I shall remain at home to be a prop to Papa. He certainly expects me to do so."

"Well, I think that would be a dreadful waste. Why do you not go to London, have another Season?"

"Papa would think it a disgraceful waste of money," she told him, smiling. "He feels I had quite enough exposure in one Season. I did not take then, so why attempt it again?"

"But—" He stopped, looking at her with compassion in his eyes. "Pardon me if I speak out of turn, but I thought—"

"Yes, indeed, there was Christopher. I kept thinking he would come home, you know, that he would get tired of fighting and come home to marry me, so I paid little heed to any suitors I might have had. Without encouragement they simply faded away. I don't even remember most of their names. I had a wonderful time, though, even lived through a storybook romance of sorts—vicariously, you know, through Joan."

"Ah, yes, the Lady Joan Whitely. You did say she married Reston? Somehow I don't think of him in connection with storybook romance. Rather a dull fellow, actually."

"Well, he is not a rake, in any event," Sylvia said with a provocative smile. "No actresses, or opera dancers."

"No, I said that—dull. She loves him?"

"Yes, is it not unfashionable of her?"

"Indeed." He lay back upon the blanket and looked

up through the trees. "Why do you not go to Lady Joan?"

"I told you, no money. And Papa would not like it. He truly thinks I have already had my chance and merely failed to take advantage of it. And to tell the truth, I agree with him. Can you not see me now, going among all the young maidens in their first or even their second Seasons? It would not answer, sir. I should merely make a fool of myself."

"I don't agree," he murmured. His eyes were closed. At any moment, she thought, he will fall asleep. He looked so young like that, so vulnerable. These past minutes he had seemed very unlike the angry man she had met in London. She wanted to reach out and touch him, to smooth the lock of hair from his forehead.

His eyes opened, and she found herself looking directly into their depths. What she saw there brought color back to her face and made her turn away, made her remember his reputation. Suddenly, she felt isolated, far from help, but surely he would not treat her in any but a gentlemanly fashion, especially here on his own property.

That thought brought a memory upon its heels that made her chuckle, and his eyebrows shot upward. "Something amuses you?"

She could scarcely tell him what she had been thinking, that his behavior toward her in London had been anything but gentlemanly. At least, she could tell him that much. She already had done so more than once. But she could not tell him about the string of thoughts that had just raced through her mind. Accordingly, she shook her head. "It was nothing, sir." She got to her knees and put the book back into her satchel. "I really must be getting back to the manor house. I had not intended to give myself an entire day of freedom, but that is very nearly what I have done. May I impose upon you to fold the blanket for me?"

"Yes, of course, but look here, Sylvia," he protested, sitting up, "you are running away. We were just having

a comfortable conversation, and now here you are
leaping up and haring off. Did I say something?"

"No, of course not," she assured him, "but I do have
duties at home, and you probably have things you ought
to be doing, so I must not keep you here longer."

"But you are not keeping me." He stood then and
looked at her, but she could not meet his gaze for fear
that the thoughts she had had but amoment before
would show in her eyes. She had not mistaken the
expression in his. She knew she had not, and though she
was able to convince herself that she was safe in his
company, she had heard about rakes and how they
behaved with young women, and she had no wish to be
the focus of such thoughts for a man like Greyfalcon,
even if they remained only thoughts that could be read
in his eyes. The very idea sent flashes of heat through
her body.

She began gathering up her belongings, and Grey-
falcon helped her to tie her satchel and blanket to her
saddle. Then walking together, leading Sunshine, they
crossed the island and passed over the arched stone
bridge to the place where he had left his horse. When he
had mounted, he bade her adieu, for he intended to ride
across the little gated plank bridge that crossed the ha-
ha, while she would return the way she had come. She
told him it was because she could not spare the time to
visit the countess and did not wish to offend her if her
ladyship chanced to glance out a window and saw them
riding together.

If Greyfalcon thought the chance of his mother's
doing such a thing was remote, he did not say so. He
merely tipped his hat to her and told her to be careful
riding through the woods.

"I have ridden here all my life, sir. I daresay I shall
manage again today without incident."

"Don't be rude, Miss Jensen-Graham. It don't
become you."

His attitude then was more familiar to her, the old
aloof manner that she had come to expect. She merely

tilted her nose a little higher in the air, bade him good afternoon, and rode away from him. But no sooner was she out of his sight than thoughts of their time together flooded into her mind. He had seemed so different today, younger and more approachable than she could remember his ever having been before. Indeed, she had been given some insight into his past life.

What was it he had said about his father? That he had never given him the opportunity to learn from his mistakes. She was seeing another side of Greyfalcon now, one that was more likable than what she had seen before. Not that she had disliked him before. But here her thoughts became more tangled, and she forced herself to think of household chores instead. Somehow, thoughts of sheets and pantry supplies seemed safer than thoughts of Greyfalcon.

In the days that followed she did not see very much of his lordship, although he did pay a call upon Lord Arthur to get his signature on some papers. She visited the countess, who was seen to be in good spirits, making plans for new buildings and condemning the old, changing her mind as often as she made it up, giving orders to her servants for redecorating certain rooms in the great house, then changing her mind capriciously and beginning a whole new plan.

On the Wednesday following her conversation with Greyfalcon on the island, she paid a call at Greyfalcon Park, only to discover other visitors ahead of her. Miss Mayfield and her mother were firmly ensconced in the countess's saloon when she entered.

"My dear child," said the countess, holding out her hand in greeting, though the other two had risen from their chairs, "you behold me suffering. Pray forgive me for not rising to greet you properly."

"Dear ma'am," Sylvia replied, hiding a smile at her first, quite unacceptable interpretation of the countess's words and bending to kiss her cheek, "what ails you?"

"Oh, nothing serious, I assure you. Indeed, Grey-falcon insists that it is naught but another of my

megrims, but then he never suffers as I do, so he cannot be expected to know."

"Oh, no, madam," Miss Mayfield interjected. "I am persuaded that his lordship is all that is kind. Surely, he frets over the state of your health as no one else could do. He is your son, after all."

"Yes," agreed the countess dryly, "he is my son."

Perceiving at once that Greyfalcon had somehow brought his mama's displeasure upon himself once again, Sylvia attempted to change the topic of conversation in order to prevent her from baring her soul before Mrs. Mayfield and her foolish daughter. It was not so difficult as she might have thought, for she was inadvertently aided by the young woman herself, who expressed a wish to know more about Greyfalcon Park's history. That she began her request with a glowing description of its present owner and a desire to know all about him was unfortunate, but since she gushed forth without pause until her full intent was known to her hostess, she did little harm.

Lady Greyfalcon was pleased to expound upon the history of the park and of the Conlan family who had inhabited it for some four centuries and more. Sylvia, who had heard the tale before, was well able to take part in the conversation and to keep the topic flowing until Mrs. Mayfield signaled for departure. She waited scarcely two minutes after they had seen the visitor's backs across the threshold before saying, "Whatever has put you out with Greyfalcon, ma'am? I could scarcely contain my curiosity, and I do hope you won't snub me, for I can see that you are displeased with him. What has he done now?"

Her ladyship sighed and reached for her salts. " 'Tis not what he *has* done, my dearest child, but what he means to do. He is returning to London at the end of the week. And just when he was getting things in hand again, too."

"But he said nothing of this to me, ma'am. Indeed, he said he meant to stay for a time. Are you certain you

have the matter correctly? Surely, he is still needed here.''

"Well, of course he is needed here. How can I possibly achieve all that needs to be done in the house if I am constantly beseiged by tenants' requests and poor MacMusker demanding to know every day what is to be done?" She sniffed strongly at the salts bottle. "I tell you, Sylvia, it isn't to be borne."

Certain that her ladyship must have misunderstood something her son had said to her, perhaps at a moment when her whims had irked him, Sylvia rode in search of him on her way home and was fortunate enough to find him one of the water meadows near the river. The grass was growing well and would no doubt be ready to use for pastureland well before the higher fields. It was also beautiful, alight with wild flowers.

Greyfalcon was riding with his steward, but when he saw Sylvia approaching on Sunshine, he waved the man away and rode to greet her.

She wasted no words. "Your mother is in quite a fret, sir. She has somehow got the notion into her head that you mean to leave us." She had not meant to include herself that way, but she realized that she would feel deserted if he went.

He smiled. "I find I can stick it no longer. If it is not Mama deciding one day she must have ells of red silk for the third-floor parlor and then changing her mind and demanding holland cloth instead to cover everything up because the room has no character, it is supper at the Mayfields' and being expected to attend and to remain polite and attentive while one is being simpered to death. I miss Brooks's."

"But the work here—"

"Is done, or at least well in hand. I have instructed your esteemed parent to give MacMusker as much of a free hand as he can bring himself to give him. Between the two of them, now that MacMusker knows I shall not breathe down his neck as my father did, everything will run smoothly. The household already does, and to tell

you the truth, my butler handles Mama far better than I ever could.''

"I see." There was a sinking feeling in the pit of her stomach, but she mustered a smile and asked how soon he meant to depart, remembering even before he said the words that his mother had already told her. He would leave at the end of the week.

The thought saddened her. She had come during the past weeks to think well of him, even to like him. Though she had not spent a great deal of time in his company, there had been a number of good moments, and she had always been very glad to see him and to speak with him. He had stopped seeming angry with her by the end of that first week, and from then on their relationship had been perfectly amicable. She would miss him.

Sylvia missed Greyfalcon more than she had expected to miss him, and when Miss Mayfield announced the day after Easter that her mama was taking her to London for another Season, she felt unaccountably bereft. Though she tried to tell herself that the feeling was caused by the fact that she had very few friends in the neighborhood, owing to the fact that the families thereabouts had few young people, she soon came to realize that while she would not miss Lavender Mayfield much at all, she really did miss Greyfalcon.

Another letter from Lady Reston—including, besides her usual invitations, another demand to know the whole story about Sylvia's sudden departure from London—stirred that young lady's restlessness nearly to breaking point. She attempted on several occasions to broach the subject to Lord Arthur, but her attempts came to naught, for he persisted in his belief that a second Season, at her advanced age, would be a pointless waste of money.

She continued to visit at Greyfalcon Park and learned that the countess had received only one letter from Greyfalcon, apparently in reply to a complaint sent to him regarding MacMusker's indifference to her wishes for certain changes within the house.

"Not that Francis has agreed to help in the slightest," said her ladyship unhappily, languidly waving a hand in the general direction of the tea tray that Thomas had deposited upon the table nearest her chair. "Do help yourself, my dear. I know I need not stand upon ceremony with you."

"No, indeed, ma'am," Sylvia agreed as she moved to

obey, "but do tell me about this latest news. I know you said only last week that you wished to do up the crimson drawing room in gold and white and that MacMusker had declined to provide funds for the project, but surely you are not financially dependent upon either his lordship or your steward. Do you not have money of your own?"

"Well, of course I do, but you would scarcely believe the paltry jointure my husband expected me to get on with after his passing. What on earth I shall do when Greyfalcon marries and I am packed off to the dower house to make do for myself, I assure you I do not know."

"I am persuaded that Greyfalcon would never behave meanly toward you, ma'am," Sylvia said, setting down the teapot and moving to take her seat in the brocaded, claw-footed chair opposite her hostess.

Lady Greyfalcon sniffed. "Much you know, my dear. I have his answer right here." She flicked a sheet of gray paper lying upon the table near her hand. "He informs me that the crimson drawing room could no longer be called so if we changed the hangings. Of all the absurd . . . Well, you may laugh if you choose, but it is no matter of amusement to me. The responsibilities I have, with this great house to look after and my health being so fragile, as you know it is . . . Well, really, Sylvia, how can Francis expect me to get on without money?"

Having heard his lordship's views on this very issue more than once during his stay in Oxfordshire, Sylvia was hard-pressed to stifle her amusement. Greyfalcon had not minced his words, saying that his mother would change the color of her bed curtains daily if he would but agree to frank her in such nonsense. And she could not fault his opinion, for she had seen for herself over the passage of years that Lady Greyfalcon had not the slightest notion of economy. That lack was evident in this present issue, for the crimson drawing room was scarcely in a decrepit state. Moreover, Sylvia knew as

well as Greyfalcon did that his parent would but change
her mind again if he were so foolish as to give her carte
blanche. She attempted to change the subject.

"Does he include any London news in his letter,
ma'am?"

"Not a bit, which is really most inconsiderate, for he
must know that we are completely dependent upon him
for the latest *on-dits*, but his letter is quite brief—only
the bit about renaming the drawing room. Really,
Sylvia, 'tis quite absurd of him, when he has the use of
all that money. But MacMusker, really a most intract-
able man, insists that he can not spend a groat without
Francis's approval or your papa's, and of course one
knows better than to ask Lord Arthur to approve of
spending money on anything other than books. I
daresay he spends a good deal there, however."

Sylvia smiled. "Indeed, ma'am, I suppose he does. At
present, however, though the Assizes begin on Monday
next, he is still immersed in the books sent him by my
Uncle Lechlade. Piles of them cover his desk and a good
portion of the floor. I believe my uncle must have done
some house-cleaning, for there were two large crates
delivered. Uncle has often sent Papa books before, of
course, but never so many at one time."

"No doubt Lechlade feels it is one way to make up to
your father for being fourth in line for the title," Lady
Greyfalcon said sympathetically. "It must have been a
sad disappointment to Lord Arthur once he was old
enough to recognize the dreadful blow Fate had dealt
him."

"Not a bit of it, ma'am. You mustn't believe Papa
would have preferred to be a marquess, for I promise
you he wouldn't have liked it a bit. Only think of all that
responsibility. Why, my uncle never has a quiet
moment. At the present, I believe he must be in
London, for he nearly always is there the entire time
that Parliament is sitting. You know he is a rabid Tory,
friend to the prime minister, and one of those who is
most distressed by the Prince Regent's unfortunate

spending habits, for while my uncle is not nearly so careful of his money as Papa is, he deplores seeing other people spend what is not theirs to spend. Indeed, he has always been kind to me, if not particularly generous. I am persuaded that if only he were married, and his wife willing to sponsor me, I should have no trouble convincing Papa to let me have a second Season in London, for he would be certain that my Uncle Lechlade would provide the ready.''

"But would he not provide enough funding for you to stay with your friend, if you were to ask him to do so?''

"No, ma'am, for that is quite a different matter and none of his responsibility, you see. He believes Papa ought to look after that, whereas if I were under his roof and in his wife's care . . . Well, surely you see the difference.''

Lady Greyfalcon nodded. '' 'Tis a pity, nonetheless, for you are simply withering on the vine here, Sylvia. If only my own circumstances were different—''

"Now, ma'am, you mustn't distress yourself,'' Sylvia said, knowing perfectly well and without resenting the fact in the least that if her ladyship's circumstances were altered, she would still find reason for not being able to help. "There is nothing to be done, and I am content as I am.''

If that last sentiment did not honestly reflect her feelings in the matter, she was at least able to disguise this fact well enough to convince Lady Greyfalcon. Convincing herself was quite another matter, but there were always chores to be attended to at the manor house, and if one threw oneself into one's work, it was possible to forget for hours at a time that one would much prefer to be in London. Thus, she responded to Lady Joan's letter, politely refusing her invitation and giving only a vague description of her journey into Oxfordshire with Greyfalcon. And on Monday morning, she allowed Sadie to talk her into tackling the library, which chamber had so far been allowed to escape their spring cleaning.

"For 'tis a disgrace, miss, that's what it be, and no mistake. That hearth is clean enough, for 'is lordship do let us clean out the ashes from time to time, though he frets over the dust we raise. I'd like to raise a real dust, I would."

"Very well, Sadie. Since Papa has had to ride into Oxford to begin the Assizes, he will be away until suppertime, so if we are ever to manage the thing, let us begin today."

Accordingly, they retired to the library, where Sadie shook her head in disgust. "Dust everywhere, Miss Sylvia. What would people think? When I think of the times 'is lordship—Lord Greyfalcon, that is, not Lord Arthur—sat in this room, I blush to think what his opinion of the help here must have been. I daresay I can count myself fortunate that I needn't apply at the Park for a position. I doubt he would consider me suited even for the scullery after sitting in all this dust."

The reference to Greyfalcon's scullery was an unfortunate one from Sylvia's point of view, and her voice was a trifle tart in consequence. "The dust is not so bad, Sadie. You are too hard on yourself. Why, I daresay it has not been a month since someone was last in here with the duster in hand."

"Aye, and had me head bitten off for me troubles, for ye needn't think I'd send any of the others in to do this room," retorted the young woman, settling her mob cap more firmly over her smooth brown hair. "Only look at it, miss. Books everywhere, and practically no proper place for them."

Sylvia saw immediately that Sadie was perfectly right. Books had been crammed into every bookcase, and there was no space left for the piles of books stacked on the desk and floor. "Papa needs more shelves," she said thoughtfully. "I shall ask MacMusker to recommend someone to build them for him. There is room on that front wall if we move the tables away and take down the curtains."

"What? Would you cover the window, then?" demanded her companion, wide-eyed.

"No, of course not, just the walls, with perhaps a shelf or two above the window. We'll need new curtains. But for now, you dust the furniture and brush the carpet, and I shall see what I can do about tidying these books."

Thus, as Sadie dusted side tables, Sylvia followed along behind stacking books neatly wherever there was room for them, and soon Lord Arthur's desk and the floor were clear enough to clean. She took careful note of those books stacked upon the desk, so that she might replace them and thus escape some of her father's certain wrath at her having invaded his sanctum; however, she paid little heed to any of the other books she moved. Thus, it was by the greatest good fortune or by some trick of her subconscience that she noted one particular title out of the lot. However, when she did so, it was enough to cause her to pause, book in hand, with her mouth wide open.

Sadie, plying her feather duster with energy over an ornately carved side table, the designer of which would have been most distressed to see the state it had been reduced to after many years of having items shoved aside in order to pile books upon it, noticed her mistress's astonishment at once. "What is it, Miss Sylvie?"

"Sadie, you'll never credit what I've found. Just sitting here among Papa's books, like any other, as though it were the merest trifle. He's only tossed it aside without reading it, too, for the pages have not even been cut."

Sadie eyed the dark-blue leatherbound book suspiciously. "Looks like any other book ter me, miss."

"Well, it is not like any other book," Sylvia told her, "but I cannot tell you more about it until I am sure, for it wouldn't do to raise a dust. Moreover, you wouldn't believe me if I did tell you. Indeed, I am not entirely certain that I believe it myself, for I am persuaded it must have been no more than an idiotish rumor. Nonetheless, this book may well provide my ticket to London. Oh, why does Papa not come home?"

But he did not arrive until darkness had fallen, and by then Sylvia was nearly crazy with impatience. It was no use, however, for he was in an uncertain mood after a day of dealing with his fellow man and wanted no part of conversation either upon his arrival or across his supper table.

"But, Papa, you must hear what I discovered—"

"Not now, daughter. Let a man relax and enjoy his supper in peace, won't you? There can be nothing important enough to disturb me tonight. I want only silence, if you please, and after I have supped, I intend to retire to my library, so be sure to order the fire lighted, if you love me."

Thus, she held her peace until he had entered his library. But then, knowing that there would be an explosion as soon as he did so, she had merely to wait in the hall until he roared her name. Then, quickly, she hurried into the tidy chamber.

"What has been going on here?" Lord Arthur demanded, his gray hair fairly bristling, his cheeks as red as the fire. "I leave the house for one day, and look at this place, Sylvia. You may give that impertinent Sadie woman her notice at once, for I know full well that no other servant would have dared."

"No, Papa, I cannot, because I ordered this room to be turned out. We have done every other room in the house, and this one was a disgrace. We did it today so as not to inconvenience you."

"Well, you are out there, my girl, for I am certainly inconvenienced. How the devil am I to find anything now? Answer me that if you can."

"Certainly, sir," she replied calmly. "The books that were on your desk are still there. The others, on the side tables, have been arranged alphabetically by their authors or, in the event that the author is not named, by their titles. I have already sent word to Mr. MacMusker at Greyfalcon Park, asking his advice with regard to having some shelves built around that window, so that you will have a proper place to put all these books soon.

In the meantime, only I touched them. Sadie did not. She cleaned and dusted, polished and brushed till there was no more to be done, and right well pleased she was to have got it done at last, I promise you.''

Somewhat appeased once he realized that order had been created out of chaos, his temper nevertheless remained uncertain until he had assured himself that she had made no attempt to do anything to the books on the shelves other than to allow Sadie to dust them. Even so, Sylvia felt as though she was taking her life in her hands when she approached him and held out the volume she had discovered.

"Will you look at this, Papa?''

"What is it?'' Lord Arthur peered at the volume through his spectacles. "*The Delicate Investigation*? Can't think how this came to be among the volumes John sent me. Naught but a damned novel, for all I can see.''

"No, Papa, Lady Reston showed me an article about this book in the *Times*. The prime minister had paid five thousand pounds for a single copy. 'Tis said to be a collection of the evidence against the Princess of Wales, gathered at Mr. Perceval's request.''

"Pack of nonsense. Why would he wish to do such a thing? Whole business was a blot on the English system of justice, and since Perceval fancies himself the great potentate of the people, I can't think why he'd wish to bring it up again.''

"Well, I don't know that he does wish to bring it up, sir. Seems he would prefer to keep the content of the book from becoming public. Other copies have been burnt, Joan said.''

Lord Arthur shook his head. "A travesty, that's what it was. Can't say I've much regard for her highness, but she ought to have been allowed to be present when others testified against her. And she certainly ought to have had someone to defend her, not to mention a proper jury to hear the evidence. Prinny's Whig counsel could find nothing to substantiate a single claim against

her, though they'd have liked nothing better than to tell the world she had had a baby that was not fathered by the Prince. Instead, they refused to make a judgment at all, left it to the king." Lord Arthur frowned, musing, "I daresay that if Perceval did collect the evidence, it would have proved embarrassing to the Whigs. Would have been a nice sword to hold over their heads. No doubt it helped the Tories gain power and then proved to be as much of an embarrassment to them, so he burnt what copies he could find."

"I don't remember very much about any of it, Papa, because of course it has been four years, nearly five, since the scandal, and I fear I didn't pay it much heed at the time, but don't you think we ought to find out if this book is worth as much as the paper claimed it might be?"

"Pack of nonsense," said Lord Arthur. "No book is worth so much, though I daresay it wouldn't help Perceval in his current dealings with the Regent if the book were to be made public now."

"Well, I should like to take it to London to find out for myself, sir, if you would allow me to do so. Lady Joan has invited me to stay with her so many times, and your only objection in the past has been the expense of such a visit, so I was hoping that perhaps you would not object if I could fund myself with a portion of the proceeds of the book."

Lord Arthur regarded the book again, more carefully this time. He opened it, flipped through those pages that would separate, scanned a page here and there, and finally handed it back to Sylvia. "I suppose it would not be amiss to discover whether there is any truth to such a rumor. Mind you, Sylvia, I cannot believe it for a minute. Though I can understand his wishing to collect this information in the first place, what would possess a man to pay so much only to destroy a book that ought to be a gift to history if its information is correct?"

She shook her head, not having the slightest idea what might be the answer to such a question. Indeed, she had

not the least wish to engage in lengthy discussion of the matter, lest Lord Arthur come to think the book worth keeping. Instead, she let him talk himself into discovering its true worth. He was not a greedy man, by any means, but he was careful with his money, and five thousand pounds was not an amount to be lightly cast to the winds merely for the lack of a little investigation. When he had reached the point of warning her that she could not expect to use the entire amount for her own adornment, Sylvia knew she had won.

"Indeed, I should never think of squandering such a vast sum upon myself, sir. I shall want only enough for some new gowns, enough so that I shall not be ashamed to be seen by Joan's friends."

"I should hope you would not be ashamed no matter what you might be wearing, my dear. Your breeding is enough to make your welcome assured wherever you might go."

"Indeed, it is, sir," Sylvia assured him, moving to kiss his cheek, "but things go more smoothly when one is properly attired. I promise you I shan't outrun the constable."

"How will you travel?"

"I suppose the best way would be by coach from Oxford."

"Not alone, Sylvia. 'Tis most unbecoming. Take that Sadie woman with you. I daresay I can get on without her well enough, only tell Cook I shan't want mutton every day while you're gone. Dashed woman has no imagination."

Sylvia chuckled. "Mrs. Weatherly is back at the vicarage, sir, and she and Cook are great friends, so Cook would not take it amiss, I think, if I were to ask her to visit during the week to discuss menus with her. And Sadie has mentioned a young niece in service several miles north of Oxford who is looking to change her place in order to be nearer home. She has two years' experience, so it would not be as though I were leaving you in incapable hands. If you do not dislike it, I will

send for her, and Sadie can tell her how to go on."

"Just so she isn't as bossy as that Sadie. If she knows her place, we'll get on famously," Lord Arthur said magnanimously. "And, look here, Sylvia, you'll be needing money to get to London. I shall give you fifty pounds."

Clearly thinking himself a most indulgent parent, Lord Arthur turned back to his books, and Sylvia took herself off to plan her journey. She was not overjoyed by the thought of a long journey on the common stage, nor did the thought of the rackety mail coach appeal, but she could think of no means to avoid either one or the other. It was Lady Greyfalcon, surprisingly, who came to her aid.

"Nonsense, Sylvia, it is not at all suitable for you to travel to town crowded in among the rabble, as you would be on the stage. And I have heard quite dreadful tales from persons—male, every one of them—who have had the misfortune to travel by mail. Drunkards in charge, overturning in ditches, persons falling from the roof and getting killed—"

"Dear ma'am, I promise you I should not ride on the roof."

"No, of course not, but it is all of a piece, I assure you. You must go post."

"Well, I cannot. Papa would suffer an apoplexy, and even with the fifty pounds he has promised me, I could not think to travel in such an expensive style. The common stage will do very well for me. Mrs. Weatherly has had occasion more than once to travel to her brother's by that means when Mr. Mayfield could not spare the old coach, and she assures me that so long as one does not attempt to travel when one knows the coaches will be overcrowded, one may do very well."

"Well, I am sure I should not know when such times might be," said the countess tartly. She was engaged upon another piece of fancywork, and she fell silent just then to examine her work rather carefully before rearranging it upon her lap and picking up the needle.

Sylvia kept silent and was awarded when her hostess looked up suddenly and said, "I know the very thing. Treadle shall take you in our old traveling coach. The thing hasn't been used in years, for when Greyfalcon—Francis's papa, that is—chose to drive up to town, we always traveled post, and Francis, of course, has never used it at all since the days when it used to carry him and Christopher off to school. But I am sure Treadle has kept it in excellent condition, for that is his way, you know, and he will be glad of an opportunity to drive to London, for his youngest daughter—Milly, that is—went up last autumn to go into service with Lord Cowper. Treadle can spend a night with my brother Yardley or with Francis and come back the following day. It would not answer if you had no maid to accompany you, but since Lord Arthur is very kindly lending you Sadie, it will answer very well indeed. You can stay the one night in Maidstone. My husband was always partial to the Saracen's Head there. They set an excellent table, and you needn't worry that the sheets will be damp."

Sylvia accepted the offer at once, and then it was only a matter of writing to Lady Joan and waiting for Sadie's niece to arrive, which was only a matter of days, owing to that young woman's having already given notice to her former employer.

So it was that late afternoon on Tuesday, the seventh of April, Sylvia found herself once again at Reston House, greeting her fond hostess.

"Sylvie, darling, how wonderful to see you again," cried Lady Joan. "You simply must sit down and tell me everything that has happened, beginning with when you were last here, for I do not believe for one moment that all was as insipid as your letters would have me believe. Harry didn't believe it either. We have known you too long, dearest. Now, come, tell all."

Sylvia allowed herself to be pushed into a deep wing chair near the fire, grateful for its warmth, for the day was a damp and chilly one, and the final hours of the

journey, despite thick lap rugs, had not been particularly pleasant. She had already divested herself of her heavy traveling cloak, so now she pulled off her hat and gloves, flung them onto a nearby table, and grinned at her hostess.

"Only wait until you see what I have brought to town with me, Joan."

"Never mind that," said Lady Reston, taking her own seat in a matching chair on the opposite side of the marble hearth. "I want to hear about your meeting with Greyfalcon and all about what transpired afterward. Had I known his reputation then as well as I do now, I promise you, Sylvie, I should never have allowed you to go to him as you did. Did you truly emerge unscathed?"

"Not altogether," Sylvia admitted, "but that is of little consequence now. Joan, I have a copy of *The Delicate Investigation*!"

Lady Joan's memory was not so tenacious as Sylvia's. She received this momentous information with a blank stare.

"Joan, really, the book Mr. Perceval paid five thousand pounds to recover. You told me about it yourself."

"But we agreed that there could be no such book," Lady Joan protested. "You cannot have found it."

"But I did. My Uncle Lechlade sent it to Papa. He is one of Perceval's cronies, you know, and must have been given it when it was first printed. He never read it, that much I can tell you, and nor did Papa, for the pages were quite uncut. But it is the same book, for I read it myself in the coach, and Joan, you would not credit the things they tried to prove against the poor Princess of Wales."

"Gracious, Sylvia, is it true they said she had a baby?"

"The accusation was made," Sylvia told her, "but the evidence showed clearly that she did no more than befriend the child of one of her servants. They tried to accuse her of having other illicit relationships, too, with

such well-known persons as Mr. Canning and Admiral Sir Sydney Smith."

Lady Joan was thrilled to discuss the matter and asked many questions. It was not until one of the servants came in to light more candles that either lady realized how much time had passed, but then Lady Joan exclaimed in dismay, "Goodness, how fortunate that Aunt Ermintrude has gone to my sister's for the week and that it was only Edmund and not Reston who came in upon our discussion. Sylvia, surely Lord Arthur does not know that you read that dreadful book."

Sylvia grinned at her. "Much he would care. Even if he had read it himself, I doubt that it would occur to him that I ought not to do so. Perhaps it would be as well, however, if you do not tell Reston we have been discussing such stuff."

Lady Joan bit her lip. "I should say I won't! Gracious, Sylvie, he would be shocked. Angry, too, I daresay. But surely he ought to be the one to approach Mr. Perceval for you. How will we tell him?"

"We won't," Sylvia said flatly. "I intend to approach Mr. Perceval on my own behalf. No, no, Joan, do not protest. My mind is quite made up. Papa has given me permission to write to him, telling him I have the book in my possession, so there can be nothing wrong in my doing so. It is not the same as writing to Greyfalcon, after all, for not only is the prime minister a married man, but he has twelve children, for heaven's sake. He has been called many things, but no one has ever suggested that he is a rake."

Lady Joan could not dispute the last fact, but she could and did argue the propriety of Sylvia's handling the affair herself. Nevertheless, Sylvia waited only until the following day to pen her missive to Perceval. Then it was only a matter of sitting back patiently and waiting for his reply, hoping that she would not be thrown on her hostess's charity before she could collect her five thousand pounds.

Though Sylvia wrote her letter the very next day, not until the following Monday did she receive a reply of any sort. In the meantime, she and Lady Joan did what they could to improve her wardrobe. Wednesday morning found them in her bedchamber with Sadie, looking over a pile of gowns that Lady Joan's tirewoman had brought to them.

"Ellen says several of these ought to fit you, dearest," Lady Joan said, picking up the first, a simple light-blue morning gown. "You left one of your own frocks here, you know, and my sewing woman was able to use it to alter these. They are all simple. She did not alter any evening gowns, insisting that they would be better done once you had arrived."

The rest of the morning was agreeably spent sorting through those gowns that had been altered and choosing three others, evening gowns, that might be quickly fitted to her shorter, more slender form, and by midafternoon, Lady Joan pronounced her guest ready to pay formal calls.

"No one will suspect for a moment that you are wearing my dresses," she told Sylvia, "for Harry is so generous that I have many more than I am ever able to wear. Not one of the gowns you chose has been seen by anyone other than my seamstress, I promise you."

"You are too kind, Joan, but whatever would Harry say to such generosity on his behalf?"

"Silly, he won't know, that's all."

The rest of the week was spent enjoyably, paying calls and attending rout parties and a supper party on Saturday evening. At this last affair, Sylvia was pleased

to encounter Miss Mayfield and her mama and to learn that the former had been doing her utmost to attach Greyfalcon's interest.

"It is very sad, is it not," that young lady said, "that the poor man is in mourning and does not attend social gatherings. He would not even accept an invitation from Mama to have dinner with us and make one of a party to the opera, although I cannot think that anyone would think such an outing at all disrespectful to his papa's memory, for we selected a tragic opera on his behalf."

"How thoughtful of you," Sylvia said sweetly. "One would not expect him to attend a ball, and a play might be considered frivolous, but there can be nothing amiss in a visit to the opera, especially a tragic opera."

"Well, that is what Mama thought, but he sent a refusal."

"At least he responded," Sylvia said dryly.

"Oh, but he is quite the gentleman," Lavender protested. "Whenever we chance to meet in Hyde Park, he puts himself out to be most affable and charming. I have formed the habit of riding nearly every morning," she added with a blush, "but I have not seen him for several days now."

She went on to describe her life in London, and Sylvia was given a clear impression that Miss Mayfield had not given up her attempt to bring Greyfalcon to kneel at her feet. Had Sylvia not had her own reasons for being in town, she might well have been content to sit back and await the outcome of her small piece of mischief. As it was, however, impatience overrode her other emotions. When the reply to her missive arrived on Monday, it did so in a manner unlike any she had imagined.

She was seated with Lady Joan in the little first-floor drawing room, happily engaged in discussing town gossip, when a footman announced Major Teufel.

"He requests a private meeting with Miss Jensen-Graham, my lady," the tall young man said quietly.

"Out of the question," said Lady Joan firmly. "Miss

Jensen-Graham cannot be expected to entertain unknown gentlemen without a proper chaperon. Pray show this Major Teufel in at once, Alfred.''

"Wait, Alfred," Sylvia said quickly. "Joan, since I do not know this man—"

"Begging your pardon, miss," interjected the footman, "but my father is in service at Carlton House, as my lady can tell you, and I have heard him mention the major's name from time to time. I believe he is one of the Regent's minions, if I may be so bold as to say so."

Sylvia looked at Lady Joan. "Goodness, I was persuaded he must be Mr. Perceval's man."

"Oh, no, miss," put in Albert. "Not if it was ever so."

"Well, that settles it," said Joan. "Show the gentleman in, Albert, if he is indeed a gentleman." She looked at Sylvia. "Goodness knows Harry would have a conniption fit if I were to allow you to meet any of Prinny's people alone. It simply wouldn't answer, my dear."

"No, I suppose not," Sylvia agreed, "but look here, if the man insists, can you not slip out and then listen at the door?"

"What a thing to suggest," exclaimed Lady Joan, but the twinkle in her eyes belied the indignation in her tone. "As if I, a lady bred and born, should stoop so low. You think he would not come to the point if I remain in the room?"

"That is precisely—"

The doors opened just then and Albert announced Major Teufel. A stocky man of medium height entered, his pace just short of being a marching step. His head was held so stiffly upon his shoulders that Sylvia found herself wondering if he could turn it without turning his whole body. His eyes moved in his head rather quickly, and his chilly gaze caused her to glance at the fire in the hearth, to wish it were a bit larger, though it had seemed until this moment entirely adequate.

Major Teufel jerked a bow, his glance taking in both ladies. "Am I correct in assuming that I address Lady Reston?"

Joan nodded regally.

"Ah, yes, well, I should hope you will not take it amiss, madam, if I request a moment alone with your guest?"

Joan's pointed little chin raised a fraction of an inch, and Sylvia was surprised to see how haughty her friend could appear when she wished to do so. "I must protest, sir. My guest is an unmarried lady. Moreover, she informs me that she is quite unacquainted with you. Therefore, it would be most improper for me to leave her alone with you."

Major Teufel's cheeks became a most unbecoming crimson. "I have no designs upon this lady's virtue, madam. Perhaps you do not know who I am?"

"Oh, but I do," Joan said quietly, her gaze showing quite plainly that his identity did not impress her in the slightest.

Sylvia's curiosity was by now growing to immeasurable proportions, and she feared that their rather interesting guest might well take his leave without divulging the purpose of his visit if her hostess antagonized him further. Therefore, she allowed herself a small chuckle and said lightly, "Do not tease the major, Joan dear. He must see for himself that I am quite past the age of requiring a chaperon and that it is no more than your own curiosity to know his business that stirs you to behave like a tigress defending her cub. He no doubt believes such curiosity to be unbecoming in a female." He looks, she added to herself, to be the sort of man who would believe most normal behavior to be unbecoming in a female.

Lady Joan bristled, but after a look down her nose at the major that could have left him in no doubt as to her opinion of him, she gathered her skirts and departed with lofty dignity. Watching critically, Sylvia wondered how someone so small could carry off such an attitude

so well. But then her attention was claimed by the major.

"Miss Jensen-Graham, it has come to our attention that you have an item in your possession that you ought not to have."

"Indeed, Major, and what might that item be, if you please?"

"You would do well not to fence with me, *fräulein*."

"I do not fence, sir. Few ladies do."

The major had made no attempt to take a seat, and he now stepped toward her, his attitude menacing enough to make Sylvia wish she had a weapon at hand. Something in her expression seemed to give him pause, however, and extracting a large handkerchief from his coat pocket, he wiped it across his forehead and attempted a small laugh. "I forget myself," he murmured, turning away.

"I am afraid you must be plain with me, sir. I am told you are employed by the Prince Regent. I cannot think what I might have in my possession that would interest your master."

Teufel turned sharply. "You have a book, Miss Jensen-Graham, as you know very well. That book was printed merely to annoy my master, and I tell you to your head that you will get yourself into a great deal of trouble if you give that book to anyone but me. I should like to have it at once."

"Dear me, Major Teufel, I cannot think how such information came into your hands. Surely, you must be mistaken in your source."

She met his stern gaze with a look of bland innocence that was nearly overset by the fact that she noticed at the same time that the tall door directly behind the major had moved slightly. Taking firm control over her countenance, she continued to meet his gaze directly until the major himself looked away.

"You are not very wise, *fräulein*," he said grimly.

Sylvia chose to display annoyance. "Sir, you have the audacity to enter a nobleman's house, to harass his guest with information that cannot have been obtained

in any honest manner. False information, in all likelihood. And I must tell you that my host is a very powerful nobleman, one whose word is listened to with respect in all political circles, one who interests himself in your master's affairs. I have other friends, as well, sir, just as powerful. Perhaps, you do not know that my uncle is the Marquess of Lechlade? No, I can see from your expression that you did not know."

Indeed, Teufel's countenance had gone quite gray. "My lady—that is, Miss Jensen-Graham—pray believe that I mean no harm to you. It is only that my master wishes to obtain that which you have in your possession."

"I have not agreed that I have any such item in my possession," Sylvia pointed out. "And I must say, Major, that you have already overstayed your welcome in this house." She arose gracefully and stepped to pull the bell. Albert entered with commendable promptitude, suggesting that her hostess was not the only eavesdropper. "Albert, be so kind as to show the gentleman out."

"At once, miss. This way, sir."

Major Teufel eyed the tall, broad-shouldered young man thoughtfully for a moment, then shrugged and jerked another bow in Sylvia's general direction. "Very well, I go," he said grimly. "But you will reflect upon this matter, miss, and if you are wise, you will see the error of your ways."

"Indeed, Major Teufel, perhaps you are right. Good day."

"Goodness," said Lady Joan, entering as soon as the major had gone. "What a detestable little man. How do you suppose he discovered you have the book, Sylvie?"

"I don't know, but my guess would be that he has got someone rather close to the prime minister, someone who keeps Carlton House apprised of Mr. Perceval's business. Indeed, since I have not received any reply whatsoever from Mr. Perceval, I must conclude that my letter has gone astray."

"Has gone to Carlton House, you mean," Joan said,

her eyes narrowing as the ramifications of such a thing began to occur to her. "Perhaps we ought to discuss this with Harry, Sylvie. I know you do not wish to do so, and I cannot say that I relish explaining how I came to allow that bumptious man to enter my drawing room, let alone to converse alone with you, but—"

"No, Joan, let it be. Major Teufel has gone, and he will not return. Did you not see his reaction to learning who my uncle is? No, of course, you did not, for his back was to you, but I assure you he will not wish to annoy Lechlade. Not that he would, of course. Nor do I wish to bring the matter to my uncle's attention. He might well insist that the book go straight back to the prime minister. Indeed, I had not thought of that before. It would never do to have to give the book back without receiving a single groat in return. Indeed, after having sustained such an interview as this one, I believe I deserve recompense merely for saving it from falling into Prinny's hands."

"I wonder why he would want it," Joan said thoughtfully.

"Indeed, I cannot tell you that, for I have read most of it, and it does not do the Prince or his Whig committee much credit. Papa said the investigation was a travesty, and so it was. People said the most shameful things about the princess, and then nothing could be proved except for those things said in her defense. I suppose the book would be embarrassing to the Prince, but since Perceval seems only to wish to keep it from being made public, I cannot think why Prinny would make the slightest push to stop him from retrieving every copy."

"Well, what will you do now, if you will not consult Harry?"

"I shall write to Mr. Perceval again, of course. I cannot continue to rely upon your generosity, Joan, and my fifty pounds is nearly gone. I need that money."

Accordingly, she sent off another missive to Downing Street and sat back to await results. The following

morning she received a message that put all thought of Perceval from her mind.

"Joan, only look at this," she said, waving the crested note at her friend across their breakfast table. " 'Tis from Lady Greyfalcon."

"Gracious, I hope all is well in Oxfordshire."

"I wouldn't know. She writes from Curzon Street. And, Joan, you will never guess who escorted her to town—Papa!"

Lady Joan stared. "You don't say so. Goodness, do you suppose he is ill, Sylvia?"

"No, of course not, for he would have Dan Travers to look after him at home. He wouldn't come to London for a doctor. He thinks London doctors are all mad, dangerous, and fools to boot. No, he must have decided Lady Greyfalcon was not safe to be let out on her own, that's all. Or else she hounded him until he knew he would get no peace, and now that the Assizes are over, he would have had no good reason to give her. Well, there is nothing to be accomplished by sitting here. She invites me to visit at once, and so I must."

"Well, you will take Albert with you, then."

"Nonsense. I shall allow you to provide me with the landaulet, if you will not come with me—"

"I cannot, for I am promised to Lady Franks this morning—one of her charities, you know—but I will not allow you to go unescorted, Sylvia, not after that man was here yesterday. I have not told Harry, for you asked me not to do so, but I cannot and will not allow you to walk into the lion's den merely for the lack of a little protection."

"Dear Joan, Sadie will provide all the protection I could want, and Greyfalcon would not thank you for calling his house a lion's den—"

"You know perfectly well—"

"Yes, of course I do, and I love you dearly for being concerned for my safety, but truly, Joan—"

"Very well, Sylvia," Joan said firmly, "Harry is still at home. He is in his bookroom, working on a speech he

means to deliver in the house, and he will not be pleased to be interrupted, but unless you agree to—''

"I don't believe for a single moment that you would behave so shabbily, Joan, but I shall not debate the matter longer. Albert shall come with me, and if I can persuade Papa to let me have a bit more of the ready, he can even come along afterward to Leicester Square, where I mean to purchase a length of cloth suitable for a new gown. Albert shall carry the parcel. Does that satisfy you?''

It did, and Lady Joan made no further objections. The landaulet was called for and Sylvia soon found herself within, Sadie seated by her side and Albert up behind. The short drive from Berkeley Square to Curzon Street was accomplished without incident, and Albert was soon letting down the steps in order to assist Miss Jensen-Graham from the carriage. Once she was safely upon the flagway, the footman ran up the steep steps to the front door to apply the knocker.

Sylvia spoke to Sadie as they turned to follow him. "It will be nice to see Papa, but I tell you, I cannot think—''

Just then her arm was grabbed roughly, and she was jerked around to find herself confronting a large, belligerent man, a total stranger, who demanded to know where she had got it.

"Let me go at once," Sylvia commanded, attempting to pull her arm free. Sadie turned at once to her mistress's assistance, but although she battered the man with her reticule, he paid her no heed, merely demanding that Sylvia "Give it over at once.''

"Give what over, you odious man?''

"The book. Ye've got it and it's wanted. Give it over, or else.''

She heard Albert shout something, but at that moment, her aggressor's shoulder was gripped from behind in a manner that made him wince and cry out sharply, and Sylvia looked up with relief as her own arm was released from his bruising clutches.

"Thank you, my lord. I cannot think what ails this gentleman."

Greyfalcon shot a look at her over the man's shoulder that told her as plainly as words would have done that he meant to discuss the matter presently. Then he turned his attention to the assailant, a man who, despite being nearly as tall as the earl and a good deal heavier, looked as unlike a criminal as a man might look. His most noticeable characteristic was a Roman nose that put Sylvia forcibly in mind of the caricatures one saw of Lord Wellington.

Greyfalcon spoke sharply. "You shall be given into charge, sir, just as soon as I can have you hailed before a magistrate."

"No, Greyfalcon, you mustn't," Sylvia said quietly. "I am persuaded this man meant me no harm, and I appeal to your mercy, sir. Let him go about his business. He will never do such a thing again."

"I never did nothing," the man said in a whining voice. "Just tried to get back what belongs to another. Just the sort of injustice a man might expect, to be given in charge—"

"Hold your tongue," Greyfalcon commanded in a tone that silenced both Sylvia and her assailant. The earl looked at Sylvia, who looked back at him beseechingly. It had occurred to her that if the man were hailed before a magistrate, her precious book might be demanded as evidence, and then what would prevent Mr. Perceval from claiming it as his property? Indeed, once it appeared in a magistrate's court, how would anyone prevent its contents from being made public—an excerpt a day in the *Gazette*? She was beginning to understand why the Prince might wish to possess the only known copy.

"Very well," Greyfalcon said at last, "I shall not delay your departure. This is no place to discuss this matter, and I have no wish to entertain the likes of you in my house. You are never to molest this lady again, however. Is that perfectly understood?"

The man bobbed his head. "Aye, m'lord. No offense intended. Just attempting to recover missing property."

"To suggest that this lady has property which is not her own is itself an offense," Greyfalcon pointed out gently.

The man flushed. "Never said such a thing. Must have been in error all along. Pray you will forgive me, sir."

"That's better. Now run along. And you," he added, waiting only until the man was out of earshot before taking Sylvia's arm in a grip not much gentler than the other's had been, "will come straight along to my library and explain this matter to me. And don't think for a moment that I will listen patiently to such fara-diddles as I know from vast experience that you are capable of fabricating. I'll have the truth, or you'll soon wish you'd remained in Oxfordshire."

On the doorstep, he dismissed Albert, telling him that he would see Miss Jensen-Graham safely returned to Berkeley Square, that it was unnecessary for Lady Reston to be deprived of her footman or her coachman's services any longer. Though Sylvia bristled with indignation at this cavalier treatment, something in Greyfalcon's tone or in his manner gave her to understand that silence would be wiser than speech, so, albeit with difficulty, she held her tongue.

Inside, they passed through the hall together, but when Sadie attempted to accompany them into the library, Greyfalcon shut the door firmly in her face with the recommendation that she take a seat in the hall and await results. "I shall thus know where to send the remains," he said to Sylvia when they were alone. "You may take a seat there by the fire or remain standing, but I want a round tale, and I'd advise you not to try my patience, my girl. I already owe you for putting it into my devoted parent's head that a sojourn in town would do her good."

"She is truly here, then? I had a note from her this morning. She is expecting me, sir."

"Then she will continue to do so. Will you sit?"

Sylvia hesitated, weighing the relative merits of losing whatever vantage might be gained by continuing to stand against the knowledge that he would also have to remain standing. At the moment, he was standing entirely too close for her comfort. She summoned up a smile. "I should be glad to sit, sir. And perhaps you would not mind ringing for refreshment. 'Tis a dry day."

Greyfalcon shook his head. "Oh, no you don't. You may have as much refreshment as you like just as soon as you join my mama in her drawing room. Now, however, you are going to tell me what that detestable oaf wanted with you on my doorstep that he was willing to chance being flattened by your footman and battered by your maid. I only preceded the former by virtue of the fact that I was on the point of departing when he knocked and was looking toward the street while he had his back to you. I daresay I nearly pushed him off the steps."

"You were very quick, my lord." She regarded him with gratitude and no little admiration. "I knew I had nothing to fear when I saw you were there."

"Enough of that," he retorted. "You'll get little cheer out of flattery." There was a silence. "I am waiting."

She looked up then, her mouth open to tell him that he might continue to wait with her goodwill, but the words died upon her lips. His expression made it clear that further delay would be unwise. "I wish you will sit down, sir."

"No doubt." He made no move. "Well?"

She sighed. "Honestly, Greyfalcon, you make me feel as though I were back at Miss Pennyfarthing's." He said nothing, and she sighed again. "Very well, it is a book he wants. I suppose he is another in the pay of the Regent, for I have not had a single word from Mr. Perceval."

Greyfalcon looked at her for a long moment as

though by doing so he might make sense of her words. When she said no more, merely waited to hear his reply, he frowned; then, finally and to her relief, he took his seat in the chair behind the large desk. "You will have to clarify the matter a bit more," he said then. "What on earth has the Regent to do with that specimen out on the pavement?"

"Well, I do not know that he has anything to do with him," Sylvia said fairly, "but Major Teufel, who visited me at Reston House yesterday, is certainly Prinny's man."

"His highness's man," Greyfalcon said. His thoughts did not seem to be on his words, however, for he went on at once, "What book? And why does it interest the Regent?"

So she told him about *The Delicate Investigation*, and it seemed he had read the rumors himself, for he did not exclaim and insist that she must be mistaken, as others had done. Instead, when she had finished, he said, "I believe I had better take possession of this book for you."

"Indeed not, sir. 'Tis worth a great deal of money to me, and I should like very much to have that money."

"Then you shall. Good grief, Sylvia, I don't intend to rob you."

The door opened just then without ceremony, and her father stepped into the room. "Good morning, my dear," he said, eyeing them both rather reproachfully. "Do you think you ought to be closed in here like this with Greyfalcon? Not the thing, I assure you, not the thing at all. Her ladyship is awaiting you in her drawing room, and I think it would be—"

"Oh, no she is not," said the countess, stepping in behind him. "As though I should leave poor Sylvia to Greyfalcon's clutches. How dare you accost my callers upon the doorstep, sir?" she demanded. "What would people say?"

"Indeed, ma'am, I don't know what they would say," her son replied easily, "for Miss Jensen-Graham

was certainly accosted upon our doorstep, though not, I hasten to say, by me."

"What is this, daughter?"

"What happened, dearest? Oh, Francis, how dreadful!"

"I am fine, Papa." Sylvia rose to greet him, giving him a light kiss and a hug. "Greyfalcon most fortunately came to my rescue and brought me in here that I might recuperate my forces before paying my respects."

"Not quite that, sir," Greyfalcon said, having also come to his feet. "The person who accosted your daughter"—here he smiled at Sylvia, who was glaring at him—"seemed to think she had a certain book in her possession that he wished to obtain."

"Book? What book?" Lord Arthur turned to Sylvia for enlightenment. "Not that book, surely. Do you mean to tell me it is worth so much, Sylvia? For I had not thought others would wish to get their hands upon it, but five thousand, now I come to think of it, is certainly motive enough—"

"Five thousand?" Lady Greyfalcon exclaimed. "Not pounds! You have a book worth five thousand pounds, and you simply handed it to Sylvia to bring with her, thinking she would be traveling on the common stage, sir? Gracious, I cannot imagine what you were thinking. What a good thing I intervened and sent her in my own traveling coach. You would have much to answer for, Arthur, if your poor daughter had been robbed on the high road. Indeed, you would."

To Sylvia's astonishment, her father attempted to placate Lady Greyfalcon by insisting that he had not had the faintest belief in Sylvia's tale regarding the five thousand, that he had merely wished to indulge her in a little trip to town and had no use for the book. This tack availed him little, for her ladyship would have none of it. It was Greyfalcon who put a stop to what looked like becoming a full-blown gale by recommending that his parent do her possible to convince Miss Jensen-Graham

that she must, for her own safety, give the book into his keeping.

Lady Greyfalcon turned immediately to Sylvia. "Oh, yes, my dear, of course you must do that at once, for Francis will be much better able to approach Mr. Perceval, you know, and from what you have told us, it truly is not safe for you to retain possession. Indeed, I believe it cannot be safe for you to remain at Reston House any longer. You must come to us here. It is perfectly proper, you know, for I shall be pleased to welcome you as my guest. Indeed, if you are here, there is no need for your papa to put up at the Clarendon, as he did last night. He can stay here, too. We shall all be quite jolly together, I daresay."

Sylvia glanced at Greyfalcon, and the expression of utter dismay on his countenance was nearly enough to induce her to accept Lady Greyfalcon's invitation on the spot.

Sylvia's original intention had been to refuse Lady Greyfalcon's invitation, albeit most politely, and return to Reston House; however, both her hostess and Lord Arthur insisted that she remain in Curzon Street. It was only when she realized that she could not hope to persuade her father to part with more money if she resisted his efforts to convince her to remove to Greyfalcon House that she gave in to their arguments. She could not continue to impose upon Lady Joan's generosity forever, and until Greyfalcon managed to meet with Mr. Perceval, to offer him the book, she would have no money of her own.

She did hesitate upon the brink of refusal, however, for it occurred to her that she would have a great deal more freedom of movement if she stayed with Lady Joan. Now that she was in London, she wished to indulge herself in some social activity, and both Greyfalcon and his mama were in mourning. She mentioned this fact, only to bring upon herself a mild reproof from her father.

"Lady Greyfalcon has been most generous, my dear," he began, "so if she has a wish to share your companionship—"

"Oh, piffle, Arthur, the poor girl don't want to dance attendance on me, and no more she should. She is young and you have kept her cooped up in Oxfordshire these past years without the slightest effort to see her properly married. Of course, she ought to go out and about, and you must see that she is properly rigged out, too."

"But, my dear ma'am, Sylvia has had a Season, and a

pretty penny it cost me, too, and nothing at all came of it—''

"Don't interrupt me, if you please. When your sister brought Sylvia to town, the poor girl was expecting to marry our Christopher and made not the least push to engage the affections of any other eligible man. Quite right, too. No one could have expected her to do so.''

"But she and Christopher were not betrothed,'' Lord Arthur protested.

"Much you know,'' said the countess. She smiled at Sylvia. "I cannot take you about myself, of course, my dear, but there is not the least reason that you should not continue to go about with Lady Joan if she wishes to sponsor you. She is well-liked and comes of an excellent family. And although they say she was a bit of a scamp in her earlier years, I have heard only good things about her since she married Reston. He is rather a slug himself—not much fun, I daresay—so she will be pleased to have your company. And if she cannot always manage to take you about, I have other friends who will be glad to oblige you. You have only to tell me when you require a chaperon.''

"Really, Mama, I cannot think that Sylvia ought to be allowed to go about with only the brainless Lady Joan for a chaperon. The blind leading the blind, if you ask me.''

"Well, no one did, Francis,'' retorted his mother, eyeing him rather grimly. "I have hitherto said nothing to you about the state in which I found this house upon my arrival, and I shall say nothing now except that I am grateful that I had the forethought to bring my own people up to town with me. That Wigan of yours—really, you ought to be ashamed, sir—the man is no more a butler than I am, and poor Mrs. Wigan could scarcely bring herself to look me in the eye. The whole house in holland covers except for this room and the drawing room, and I daresay your bedchamber.''

"If you had warned me of your impending arrival—''

"Yes, I daresay, but since you had been living here

for years, it simply didn't occur to me that any warning was required, and this is neither the time nor the place to discuss it, I might add.''

Sylvia stared from one to the other, astonished by the change that had been wrought in the countess. This was not the same vague, whining creature she had left behind in Oxfordshire. This was a lady capable of command, a lady, moreover, whose temper had clearly been aroused. To see Lord Arthur seemingly wrapped around the countess's thumb had been peculiar enough, but to witness Lady Greyfalcon reprimanding her generally awe-inspiring son was another matter altogether. Sylvia waited with bated breath for his reaction, but when it came, she was disappointed.

"Very well, ma'am," Greyfalcon said quietly, a slight flush in his cheeks. "I daresay you have the right of it. I ought to have looked after things better here."

"Indeed," said the countess, having the last word. "Do you come with me, Sylvia, and we will see if any of the bedchambers other than my own has been turned out. You would not credit the amount of dust I found when I arrived. If what I have seen is any example of the best she can do, Mrs. Wigan ought to be dismissed."

"Oh, no, ma'am, I am persuaded she has done all she can do under trying circumstances."

"Indeed, and what circumstances might those be, if I may ask?"

Sylvia stared at her hostess in dismay, realizing that she was not supposed to know a thing about the manner in which Greyfalcon conducted his household. Thinking quickly, she said, "I am sure I couldn't say, ma'am, but one does hear rumors, you know."

Lady Greyfalcon nodded. "Of course, my dear. I did not realize those rumors were quite so widespread that you should have heard them. If they are true, I daresay Mrs. Wigan has had difficulty finding maids willing to work here. I do know that Yardley would not tell me such things as he has told me if he did not fear I would hear them from other sources."

Sylvia had forgotten Lord Yardley, but now she remembered an earlier conversation when her ladyship had complained about her brother's labeling her son a rake. Lady Greyfalcon had undoubtedly heard all the rumors that were going. Did she know then the sorts of parties her son liked to give in her house?

It appeared that she did. "My own housekeeper, Mrs. Holt, discovered such items in one bedchamber as you would not believe," she said now. "Some of Francis's guests have not behaved as they ought, I fear."

Remembering the things Mrs. Wigan had said to her, Sylvia could not bring herself to reply to this statement, and did her best instead to turn her hostess's mind to more practical matters. "I am persuaded, ma'am, that everything will run smoothly now. Even his lordship is all admiration for the capabilities of your butler and housekeeper. Who is looking after things at Greyfalcon Park in their absence?"

"Oh, the underbutler is quite capable," her ladyship replied, turning to push open the door to a charming bedchamber, done up with white muslin curtains that boasted pink silk ribbon ties. There were likewise pink silk cushions and a quilted pink-and-white bed-covering. The walls were papered in a pink, green, and gilt French print that had been all the rage just before the revolution in that country, but her ladyship eyed it askance now. "Really, I am going to speak to Francis. This room is positively dowdy, Sylvia, and I must apologize. Perhaps there is another that would be more suitable, although I cannot say, for I am persuaded that nothing has been done to refine the interior of this house in many years. Indeed, I cannot think when was the last time Greyfalcon's papa allowed me to repaper a single room."

"Never mind, ma'am. I find this bedchamber charming, and I am certain I shall be perfectly comfortable here. If I pull the bell cord, will they know to send Sadie?"

"I daresay," said the countess in a vague tone that

showed quite clearly that her mind was still on the decor. She moved to the window. "At least the view is a good one, for you look over the garden. I remember when Greyfalcon—Francis's papa, that is—first brought me to this house; my own bedchamber looked out over the street, and even with the windows shut quite tightly and the curtains drawn, one could not sleep for the noise. If it is not carriage wheels rattling on the cobblestones, it is hawkers bellowing at one to purchase their wares. Really, most unnerving. I changed my room at once."

" 'Tis a lovely view," Sylvia said, moving to stand beside her. The garden below was not large and did not look as though it had received a great deal of care over the years, but its very wildness lent a certain charm, and at the moment nearly everything growing there appeared to be in bloom, displaying a bright patchwork of vivid colors. From her window, she could see over the rear wall into the mews, but the stables were set far enough back that she did not anticipate being disturbed by any activity there.

Lady Greyfalcon looked at her searchingly. "I am glad to have you here, my dear. I declare, I have come to look upon you as a daughter these past months, so I hope you will not take it amiss if I give you some advice." She paused, but when Sylvia only regarded her with wide-eyed curiosity, she went on quickly, "Do not allow yourself to be overset by Francis's temper. And pray do not attempt to tell me that he was not displeased with you just now, for I noticed when we intruded upon your *tête-à-tête* that he was looking like bull beef."

"What a thing to say, ma'am!" But Sylvia laughed. "He was not best pleased with me, to be sure, but I think perhaps the brunt of his anger was still directed at the fellow who accosted me on the pavement."

Lady Greyfalcon shuddered eloquently. "What a dreadful thing to have happened. You will be quite safe here now, however, for I shall order one of the larger stableboys to remain out front by the steps at all times,

as we do at home. One does not wish to be assaulted upon one's very doorstep."

"No, ma'am."

"Now, then," said her ladyship with more of that new decisiveness in her voice, "we must arrange to visit my modiste at once. I shall need some proper mourning clothes, for I do not intend to hibernate or to turn away callers. You may be certain of that. And you require a great many clothes yourself, for you have been allowed simply to vegetate in Oxfordshire, and I mean to put a stop to that."

"But, ma'am, I cannot allow you to frank me."

"No more I shall. Indeed, I have not the means to do so, for as I have told you time after time, my dear, my husband was most ungenerous. No, no, your bills shall be sent to Lord Arthur, and mine"—she grinned like a child in mischief—"mine shall be sent to Greyfalcon."

Sylvia was a bit wary of following the countess's advice, but that very afternoon she allowed herself to be borne off in her ladyship's elegant landau to the shop in Bruton Street that enjoyed Lady Greyfalcon's custom whenever she chanced to be in town. Since this happy event had been postponed for several years, her modiste was particularly pleased to see her, and even more pleased to learn that Lady Greyfalcon had brought Miss Jensen-Graham to be thoroughly rigged out in the first style of elegance.

"Bad enough that I shall have to go about looking like one of the Tower rooks, Céleste, but it would never do for my dear Sylvia. Her light has been hidden under a bushel long enough."

"Indeed, *madame*," said the plump woman who whisked hither and yon like a dervish to present materials and patterns for their careful inspection. "If I might be so bold, *madame*, no color suits you so well as black. You are a vision, *madame*, with your so-white hair and your exquisite skin. So slender as to appear to have height, and such a manner, *madame*. Quite regal, *madame*."

Lady Greyfalcon lifted her chin a little. "Perhaps you

are right. The color suits me well enough, but I don't care for it. I prefer gaiety, Céleste, as you know, bright colors.''

"*Oui, madame*. I, who serve you, know this well. But you have condescended to take advice from my unworthy self before, and I tell you, black is excellent. With this so beautiful black crape, a trifle of Naples lace here, and just here"—she indicated the appropriate places on the pattern plate—"and *c'est magnifique, madame*."

Sylvia had been observing critically, uncertain whether to trust the countess's modiste to assist her, but after this exchange, she relaxed. Céleste, who was one of the many émigrées to escape France during the Terror, was apparently a woman who knew her business.

When the other two turned their attention to her, Sylvia was quite willing to allow herself to be talked into ordering a new riding habit and several evening gowns, for she knew she could not continue to wear the three gowns she had had from Joan. Indeed, a young lady rarely wore the same dress twice if she did not wish to be condemned for a dowd. But when the countess began ordering large numbers of morning and afternoon frocks, walking dresses, shifts, and underdresses, she cried out in alarm, "Ma'am, desist if you love me. Papa will—"

"Have an apopletic seizure?" inquired the countess sweetly. When Sylvia stared at her in dismay, realizing she had been about to say that very thing, and to a woman whose husband had died of such a seizure, the countess laughed. "Really, Sylvia, do not wear your thoughts so clearly upon your countenance. 'Twill never do. One must appear always as though one has behaved with perfection, particularly when one has not. No, no, do not apologize. I see that you must be introduced to Mr. Brummell, who will give you the same excellent advice. He never apologizes for the dreadful things he says, and people only listen more carefully to hear what he might say next. Have you ever met him?"

"No, ma'am, but truly I ought not—"

"Piffle. My husband's own temper carried him off, and I can promise you that your father can't hold a candle to him in that regard. If he is distressed by your expenditure, refer him to me. He is well aware of the fact that I know better how to spend money than I know how to do anything else, so he will not expect you to argue with me. And don't think Lord Arthur can't afford to spend a little. The change will do him good."

"I am sure you know best, ma'am, but I should prefer not to outrun the constable. I do not need so many gowns, certainly not immediately. After all, I do not even know how long Papa intends to allow me to remain in London. I came up only to exchange that book for Mr. Perceval's five thousand pounds, you know, and to spend a week or two with Joan."

"Well, we are all here now, and I for one do not intend to leave so soon as that. I am persuaded that town life agrees with me better than country life did, and I daresay I can manage to persuade your father to let you remain as long as you like if I put my mind to it."

Sylvia did not have the heart to debate that statement. She did reflect, however, that although her parent had never had anything of a complimentary nature to say about the countess, he had escorted her to town and had, moreover, accepted her invitation to stay at Greyfalcon House. Perhaps it was uncharitable of his loving daughter to think that he had done so only to save himself the expense of a hotel.

After they had paid visits to the shop of Mrs. Clevenger, the excellent milliner in Covent Garden, where they were waited upon by the owner's son, who knew a great deal more about millinery than most ladies knew, and to the shoemaker's in St. Martin's le Grand, where Sylvia ordered a pair of new riding boots of York tan leather as well as dancing slippers and sandals for everyday wear, they retired to the landau with such packages as they had been able to carry away with them.

"Oh, my dear, what a day. I declare I am quite exhausted."

"You ought not to have attempted so much, ma'am," Sylvia said, worried that her hostess had indeed overtaxed her strength. "Your heart is so uncertain. I am persuaded that you ought to be laid down upon your bed instead of trotting about with me."

"Piffle." But her ladyship leaned back against the plush squabs and shut her eyes. Just as Sylvia was quite certain that the countess was fast asleep, one eye opened. "I've given orders that you are to be put down in Berkeley Square, dear."

"That is very kind of you, ma'am, for I must take my leave of Joan and see that my things are properly packed. Sadie is at Greyfalcon House, after all."

She discovered, however, that all was in order for her departure from Reston House, for someone had evidently sent word to Lady Joan earlier in the day.

"I thought at first that the message came from the countess, you know," that young woman told her, "for it stated merely that Miss Jensen-Graham was removing at once to Greyfalcon House and that it would be appreciated if her belongings could be organized for immediate collection. Then I decided the note was too pompous to have been written by her ladyship. Not that I have received any other messages from her, but you did read the one you received this morning. Not at all the same flavor, I assure you."

"No, it isn't," Sylvia agreed, thinking of the countess's rather impulsive but vague manner of writing.

"I suppose Lord Arthur wrote it."

"No, Joan, I don't think it would have occurred to Papa that my things ought to be collected from Reston House."

They stared at each other as it dawned upon Lady Joan that there was only one person who might have taken it upon himself to write such a note.

"Why didn't he sign it?" she asked.

"Was the note on gray crested paper?" Joan nodded. "No doubt he thought a signature unnecessary. Do you come with us tonight?" Sylvia added in an attempt to forestall further questions on that particular subject. "Lady Greyfalcon has decided that it is prefectly in keeping with her state of mourning to go to a simple reception where there will be nothing more frivolous than quiet conversation."

" 'Tis sometimes more than that," said Joan with a laugh, "but Harry enjoys Mr. Rupert Ackermann's weekly gatherings, so I daresay we shall meet you there."

Accordingly, Sylvia and Lady Greyfalcon met Lord and Lady Reston that evening at Ackermann's Repository of Arts, which spread itself from number 96 to number 101 in the Strand. The shop was a popular gathering place, where persons of fashion gathered one evening each week to view Mr. Ackermann's latest prints and to converse with other members of the *beau monde*. Mr. Ackermann had begun only the previous year to publish a monthly periodical with the same name as the shop, and Lady Greyfalcon was one of the many persons on his subscription list, so Sylvia was well acquainted with the magazine, a faultless production containing exquisite color prints displaying furnishings and furniture, dress, carriages—indeed, all the appurtenances of elegant living—but she had never before attended one of Ackermann's receptions.

When they arrived at the large, brightly lighted shop, the countess dismissed their coachman, giving orders that he should call for them in an hour. "For I do not believe we will wish to stay longer than that, my dear, although if you do desire to go on with Lady Joan, you may certainly do so. I shall return home, safe in the knowledge that Reston will look after you properly."

Joan and her husband were already there, standing by a rack of new prints. Lord Reston was turning them for his wife and another, rather stout lady, whom Sylvia recognized as Joan's Aunt Ermintrude. Reston was a

slim gentleman of moderate height with light-brown hair arranged in a windswept style with long side whiskers. He wore a coat of dark blue over yellow pantaloons tucked into shining topboots, and his well-starched white neckcloth was neatly if conservatively arranged beneath his firm chin. He was a handsome man, but one who seemed quite unaware of his masculine beauty. He paused now with a neat bow and a smile, having seen the newcomers before his wife did.

"Good evening, Lady Greyfalcon, Sylvia. You know Joan's aunt, Lady Ermintrude Whitely?" They nodded, exchanging greetings, and Reston went on, "I was sorry to learn of your departure today, Sylvia. Rather abrupt, was it not?"

"Indeed, sir, you must not have heard the whole tale," the countess said, speaking in her usual dignified and carrying tone as she accorded him a polite nod.

Sylvia, noting that Lady Ermintrude and other persons in the vicinity were displaying sharp curiosity, interrupted quickly to assure Lord Reston that she had merely bowed to the countess's entreaties. "So dull for her, you know, sir, alone in that great house with only Greyfalcon and my esteemed parent for company. Papa's nose is always in a book, and Greyfalcon—well, he is Greyfalcon. I could do no less."

"And you needn't," put in his wife, speaking just as quickly, "think for a moment that she has left me in the lurch, Harry, for not only do I have dear Aunt Ermintrude to bear me company, but I go about much more than Lady Greyfalcon can do, for I am not in mourning. And you have already said that you think it an excellent idea that I take Sylvie with me—sponsor her, you know—so I hope you do not mean to spoil it by scolding her for leaving us so soon after her arrival."

While Lord Reston attempted in his grave way to explain to his wife that he had not the slightest intention of scolding anyone, Lady Greyfalcon looked at Sylvia with a guilty grimace, showing that she understood how close she had come to speaking of the book and the

would-be assailant, both matters that her companion would as lief leave unmentioned. Thus, when Joan had allowed herself to be placated, Sylvia was able to continue their conversation without concern for her hostess's loose tongue. She could not, however, be easy some twenty minutes later when she looked up to see that Greyfalcon himself had entered the shop.

By that time, Lady Ermintrude had wandered off with one of her friends, and Sylvia and Joan had collected quite a number of young men, for Joan was determined to bring Sylvia to the notice of as many eligible gentlemen as possible, as quickly as possible. Sylvia had been listening to one of these expounding upon the merits of several examples of the latest furniture styles. She didn't have the faintest idea whether he knew anything about the subject, but he had a charming smile and a manner that was flattering without being in the least obsequious. She had just rewarded him with an appreciative smile when she looked up to see Greyfalcon entering, his gaze fixed upon her face, his countenance arranged in a particularly ominous frown.

There were two other gentlemen with him, and when he approached and greeted the members of their group, one of these, an exquisitely attired, carroty-haired gentleman, demanded an introduction. Since Sylvia recognized him immediately as one of Greyfalcon's erstwhile companions at the card table in Brooks's Subscription Room, she was hard-pressed to play her part in the ensuing amenities with her usual grace.

"May I present the Honorable George Lacey?" Greyfalcon said carelessly. "My mother, Lord and Lady Reston, and Miss Jensen-Graham. These other gentlemen you no doubt already know. Make your bow, George, and then take yourself off like a good fellow. I wish to speak with Miss Jensen-Graham privately."

"Then take your place in line, laddie," recommended the insouciant Lacey. "Your servant, Miss Jensen-Graham. Will you be so kind as to point out which of

these elegant prints I must most admire? Save time, don't you know.''

Sylvia liked Mr. Lacey and she had no wish to be private with Greyfalcon when he looked at her with that particular expression on his face. She had no idea what she might have done to put it there, but it put her most forcibly in mind of the discussions they had had in his bookroom. Therefore, assured by Lacey's manner that he had not the faintest recollection of having laid eyes upon her before, she allowed him to carry her off to look at Mr. Ackermann's prints. And when another of the gentlemen so recently met offered to fetch her some lemonade and cakes from the refreshment table set out at the end of the shop, only to be challenged by several others who wished to perform the same service, she had not the least reservation about agreeing to go with them en masse.

It was not until one of the gentlemen mentioned the time that she realized she had not made any arrangement with Joan for the rest of the evening, and it was some time past the hour allotted by Lady Greyfalcon to the reception. In the meantime the crowd had grown, so she could no longer simply look across the room to find her party. Designating Mr. Lacey as her escort, she insisted that he take her back to her hostess.

"For I am persuaded she must be ready to depart, and although I expect to go on with Lady Joan, it is only polite to wish Lady Greyfalcon good night before she leaves. Can you see where they are? Being short is quite a disadvantage in a crush like this one.''

Flattered, for he was not very tall himself, Lacey craned his neck to peer over the shoulders and heads of those nearest them. "I see Greyfalcon," he said at last. "I daresay the others are still with him.''

Sylvia was by no means so sure of this, but she allowed him to guide her through the crowd to his lordship's side. There was no sign of his mama or the others.

"Mama is over there in a deep converse with Lady

Grazenby, whom she assures me was quite her bosom bow when they were girls, and Reston has taken his ladies on to some rout or other," Greyfalcon explained in answer to her query.

"But I was to have gone with them," Sylvia protested.

"I decided that you would be the better for an early night," he replied easily, "and Reston agreed with me. I have already called for Mama's carriage."

Lacey spoke up before Sylvia could vent her indignation at such cavalier treatment. "I should consider it an honor, Miss Jensen-Graham, if you and her ladyship would accept my escort to Curzon Street. No doubt you have your coachman, but in my experience, coachmen are elderly and it is far better for ladies to be properly escorted by a gentleman who is capable of protecting them."

"And so they shall be, Lacey," said his lordship gently. "I will escort my mother and her guest, thank you."

"But I thought you was merely stopping by this place on your way to Brooks's, Fran. Dash it, man, no need to go out of your way. I don't mind a bit, assure you."

"And I assure you," said Greyfalcon, speaking in an even gentler tone than before, "that your services are no longer required. Good night, Lacey."

Abashed at last, the younger man bowed and took his leave.

Greyfalcon took Sylvia's elbow then, and moments later, without being altogether certain how he had managed it so quickly, she found herself inside the countess's carraige, seated beside the countess and across from Greyfalcon, who scarcely waited for the door to be shut upon them before saying, "You ought not to encourage such rattles as Lacey to fawn over you like that, Sylvia."

"Fawn over me! How dare you, sir! You have no call to say such things to me. I have not behaved improperly, and even if I had, you have no authority over me."

"You are residing in my house, my girl. That gives me every authority."

"Not when my father is also residing there, sir," she responded tartly.

"Very true," agreed the countess. "You cannot dispute that, Francis. Sylvia is answerable only to her father. You have overstepped yourself, my dear, and I think you must apologize."

Fortunately, both Sylvia and the countess knew better than to expect him to comply with this suggestion. They also knew better than to attempt to tease him into a better mood. Thus, the rest of the journey to Curzon Street was accomplished in grim silence.

Sylvia's new clothes began to arrive in Curzon Street by the end of that week, and by then, too, she had attracted enough gentlemen admirers to make her realize that her advanced age was not such a detraction to her popularity as she had feared it might be. Indeed, there seemed to be more gentlemen buzzing around her now than there had been during her first Season in London. When she mentioned this to her hostess, that lady chuckled delightedly.

" 'Tis no wonder, child, for you are far more interesting now than you were then. You'd understand that for yourself if you would but listen to yourself speak. A girl in her first Season generally talks nothing but drivel. Indeed, if she were to talk anything else, she would be an oddity. No doubt you walked about with your eyes wide with astonishment, blushing at every remark addressed to you and talking the most unutterable nonsense. Now you talk like a sensible young woman."

Sylvia shook her head. "That cannot be the case, ma'am, for I assure you I talk as much drivel now as the next person. Why, for that matter, have you ever tried to discuss the classics or the political situation with any gentleman other than my father?"

"I said 'sensible,' Sylvia, not bookish. I do hope you are not so foolish as to go about demanding to hear a gentleman's opinion on something that he's as like as not to have forgotten all about—that is, if he ever knew the least thing about it in the first place. I trust you have learned by now that gentlemen by and large are not interested in what you have to say for yourself so much

as they are in what you have to say about them. They prefer, actually, that you listen to them rather than the other way about.''

"So long as I allow them to choose the topic on which they will discourse,'' said Sylvia with an ironic nod.

"Exactly, and so long as you are aware of the fact that that topic will more often than not be the gentleman himself.'' Lady Greyfalcon lifted a tortoiseshell-handled lorgnette, her latest affectation, and peered briefly at Sylvia. "You are amused, my dear, and I cannot condemn you for that, but I trust you do not allow such amusement to show when you are with any gentleman whose acquaintance you wish to cultivate.''

"Of course not, ma'am. Though I do wish,'' she added thoughtfully, "that I might find someone to talk with occasionally who would not be offended if I should show amusement at something he has not said on purpose to amuse me. Someone with whom I might just be myself.''

"Goodness, you will never bring a man up to scratch with that attitude,'' Lady Greyfalcon warned her. "Men are fragile creatures with fragile egos, and you must never, never speak to one without first weighing your words. Even more important, you must never, never laugh at one whose good opinion you wish to retain. He will never forgive you.''

Something in her ladyship's tone made Sylvia change the subject rather abruptly at that point. It was as though Lady Greyfalcon had suddenly looked back at some hurtful incident or other in her own past and being with her while she did so was uncomfortable.

Sylvia's evenings were filled with activity, and her days were no less so, for Lady Greyfalcon insisted upon her company as she paid and received calls, and Lady Joan made a point to include Sylvia in every invitation that she could without offending a hostess. And since Lady Joan's hostesses had even less wish to offend her, Sylvia was generally included once it became known that Lady Joan wished it so. It began to seem as though

Sylvia never had a spare minute to call her own from that time forth. If she thought to have an hour to herself to read a book, a footman chose that moment to announce a caller. And if she expected to get home early on a given night, that would be the very night that Joan had discovered at the last minute somewhere particularly amusing to take her.

One evening, at the opera, she espied Greyfalcon in a box opposite theirs, a pretty young woman in plunging décolletage beside him. He bowed, and Sylvia was surprised at the surge of anger that swept through her. Though she told herself that her reaction was due to the fact that the man was in mourning and ought not to be at the opera, she carefully refrained from looking at the woman again.

By Friday of her third week in London, she was exhausted but had decided that social life agreed with her. Late that afternoon, the Reston carriage deposited her upon the Greyfalcon House doorstep. Dusk had already fallen, and she glanced warily to the right and left as she stepped down from the carriage, grateful for the presence of Joan's tall young footman and glad, too, to see a hefty young man in the Greyfalcon livery standing beside the steps. Even so, she started when another carriage clattered rapidly up behind the Reston carriage, its team being pulled to a plunging halt, its door flung open as though someone meant to leap out.

Looking at both footman and the Greyfalcon servant to reassure herself of their presence, Sylvia looked back to see who might be erupting from the other carriage, and let out a breath of relief when she saw Greyfalcon himself descending with his normal, casual grace.

Once upon the pavement, he smoothed his coat sleeve and nodded to his coachman. "Take it 'round, Franks. I shan't need it tonight." Then and only then did he seem to realize that Sylvia was standing on the flagway watching him. "May I escort you inside, Miss Jensen-Graham? You will catch a chill standing here."

"Thank you, sir." She looked at the footman. "You

may go, Alfred. Tell her ladyship for me that . . . Or, no, that will not be necessary. I shall see her this evening."

Greyfalcon cleared his throat impatiently.

She glanced up at him from beneath her thick lashes. "Do not let me keep you standing, sir. There is no need."

"There is every need. I wish to speak to you."

"In that case, I am yours to command, sir. Or if not that, precisely," she added when his eyebrows rose mockingly, "at least I shall be pleased to hear whatever you might like to say to me."

"No, you won't. Come along." He took her right hand and tucked it into the crook of his elbow, nodding to the liveried servant upon the doorstep. "Take yourself off, Jackson, and get some supper. You'll not be needed here again tonight. Her ladyship intends to remain at home."

"Very good, m'lord."

"I do not intend to remain here, however, my lord," Sylvia pointed out.

"That remains to be seen."

"No, I am afraid it does not. My plans are settled, sir and the Reston carriage calls for me at eight."

"This is not the place for discussion. Come inside.

He might just as well have ordered her to go straigh. to his library, Sylvia thought. Really, she was becoming quite familiar with the place, considering that it was clearly a masculine sanctum. She made no demur, however, when he guided her toward the tall doors, barely allowing the footman time to get there first to open them, then dismissing the man with a curt nod before he had so much as opened his mouth to ask if anything further was required of him.

Sylvia walked toward the hearth, stripping off her gloves and reaching to untie her hat, a delicious confection of chip straw that dipped enticingly down over her left eye. It also, however, obscured her view of Greyfalcon's face, and at the moment, she believed, reading his expression was important.

He looked at her for a long moment, giving her the odd notion that he was somehow gathering his courage to speak his mind. When he did speak, however, his voice contained not the slightest note of doubt. Indeed, he sounded as dictatorial as he had sounded that first day at Brooks's.

"You have been going the pace rather fiercely, have you not? One cannot turn around in this house without tripping over one or another of your admirers. I should think, Sylvia, that you would have rather more care of my mother's health."

"Do you think I do not care, sir?"

"Have you spent a single evening at home this week?"

"Have you, sir?"

"We are not discussing me."

"Well, I do not believe we ought to be discussing me, either, if it's all the same to you. I am quite grown up, whether you like to admit it or not, my lord, and you have not the slightest authority over me, nor can I think for a moment why you should concern yourself with my comings and goings."

"I concern myself with my mother's peace of mind."

"Do you, indeed? No one who knows the least thing about your reputation would credit that, I believe. You show not the smallest concern for her ladyship by your own actions. Why, only Tuesday evening, at the opera—"

"We will leave my actions out of this discussion, if you please," he cut in swiftly.

"But I do not please. Really, Greyfalcon, you have misjudged your victim in this case, I fear. My father has said I may do as I please, and I believe his word must carry more weight with me than yours."

"You make a spectacle of yourself," he said sharply. "Do you honestly think any one of the gentlemen who fawn about you has serious intentions toward you?"

"No," she replied, goaded despite her determination not to allow him to irritate her, "I believe they dance

attendance on me merely because I am an inmate of this house. Some of them no doubt believe that you have some sort of interest in me, and thanks to your own fascinating reputation, that must make me an object of some interest to them. Others simply wish to be satellites in your orbit, one way or another. I provide them with an excuse to do as they wish. For the most part, you are the person these minions court, sir, not I. But I would be a fool if I did not take advantage of their attention when it affords me such a grand opportunity to meet eligible young men. My portion is not large, but neither is it despicable.''

"That is enough, Sylvia.'' He held up his hand, and despite herself she fell silent. When there was only more silence, it took all her self-control to keep from nibbling on her lower lip, to keep her gaze fixed firmly upon his chin. She could not meet his eyes, for she knew without his saying another word that he was angry again, and she did not know precisely why. She had done nothing of which even the highest stickler might disapprove, except enjoy herself.

"You cannot honestly believe that I have neglected Lady Greyfalcon,'' she said at last when he still did not say anything further.

"No.'' He turned away, walking toward his desk, but he turned back again before he reached it. "You cannot truly expect me to believe either that *you* believe all the attention you receive is due only to your presence in this house. I am not such a fool, Sylvia, and neither are you.''

"Perhaps not all the attention, but a good deal of it,'' she said quietly.

He looked at her. "Lacey is certainly not the man for you.''

"I like Mr. Lacey. He amuses me.''

It was as though she had touched a candle to dry straw. "Dammit, Sylvia, I won't have it! That man is a fortune-hunter, a gamester, a loose screw. In short—''

"In short, sir, he is one of your good friends.''

"That has nothing to do with anything. You ought not to know my friends, and that's the long and short of the matter. Where is your loyalty to Christopher's memory, for God's sake? Just what would he think of the rattles and loose screws you've been encouraging to dangle after you, may I ask?"

"No, you may not ask, for it is not any business of yours, Greyfalcon." The tears that leapt to her eyes only exacerbated the anger she was feeling. "I am your mother's guest; yet you persist in treating me like a child over whom you have some sort of control. You do not have the right, sir, as I have told you over and over again. For you to throw your brother's name in my face as you have done today is as bad as if I were to fling in yours the fact that by your own actions you precipitated your father's death."

He stared at her. "I had nothing whatever to do with my father's death."

"Nonsense, of course you did. Merciful heavens, sir," she said when she saw the expression her words had brought to his face, "you didn't know?"

His face was white. "Tell me."

"Your gaming debts," she said reluctantly. "The night you dropped twelve thousand at Brooks's. Your father heard about that."

"My Uncle Yardley—"

"Your father would have heard from someone, my lord. The only way he would not have heard is if it had never occurred."

"Not occurred—" He seemed to be in a daze.

Sylvia gave herself a shake. "Look here, Greyfalcon, I am sorry if I have upset you, but I have told you no more than the truth. If you must take it upon yourself to lecture me on my behavior, it does seem to me that you ought first to look to your own. Persons living in glass houses . . . But that is all I should say on that head. I'll leave you now. Good day, sir."

He said nothing more, and she took herself out and upstairs, feeling a little as though she had been part of

some sort of anticlimax. She also felt guilty, for she had led him to think that she held him responsible for his father's death. "And I don't," she muttered to herself as she entered her bedchamber and rang for Sadie. "Not in the least."

It also occurred to her that she had not reacted the way one might have expected her to react when he had flung that bit about Christopher in her teeth. Surely, it hurt, but it was not memory of Christopher that caused the hurt. It was the fact that Greyfalcon could say such a thing to her. On the other hand, she had retaliated in kind. Perhaps she ought to apologize for that. Before her maid had arrived to help her dress for the evening ahead, however, she had managed to convince herself that it would do him no harm to stew for a while. Heaven knew his behavior could do with some improving.

She had a wonderful evening, because for once Reston was tied up with his own affairs and Lady Ermintrude was with friends. That meant Sylvia and Joan could enjoy themselves with their usual male coterie without concern for anyone's critical eye upon them.

"This evening has been lovely," Sylvia confided in the carriage on the way home. "I declare I am exhausted and will no doubt sleep until noon."

"Well, yes, I suppose it was nice," Joan agreed. She was silent for a moment, then added, "I didn't miss Aunt Ermintrude, but I do wish Harry hadn't had to go to that meeting of his. It is such a bore when he cannot go with us."

Sylvia stared at her. "But all he does is cast disapproving glances at us, and neither of us can talk for as much as two minutes alone to a gentleman without Harry's approaching to see if we want orgeat or some such thing. Really, Joan, I cannot imagine how you abide it."

"Yes, he is rather jealous, is he not?"

"You like it," Sylvia exclaimed. "For goodness'

sakes, Joan, how can you like to be watched like that?"

"Once he knocked a man down for pushing one of my curls off my shoulder," Joan said with an impish grin. "It was really too bad of him, for no one else asked me to dance that entire evening—well, not until we had gone on to another party, at all events."

Sylvia blinked, thinking over this new side of her friend. "I don't believe I should like a man to keep such a guard on me," she said. "In fact, I know I do not like it. Only look at Greyfalcon. I bristle like a hedgehog guarding his worms when he attempts to interfere with my pleasure."

"Yes, well, you don't love him, do you."

It was a statement, not a question, and Sylvia was glad for the darkness inside the carriage, for she had not the least notion what her countenance might betray. She didn't love Greyfalcon. Certainly not. The very notion was absurd.

Joan made no attempt to break the silence, and just as Sylvia was thinking she really must say something, the carriage swung in next to the flagway and came to a halt, the footman leaping from his perch to swing open the door.

"Alfred will see you up the steps, dearest," Lady Joan said then. "Come to me in the morning. We must discuss what we intend to wear to the Carlton House ball."

"But that is weeks off yet," Sylvia protested, laughing.

"One cannot plan too far ahead," said Joan simply, "and besides, 'tis little more than two weeks away. Everyone will be there, Sylvie. We don't want to be despised for dowds."

Laughing again, Sylvia agreed to call at Reston House the following morning and went up the steps with the footman at her side. Before they reached the door, it was swung open by the porter, who had evidently heard their arrival, and upon entering the hall, Sylvia noted that the door to the library stood ajar. There was a

warm glow of light within, but she told herself she felt no urge to enter. That no one invited her to do so was rather disappointing.

The following morning she was only too glad to take herself off to Reston House, for Greyfalcon was in the breakfast parlor when she went down, which was unusual; normally he would have broken his fast hours before and gone to his club. He did not look as though he was enjoying himself.

Her father was also there, which was not so unusual. Lord Arthur enjoyed reading late into the night, and he had been taking advantage of his sojourn in London to acquire more books and to visit a number of museums. Fortunately, he seemed in a mood to chat, for Greyfalcon did not. Indeed, the earl's silence was nearly grim.

"Papa, I cannot tell you how surprised I am that you have stayed in town so long," Sylvia said into that silence.

Lord Arthur looked at her in surprise. "But we have not been here so long, my dear, and there is so much to see and to do. Today, I go to the British Museum. Her ladyship informs me that there is a new exhibit there that she wishes to see."

Sylvia had all she could do not to exclaim aloud at the thought of Lady Greyfalcon willingly attending an exhibit at any museum. So certain was she that her parent had made some sort of error that she was still racking her brain in an attempt to think of a tactful way to tell him so when Lady Greyfalcon herself walked into the breakfast parlor, looking particularly becoming in an elegant walking dress of black bombazine trimmed with sable.

"Goodness, quite a family party," she said as she raised her lorgnette to scrutinize the offerings on the side table. "Just some tea and toast, Alexander," she said to the footman as she turned to take her seat at the table. "Nothing more."

"Very good, m'lady."

She looked at Sylvia. "That's a becoming rig, my dear. The blue sprigging in that frock makes your eyes look blue rather than gray, and the darker blue sash is a nice touch. Don't you agree, Francis?"

The earl looked up from his plate, seemed to hear the echo of his mother's words in his memory, and gazed obediently at Sylvia. "Very nice," he said, turning his attention back to his beefsteak and eggs.

Lady Greyfalcon looked at him more carefully, seemed about to remonstrate with him, then looked at Sylvia and smiled instead. "Where are you off to this morning, my dear?"

Sylvia told her, glancing at Greyfalcon to see if he would object, but he paid her no heed at all. Indeed, his behavior took the edge off her pleasure, and things were no better when it became clear to her in the next few days that he apparently meant to say nothing to her that he could avoid saying.

"It isn't so much that he isn't speaking to me," she confided to her friend after nearly a week of this treatment. "It is more as though my activities have ceased to interest him. No, no, that is not what I meant," she added hastily when Joan looked at her quizzically. "I meant that having made such a fuss before over the gentlemen who visit me, it is a trifle odd that he now says nothing at all. Why, only last night, at Lady Jersey's Roman supper . . . Oh, I can't explain what I mean."

"Do you speak to him?" Joan asked, her eyes twinkling.

"No. Why should I? I would most likely only say the wrong thing and make him angry again. I may wish he would speak civilly to me, but I don't wish to have him caviling and carping again, I assure you."

"Did you say the wrong thing before, Sylvie? You didn't tell me about that."

Sylvia shrugged, reluctant for once to confide in her friend. At the same time she wondered if Greyfalcon's new attitude could be the result of nothing more than

the casual words she had spoken about his father's death. Surely, what she had said to him was no worse than what he had said to her.

"Tell me about it, Sylvie." Joan's voice was gentle, and Sylvia knew that once again her countenance had betrayed her.

"It was nothing," she said. "He doesn't approve of all the racketing about I have been doing, and he said Christopher wouldn't approve either. Well, that was a dreadful thing to say, don't you think?"

Joan had not taken her eyes off Sylvia, and now she frowned. " 'Tis not what I think that matters, dearest. What did you think? More to the point, what did you say to him?"

"I-I—" Suddenly it was difficult to explain, but Sylvia knew there was no use in telling Joan she didn't wish to discuss the matter, for Joan would have it out of her one way or another. "I-I simply told him he ought not to say such things, that it was the same as though I were to fling at him the fact that his actions caused his father's death."

"Sylvia!"

Joan's exclamation was not necessary, for even as she spoke, Sylvia saw Greyfalcon's white face in her mind's eye and realized how truly thoughtless she had been. At the time she had been too much taken up with the things he had said to her, with his attempt to curb her activities, with the fact that he had continually, since that first day at Brooks's, attempted to interfere in her life. Now, in putting the matter so plainly to Joan, she saw and heard herself clearly for the first time. His words to her, though she had described them as cruel, had not touched her in the same way that hers had touched him. What she had said no longer bore thinking about.

She jumped to her feet. "I must go, Joan, at once."

Joan made no attempt to stop her, and Sylvia reached Greyfalcon House less than fifteen minutes later, hurrying up the steps and into the hall.

"His lordship, where is he?" she asked the plump porter.

"Yonder, miss." He shut the front door quickly and moved ahead of her toward the library, but in her haste to have the matter fixed, Sylvia didn't wait for him to announce her. She merely pushed past him into the room.

Greyfalcon, seated behind the large desk with a pile of papers in front of him, scrambled hastily to his feet. "Sylvia, what is it? Is something wrong?"

"Indeed, my lord, I must speak to you." She glanced over her shoulder at the interested porter.

Greyfalcon signaled to the man to close the doors, and when he had done so, the earl gestured toward the upholstered Kent chair. "I'm glad you have come," he said. "I owe you an apology for my recent behavior as well as for my hasty words—"

"No, Greyfalcon, I am the one who must apologize. You had every right to remind me of Christopher, for he was your brother, but I had not the least right to say what I did about your father. It was cruel, and it was untrue."

"Yes, it was certainly untrue." He had moved around his desk as she spoke, and he was now standing rather too close for her comfort.

She took a step backward, speaking hastily. "No one truly believed you were responsible for his death, sir. His temper was uncertain at the best of times—"

"Choleric is, I believe, the proper description of Papa's temper," he said, smiling down at her now. "But—"

"That's an excellent description," she said, wanting to have the whole matter over quickly but not wanting him to forgive her until she had made the matter completely clear to him. "His temper would have carried him off, soon or late. It is unfortunate that it was word of your debts that, that—"

"That did him in?" Greyfalcon didn't wait for her to comment. Shaking his head at her, he said quickly,

"When I agreed with you earlier that it was untrue, I meant that quite literally, my dear. There was no debt."

She stared up at him, paying no heed to the fact that he had closed the distance between them again. "No debt?"

His hands came to rest upon her shoulders, and he looked directly into her eyes. "Foolish Sylvia, did everyone truly believe I lost twelve thousand pounds in one sitting and never mentioned it to anyone? Did no one, particularly your worthy sire, wonder how I paid such a debt?"

"I assumed you hadn't paid it yet," she said, her eyes wide. "I did ask Papa once, and he said he had had no word of any twelve thousand pounds, so I just assumed that no one had yet asked him to authorize payment."

"Foolish beyond permission," he said, giving her a little shake. "Do you not know, my dear, that gaming debts are quite sacrosanct? Your father ought to know, if you do not, for he knows that if I'd needed such an amount I'd most likely have had to apply to him for it out of my capital. Whatever reputation I might have, no one has ever accused me of playing and not paying. No, Sylvia, if anyone is to blame for sending my father into an apoplectic seizure, it must be my Uncle Yardley for getting his facts wrong."

"Did you never lose so much, then? How could he have made such an error?"

"Oh, I lost all right, but I had won nearly fifteen thousand before that. I ended the night three thousand to the good."

"Gracious, but surely Lord Yardley must have known that, sir?"

Greyfalcon shook his head. "I have thought the matter over carefully, and it is entirely possible that he knew only about my losses. It was one of those marathon sessions that are so common at Brooks's, you know. At least, you don't know, but you may take my word for the fact that they are quite common. I was playing with several friends, but Lancombe seemed for

the first half of the evening to have the very worst luck possible, while I could do no wrong. I won the bulk of the fifteen thousand from him. Then the cards turned. I don't know how it is that they seem sometimes to have minds of their own, but from eleven on, I could do nothing right.''

''I have heard that that sometimes occurs,'' Sylvia said. ''Is that not a good time to quit playing?''

''It is not particularly good form, my dear, to quit while one is so far ahead, but I did do what I could to confuse Lady Luck. We changed decks, first of all. I even followed Lacey's advice and turned my coat wrong side out, which only shows that I was drinking more heavily than I usually do, which may account for the whole, now I come to think about it. Nonetheless, I lost twelve thousand in less than five hours, and I seem to recall my uncle leaning over my shoulder toward the end, telling me I ought to go home. No doubt he didn't come in until I had begun to lose, and since most of the betting consisted of scribbling on Lancombe's vowels and shoving them back to him—well, it is entirely possible that Yardley knew nothing of my earlier winnings. He must have gone straight home and written my father. And of course, even if someone had heard about what he told Papa, they would never have repeated it to me. Very few people except for those at the table would have known the whole tale anyway. And as you said earlier, it scarcely makes any difference. Something would have sent him off soon or late, true or false.''

Sylvia looked down at her shoes. ''Still, I ought not to have said such a thing to you.''

''It was a shock,'' he said quietly, ''but it is as well that I know the worst, and I had said quite as hurtful things to you. I am not proud of that, Sylvia.''

His hands still rested upon her shoulders, and he still gazed down into her eyes. There was a look in his eyes now that was unlike any she had seen there before, a look that sent shivers racing along her skin that were

completely at odds with the strange warmth that filled her from within. Both sensations were new to her, both were most unnerving. She tried to meet his gaze directly and found it impossible to do so. She was entirely too conscious of his large hands on her shoulders, of his large body so close to hers.

Sylvia swallowed carefully, then drew a long, steadying breath and straightened her shoulders, moving a little away at the same time. Fortunately, he seemed to realize that he ought not to be holding her so, and he made no effort to retain his grip upon her shoulders. "I-I am glad we have had this little talk, sir," she said carefully. "I must go now, for I promised her ladyship that I would drive in the park with her this afternoon." And without another word or look, she fled.

The following morning Sylvia entered the breakfast parlor to discover her host and hostess engaged in a lively discussion.

"You cannot simply ignore these invitations, however much you might like to do so, Francis. 'Tis most unbecoming behavior. They are neighbors from home, and you simply must not offend them."

"Dear me," said Sylvia, smiling when they both looked at her. "Shall I come back later?"

"No, of course not, my dear," replied Lady Greyfalcon. "You shall help me convince Francis that he must accept Mrs. Mayfield's invitation to escort her to the opera at Covent Garden this evening. The poor woman has been left in the lurch by her usual companion, and she has written begging Francis to do her the honor. He cannot refuse."

"He can, and he will," retorted her dutiful son. "Mama, that woman and her daughter nearly drove me to distraction in Oxfordshire, and now they are doing their possible to make my life miserable here. I do not intend to encourage them."

"Mrs. Mayfield has always been very kind to me," said the countess stiffly. "She never once showed anything but a cheerful face when she visited me, though heaven knows I was anything but a cheerful hostess. She bored me, and I never failed to let her know as much, and she was too kind to neglect me, nevertheless. I owe her some extraordinary kindness."

"Then you go to the opera with her."

"Francis, I shall not allow you to speak to me so."

"And quite right, too," interjected a new voice from

the doorway. Sylvia stepped aside to allow her father to enter the breakfast parlor. "Just came along to see if you'd like to drive to Richmond Park this morning, ma'am, but I must say, Greyfalcon, that is not the way for a gentleman to speak to his mother, and I do not scruple to tell you so to your face, sir."

Greyfalcon's gaze met Sylvia's. "Would you like to add your mite before I apologize?"

She grinned at his obvious discomfort. "No, sir. I doubt it would be necessary."

"It isn't. Mama, I do apologize. I ought never to have spoken so rudely; however, I do not propose to encourage Miss Mayfield to think she has added my name to her list of conquests, and that is what these constant invitations are in aid of. Do you realize they have invited me to partake of nearly every pleasure imaginable these past weeks? If they are not desiring my presence at their dinner table, they are demanding my escort to Almack's."

"But, surely, they would not expect you to go to Almack's when you are in mourning for your father," Lady Greyfalcon told him. "You are exaggerating, Francis, are you not?"

"No, ma'am, I am not. They do not seem to believe that I am truly in mourning, I fear. My lamentable reputation, you see." He shot a glance at Sylvia just then, and she was certain she must look guilty, for his eyes narrowed suddenly.

She had not said or done anything since coming up to town to encourage Lavender Mayfield, but that had been only because she had quickly become aware that encouragement was unnecessary. Never had a citadel been so beseiged as Greyfalcon was. The young lady and her redoubtable parent called nearly every day at Greyfalcon House, ostensibly to pay their respects to the countess; however, if she was not at home, they did not hesitate to ask for his lordship, giving as their excuse their desire that he deliver a message to his mama. Sylvia had been invited more than once to join them in

an outing, and whenever she had accepted, she had suffered their cross-questioning on the subject of Greyfalcon.

Lady Greyfalcon spoke up just then, interrupting her thoughts. "I daresay, Francis, that your reputation is to blame for a good deal, but I have already told Jane Mayfield that I was certain she could count on your escort tonight. There can be nothing amiss in your visiting the opera. Indeed, I know for a fact that you have gone many times. And this is a tragedy, not a comedy, so no one will say you ought not to go."

When Sylvia refused to meet his gaze, Greyfalcon glanced at Lord Arthur and saw that the gentleman was ready to add his encouragement to her ladyship's, so with a sigh and a shrug, he agreed to send a note to Mrs. Mayfield at once. Satisfied, Lady Greyfalcon allowed Lord Arthur to escort her from the room, leaving Sylvia alone with Greyfalcon.

She moved to the side table to help herself from the various dishes there.

"Shall I ring for a maid?" he asked.

"Yes, please. I should like some tea."

He rang and gave the order, then stood to hold Sylvia's chair for her. "I understand you had quite an evening for yourself last night," he said then.

She glanced up at him. "Why, what did you hear, sir?"

"That you have a new conquest, rather a wealthy one this time."

The maid came in with the teapot, and Sylvia waited until the girl had poured out her tea and departed again before replying, "I should think you would approve, sir. Lord Gilman is neither one of your gaming companions nor a fortune-hunter."

"No, but he is certainly a loose screw," said his lordship tartly. "Really, Sylvia, have you no discrimination? The man has morals akin to those of the Prince Regent. Indeed, he is one of Prinny's dearest friends, and none of his highness's servants or

companions is fit to be seen with you. Where on earth did you meet him?''

"At Lady Cowper's," she said, spreading marmalade on a muffin and concentrating upon the task so she would not have to meet his steady gaze. She had not known Lord Gilman had such a reputation, but she could not doubt Greyfalcon's word. He would know if anyone did. She wondered briefly if perhaps Lord Gilman was attempting to draw her interest in order to lay his hands upon the book. Whatever his purpose, she was not about to allow Greyfalcon to dictate to her. It was a bad habit of his, and she meant to break him of it.

"Were you with Reston?" he asked now.

"I was with Joan. Harry has been busy of late with politics. Joan says the Regent is making new demands. I daresay there are problems, as always, with regard to his debts. Joan says Harry seems to think things have bogged down a bit, mainly because the prime minister does not recall having made certain promises to the Prince that Prinny says he made."

"Don't try to change the subject, Sylvia. Even Joan ought to know Gilman's reputation, and if you try to tell me that Emily Cowper introduced you, I simply won't believe you."

"I shouldn't lie to you in any event, sir, but she did not. His lordship asked me to dance, and I found him amusing, so when he asked me to dance again, I agreed. If that caused people to talk, well, then they will talk about anything."

"Of course they will talk about anything. Do you mean to say you accepted an invitation to dance with a man to whom you had not been properly introduced?"

Seeing storm warnings, Sylvia at once defended herself. "Of course I was introduced to him, though I don't recall who introduced us. You know how it is at a ball, Greyfalcon. A gentleman is presented to one as an eligible partner, and half the time one doesn't recall his name ten minutes later, and one never meets him again."

"But you did meet him again."

"Oh, for heaven's sake, sir, let it go. I've no intention of marrying the man, even if he were to ask me to do so, which I am persuaded he will not. As for the other, if you think I am not capable of fending off the sort of offer you seem to think he will be so insulting as to make me, you do not know me at all. And if you want my opinion, I believe you raked up this conversation merely to stave off any attempt I might make to tell you how abominably you behaved toward your mother just now. I saw you watching me, wondering what I might say. Confess, Greyfalcon, I am right, am I not?"

He opened his mouth to deny it, but then he laughed instead. "I don't think I really had such a motive," he said, "but I'll bow to your superior knowledge for the simple reason that I cannot in good conscience deny it now. Perhaps that was my intent. Lord knows I don't wish to discuss it."

"Shall you really go to the opera?"

"I must. I have promised Mama. But I tell you I think it a grave mistake to encourage the rapacious Miss Mayfield. That young lady is out to make herself a countess, and I don't wish to find myself with a suit on my hands for breach of contract. She is just the sort to dream up such a thing and to believe it once she's dreamed it up."

"Oh, I don't believe that, sir. Lavvie is a perfectly charming girl. If her imagination is a bit overactive, then one simply must realize the fact and work to keep her from believing something merely because she wishes it to be so. I'll admit I never expected her to carry—" Sylvia broke off quickly, realizing that her impulsive tongue had carried her into deep waters. "Would you be so kind as to ring for more tea, sir?" she added hastily.

But he was staring at her now. "No, I don't believe I shall. You are going to explain that last statement in full, my girl. It occurs to me that Miss Mayfield never showed the slightest interest in me when she was in town last year. It has only been since my little sojourn in Oxfordshire."

"Oh, but perhaps she had not realized before how charming you can be, sir," Sylvia said sweetly.

"Enough of that. I believe you were about to say that you never expected Miss Mayfield to carry matters so far. If that is indeed the case, I want a full explanation, and I'd suggest that you enlighten me immediately, before I begin to think I shall have to shake the information out of you."

She knew him quite well enough to know that his last words were spoken more in the nature of a promise than a threat, and she could not make herself believe that he would not dare to lay a hand upon her. The only problem was that he might well be even more inclined to use her violently when he knew the truth. There was nothing for it but to tell him, however, and to her surprise, she was not at all afraid to tell him. Indeed, she rather looked forward to it.

" 'Tis a simple-enough matter to explain," she said, still in that saccharine tone of voice. "I merely repeated to Lavvie the fact that you thought her a pretty girl."

"I never said any such—"

"Oh, but you did, sir. You said she was pretty right here in this house, when I was here before. Perhaps you do not recall, but you did say that."

"Pretty is scarcely a raving compliment," he pointed out dryly.

"No, I suppose not, but then I just told her you thought her pretty. She probably drew more from that than I meant."

"Nonsense, you meant to pay me back for the way I treated you here in London. Clearly, forcing me to pledge my watch as payment to that dreadful innkeeper was not enough to satisfy your need for revenge." His eyes narrowed, and the look on his face dared her to contradict the statement.

She grinned saucily at him. "So what will you do now, my lord? Will you tell her she is mistaken, that after further consideration you find that you do not think her pretty?"

"Of course not. No gentleman could do such a cruel

thing, but now that I know how I got into this mess, I daresay I shall think of a way for you to help me out of it."

"Oh, I think you will manage nicely on your own," she said airily. "Besides, I don't think we ought to make any more pacts to help each other until you have fulfilled your earlier obligation to me."

"And what obligation is that?"

"Why, my book of course! You promised to make arrangements with Mr. Perceval for me. Surely, you have not forgotten, Greyfalcon."

"No, but I thought that since your father has agreed to frank your stay in town, there was no longer any need."

"Five thousand pounds is need enough, sir. Good gracious, surely you didn't think I should no longer be interested in such an amount. Only a zany—"

"All right, Sylvia, you have made your point. I did write to Perceval some time ago, but since even my worst enemies have never accused me of being political, let alone of being a Tory, he has shown no interest in setting an appointment. I did nothing further because I did not see any urgency, but if you insist, I shall see what can be done. Not today, because it is Friday, and I am quite sure he will not see me. But Monday I will go to the House and see him, willy-nilly. Fair enough?"

"Fair enough, sir."

After that, just to show him that she harbored no hard feelings, she accepted his invitation to drive that afternoon in Hyde Park, and at the opera that night, she not only waved to him from the Reston box, but she forbore to allow her companion, Mr. Lacey, to flirt outrageously with her. In spite of that, she discovered during the intervals that Greyfalcon's eye was on her every time she looked his way. And when Lavender Mayfield rested her hand lightly upon his lordship's arm, Sylvia discovered that her own slim hands had curled into claws at the sight.

The weekend passed quickly, for there were several

amusements planned, and on Saturday Greyfalcon accepted an invitation from Lord Reston to join them for a jaunt to Hampton Court. He nearly turned back at the last minute when he discovered that Miss Mayfield and Mr. Lacey had been included in the party, but when Sylvia grinned at his look of horror, he grimaced, shrugged, and set himself to behave agreeably.

Fortunately, they traveled by boat on the river, so neither he nor Sylvia was forced into intimate contact with their escorts. Indeed, Sylvia found herself paying little heed to any of her companions while she compared the bursts of scenery with those at home. The arched bridge at Richmond was certainly noteworthy, and there were any number of magnificent houses perched high on the banks there as well, but for the most part she preferred the river below Oxford to the traffic-congested route between London and Hampton Court.

They enjoyed a nuncheon at the Toye Inn, which dated, according to Lord Reston, from the reign of Henry VIII. "In those days," he explained to the rest of his party as they gazed out the bay window of the dining room across the river at the magnificent palace, "the flow of the river was entirely uncontrolled, subject to every drought and spate. Thus, travelers arriving at the ford here on the Surrey side might well discover that there would be no possibility of continuing their journey until a flood had subsided. They would find warmth, good food, mulled wine, and comfortable beds at this very inn. You all know the history of the palace, of course."

"Yes, darling," said Joan, smiling at him. "You told me yourself, and with all the books poor Sylvie's father has made her read over the years, I am sure she knows as much about Henry the Eighth and Cardinal Wolsey as you do, if not more, and she has probably told dear Lavvie, too."

Noting Reston's look of disappointment as well as the blank stares on both Lavender's and Lacey's faces, Sylvia took pity on her host. "I am sure I do not know

so much as you think, Joan. Only that as the building of that palace progressed, the king began to inquire why the cardinal should set up a court even more royal than his own, and that finally, with Wolsey's fall from grace—rather a common occurrence for gentlemen under that particular Henry—the cardinal presented the palace to the king. Hampton Court has been royal property ever since, except, I daresay, for that bit of time when nothing was royal, under Cromwell, you know. But I promise you, that is all I know about the place.''

"Well, I shall not attempt a history lesson, of course. Nothing could be more boring.'' Reston glanced quickly at Greyfalcon, who coughed just then, but that gentleman's expression was bland enough to suit him, and he went on, "I daresay you did not realize that the cardinal stayed at this very inn quite often while the palace was under construction across the river.''

"Hadn't thought about it,'' Lacey said dryly, "but I daresay we'd have figured it out, since this was very likely the only place a man might have taken decent shelter. Oh, don't poker up like that, man. History is all very well in its place, but I am dashed hungry, and the servants are only waiting for your signal to serve us.''

Recalled to his duties, Reston nodded to the innkeeper, who was personally overseeing their service, and the rest of the meal passed without incident, Sylvia having had the presence of mind to ask their host to explain to them the business going on in Parliament regarding the Prince Regent.

"So now we know,'' Greyfalcon said later as he arranged a rug to cover her legs against the chill wind that had descended upon the river. "No wonder Perceval has been too busy to attend to such trifling matters as ours. Prinny must be leading him a merry dance.''

"Well, if Mr. Perceval did indeed promise to see the Prince's debts settled when Prinny pledged himself to switch his party loyalty from the Whigs to the Tories, I think he is honor-bound to do so.''

"But Perceval claims to have no recollection of such an agreement," Greyfalcon pointed out, taking his own seat beside her. "He has always seemed to be an honorable man, though I cannot agree with his politics."

"Are you really a Whig, sir?"

"Certainly, and for the same reason that Prinny has always before now claimed allegiance to that party; that my father was a Tory."

She laughed. "Hardly a matter of principle, then."

"Indeed, solid principle, and never doubt it."

"Well, I think the Prince cannot be very solid in his principles, if he would change parties merely in order to see his debts paid."

"Have you the slightest notion as to what sum those debts amount?" Reston inquired. She shook her head, then gasped when he told her. "Moreover," he added with a smile, "according to Perceval, Prinny agreed to switch his allegiance to the Tory party for the simple reason that Perceval threatened to name the Queen Regent instead of him if he did not. They have been bickering since the end of last year, when his highness presented a bill for five hundred fifty-two thousand pounds plus a separate reckoning for one hundred fifty thousand more for what he called 'regency services,' to the cabinet. They refused to pay, of course, saying they had never heard of such an agreement. Yesterday, Prinny presented the bill again, personally, to the prime minister in front of the gathered House of Commons. Perceval laughed at him, and though I did not witness the exchange for myself, of course, others who did say that Prinny was nearly in tears. I daresay we shall not have heard the end of it."

Lacey, who was thoroughly tired of hearing about the matter and who had no qualms about letting the others know it, suggested that they sing a song. Miss Mayfield quickly agreed, and so it was that the rest of the journey was spent in more pleasant pursuits than the pursuit of political knowledge.

Sylvia accompanied Lady Greyfalcon to Saint George's Chapel in Hanover Square on Sunday morning, and then spent the afternoon at an al fresco picnic alongside the Serpentine in Hyde Park, given by the Earl and Countess Cowper for their many friends. On Monday morning she awoke to a gloomy day, for the sky was overcast, and it looked very much as though it might begin to rain at any moment.

"Good thing this weather didn't descend yesterday," said Sadie when she brought her mistress's chocolate.

"This is the sort of day to spend curled up by a fire with a good book," Sylvia agreed. "I was going to go to Bruton Street to have a gown fitted this morning, but I think I shall just stay quietly at home instead."

"Be nice if others did the same," said Sadie, "but they won't. Shall I tell Merrill that you are not at home today?"

"No, there is no need. I daresay no one will come this morning."

She soon discovered the error of such thinking, however, for several people called before noon, thus showing that they considered themselves practically members of the family. Among these, curiously enough, were the Mayfield ladies and Mr. Lacey, who arrived at very nearly the same moment.

"I did not dare put this business off any longer," Lacey said when he noted Sylvia's surprise at seeing him so early. "I know I ought to have waited until this afternoon, but I realized only while I was being shaved this morning that I have not put my name down for any dances with you at the Carlton House ball, and the date is nearly upon us."

He looked so appalled that she could not help laughing. "Really, sir, 'tis not till a week from Tuesday. You might just as well have waited."

"Well, I like to be beforehand. Might I hope for a minuet, or perhaps a country dance?"

Laughing, she agreed to save the first set of country dances for him. He made her a little bow and then

seemed to realize for the first time that she was not the only young woman in the room. With a remorseful smile he turned away to pay his respects to Lady Greyfalcon and to Mrs. Mayfield, then made his bow to Miss Mayfield.

"I hope you will also honor me," he said, according her his most charming smile.

"It shall be my pleasure, sir."

Sylvia left them to exchange pleasantries and saw them off together twenty minutes later. There were other callers, but not many, and none came after noon, for the sky opened while she and Lady Greyfalcon were enjoying a nuncheon, and the rain poured down, beating so hard against the windows and upon the pavement outside as to make conversation difficult.

After expressing the hope that neither Lord Arthur nor Greyfalcon would drown attempting to get back to Curzon Street, the one from the British Museum, the other no doubt from Brooks's, Lady Greyfalcon announced that she was going to lie down upon her bed, and Sylvia considered ordering a fire lit in her own bedchamber, but then decided that Greyfalcon would not consider it an invasion of his privacy if she took her book into his library. One of the footmen lit the fire there, and she curled up in one of the big wing chairs with a thoroughly unacademic romance to while away the afternoon.

It was necessary before very long to light several branches of candles so that she could see to read, but after that, nothing disturbed her until there came a clattering in the street, as of the wheels of a fast-drawn carriage.

When the vehicle drew up outside Greyfalcon House and men could be heard shouting in the street, Sylvia tossed her book aside and hurried to look outside.

Pulling the curtains aside, she peered out through the rain-streaked window to the scene below. There were several men gathered around the carriage, but the rain and gloom made it impossible to recognize any of them.

Only when they pulled another man from within the carriage and began to carry him up the steps did she realize what was happening. Not for a moment did she mistake the man they were carrying for Lord Arthur.

Running into the front hall, she saw that the porter already had the door open and that two of the footmen had gone to assist the men with their burden. As the rain-dampened group crossed the threshold, she recognized Lord Reston.

"Harry, what happened? What's wrong?"

"Don't fret, m'dear, 'tis merely a clout on the head. He's unconscious, and we've already sent one of your lads running for Dr. Baillie. He's not dead yet, and if I'm not much mistaken, he's a good many years left to him."

"But what happened, for goodness' sake?"

"Some idiot assassinated Perceval," Reston said brusquely. "Greyfalcon just got bumped in the ensuing melee, is all. Found him crumpled up by the wall when the place cleared out. Sylvia, here I say, Sylvia, don't faint on me now, you wretched girl!"

Sylvia recovered quickly from her momentary faintness and, noting that the men were dripping on the hall floor, ordered them to carry Greyfalcon upstairs to his bedchamber. Before they reached the wide stairway, the earl had begun to stir and his eyelids fluttered.

"Here, I believe he's coming 'round at last," said Reston. "Greyfalcon, wake up, man." But although Greyfalcon looked around him vaguely, he did not respond, and his eyelids flickered shut again.

"Perhaps it would be better if you took him into the library," Sylvia said. "The room is quite warm, and there is . . . No, there is no sofa in there, only wing chairs. And the drawing room—"

"No need to spoil any furniture," said Reston gravely. "He's isn't so damp as some of us, but he's taking a wetting just getting to and from the carriage. Besides, the doctor is going to want to take a good look at him."

"Don't need any damned leech," Greyfalcon muttered.

Sylvia saw that his eyes were open again and decided that the quicker he got upstairs, the better. "Take him up, Harry. I'll wait the doctor here. I have heard her ladyship mention that he lives in Half Moon Street, so he shouldn't be long."

"Don't need any damned leech," repeated Greyfalcon in a more surly tone.

"Take him up, men," commanded Reston. "I shall be right behind you to see he gets tucked into bed. No argument now, man. I'd not risk your displeasure if you

were hale and hearty, but I daresay my weight's up to yours now."

They disappeared up the stairs, leaving Sylvia alone in the hall, but she enjoyed her solitary state for only a moment before, in a flurry of black gauze, the countess came rushing down the stairs. "Oh, Sylvia," she cried, "oh, my dear, what has happened to Francis? I saw them carrying him into his bedchamber, but Reston said that everything was in hand and that I need not accompany him. Oh, Sylvia, I am his mother. Ought I not to be at his side?"

The thought of Lady Greyfalcon caring for anyone else was if not ludicrous, at least incredible, and Sylvia bit her bottom lip to keep from saying so. Instead, she guided her hostess firmly into the library and pushed her into a wing chair before the fire, ordering her to sit still until tea could be ordered for her.

"You must not fret, ma'am," she said after seeing to the order and leaving the door ajar so that she might hear the doctor's arrival. "He is in good hands now, and Reston is certain that he suffered no more than a bump on the head. He might just as well have done that in a hunting accident, you know. Only remember when Christopher put his pony at the gate in the hay meadow and came a cropper on the other side when the pony refused. He was unconscious for nearly half an hour and laid up for only a week."

"Which was all that saved him from his papa's wrath," said the countess tartly. "I cannot think how many times that boy had been told he was not to attempt jumping that idiotish pony. Oh, dear, I could not bear to lose Francis, too," she added, wiping a tear from the corner of her eye with her handkerchief.

"Well, you shall not," said Sylvia briskly, ignoring the shiver that raced up and down her spine at the countess's words. How could she have been so thoughtless as to put that notion into her head. Anyone but a complete ninny ought to have realized what route her thinking would take at the single mention of Christopher's name. "I promise you, ma'am, that his

lordship will have the very best nursing, for I shall see to that myself, and I have had some experience, you know, for when Papa was ill two years ago, I looked after him, and he, you must realize, was not the easiest of patients. The doctor will be here shortly, and if you like, I shall go up with him, and he will tell me just what to do. Wigan will help me, so you need not be thinking that it will be too much for me."

"Oh, Sylvia, if only you could, but Greyfalcon will not allow it, of that I am certain. And your father will not like it either. He will say—and rightly, too—that you are in London to enjoy yourself and not to play nursemaid to a man who can afford any number of proper nurses to look after him."

"Well, pooh to that, and so I should tell him. I am a grown woman and not some simpering miss who will whine and mope at missing a party or two, and I daresay that is all I will miss. But there is one thing you cannot have considered, ma'am: there is no one else in this house who does not go in awe of his lordship. He will not wish to obey the doctor. Of that I am as certain as you are. And you will remember that when Christopher had his accident, Doctor Travers warned us that although he might seem perfectly fit, concussion was extremely dangerous and must be treated with great respect. I am not at all afraid of Greyfalcon, and I promise you that if the doctor says he must stay in bed, he will do so."

There were noises of arrival from the hall just then, so she left her hostess and hurried to greet Doctor Baillie, a tall man so slender as to be more correctly described as skinny. He walked with a slight limp and with his head and shoulders thrust forward as though he were always in a hurry. He introduced himself and demanded to be taken at once to his patient.

"I'll take the doctor up, Merrill," she said to the butler, who appeared through the green baize door under the stairway just then. "Do see you what has become of her ladyship's tea, if you please."

"Yes, miss."

Greyfalcon's bedchamber was located near his mother's and at no great distance from Sylvia's. She had never been inside, however, and she did not go in now. When the door opened, she saw that the group of men had succeeded in getting the earl out of his wet clothes and putting him to bed. His voice, sounding quarrelsome, mingled with those of the others.

"Here now, clear all this lot out of here," commanded the doctor as he stepped inside. "I shall want one footman to assist me. The rest of you, out." He waited until they had obeyed him, then shut the door firmly behind them.

Most of the men continued past Sylvia and down the stairs. Only Reston lingered.

"He is awake, then, Harry?"

"You heard him. He doesn't wish to be in bed, and I doubt that that doctor will keep him there without he ties him down. Got a mind of his own, Greyfalcon has."

The door opened a moment later, and Baillie stepped out. "I can do nothing with him, Miss Jensen-Graham, if he insists upon getting out of bed, and so I tell you. That young footman in there has been ordered to get him dry clothes, and he seems to be obeying the order. If the man will not allow me to bleed him, I cannot be held responsible for the consequences."

"Harry, don't go anywhere," Sylvia said quickly. "I want to talk to you. Now, let me pass, Doctor."

"But, look here, you can't—"

"For heaven's sake, sir!" She pushed past him, thrusting the half-open door out of her way and thereby surprising the earl as he was about to emerge naked from his bed.

Hastily, Greyfalcon dived back beneath the covers, pulling them up to his chin, his face paling with pain at even this much exertion. His voice seemed to come with effort, but his words were clear. "What are you doing in here? Get out."

"Very pretty manners, my lord. Where did you learn them?"

"Never mind that, my girl," he retorted, his pain-ridden voice turning the words into a breathless growl. "Your own are nothing to boast about. You've no business in my bedchamber."

"No, but if you do not cease to behave like a child and let the doctor examine you, I shall remain here, sir. Take those things away, William," she added, speaking to the footman who emerged just then from Greyfalcon's dressing room. "His lordship does not want them, after all."

William, looked from Sylvia to his master, swallowed carefully, and flushed to the roots of his hair. "M'lord?"

"Bring them here, William. At once." This time there was no mistaking the fact that the effort to speak was painful.

"Stop right there, William," commanded Sylvia as the footman took another step toward his master.

William hesitated, looking again from one to the other, and Greyfalcon demanded angrily, "Where the devil is Wigan?"

"Out, m'lord. You told him you wouldn't need him until after eight, that you was dining at Brooks's."

"So I did. Don't stand there gaping at me, man, bring my clothes. You don't take your orders from Miss Jensen-Graham."

"William," Sylvia said quietly, "put his lordship's clothes back at once and run downstairs to call those men back up here. They will not have gone yet, because I am persuaded that her ladyship will have ordered refreshment for them. Tell them they are needed here again, and quickly."

Greyfalcon turned his gaze upon her. "What do you propose to do with them, if I may ask?"

"Certainly, sir. If you will not behave yourself and let the doctor examine you and prescribe for you, I shall have them tie you to the bed until he can accomplish his business. Reston suggested that course, and while I daresay you will not like it much, it will serve the purpose excellently well. And if you forbid William to

obey me, I shall simply send Reston himself. He is in the corridor.''

Greyfalcon glared at her. "Rather drastic methods, are they not?''

"To be sure, sir, but your mother is very worried about you and cannot help but compare this occasion to that when Christopher was thrown by his pony. Having remembered so much, she also remembers that you are the only son left to her. It is for her sake as much as for yours that I am determined that you shall let the doctor examine you.''

"But I am fine," he protested. "Barring some bruised ribs and a bump on the head—a bump that aches like the devil, I might add—and barring the fact that I've not the slightest memory of how I got home—''

"Do you remember what happened before that?'' Sylvia asked, recalling just then that Christopher had retained no memory of the incident that had led to his injury. As soon as she saw the arrested look in Greyfalcon's eyes, she knew the answer to her question.

"I went to the Commons to look for Perceval," he said slowly. "I remember that much. The session was just ending, and I remember thinking I might not see him straight off in the crowd, so I moved a little nearer the wall and made my way toward the door through which I thought he would come." He frowned, making the effort to remember, but then, with a grimace of pain, he gave it up. "I must have been pushed against the wall or something. Extraordinary. I ought to remember. I don't even know if I saw him, so I don't know if I've got an appointment to discuss your book with him or not.''

"Never mind about that, sir," she said, deciding on the spot to tell him nothing at the moment about the prime minister's assassination. "Surely you can see that you must let the doctor look you over. Must I call for reinforcements, or will you behave reasonably?''

He leaned back against the pillows, his lips twitching

slightly as though they would smile if he would but let them. "You seem to leave me no choice, ma'am. Go away, William."

"He is to remain in case the doctor requires any assistance," Sylvia told him. When Greyfalcon looked mulish, she added sweetly, "Or if you prefer it, sir, I can remain."

His lips tightened into a thin line for a moment, but then his countenance relaxed. "That's two, my dear."

"Two, sir?" She tilted her head a little to one side.

"Miss Mayfield and now this. Revenge will be sweet."

She chuckled. "Do your worst, my lord. I shall only be glad to see you up and about again, but not until the doctor gives you leave. Understand that, Greyfalcon. I will have your word before I depart from this room."

His gaze met hers, and she was certain for several moments that he would refuse to comply with her demand, but finally and without looking away, he said, "Very well, ma'am. I am your obedient servant. Now, go."

She turned to obey and had her hand on the doorknob when he said her name quietly. She looked back.

"What would you have done if I had simply got out of bed despite your presence? Had you considered that?"

At a sudden loss for words and blushing furiously at the vision that leapt to her mind's eye, she flung the door open and hurried into the corridor. "He'll cooperate, Doctor," she said, grinding her teeth. "I hope whatever you do to him is excruciatingly painful."

Baillie smiled. "Sorry to disoblige you, ma'am, but I'm only going to take a look at his ribs and then bleed him to relieve the pressure of the concussion. I won't ask how you convinced him to submit to my examination, but I think perhaps that I had better speak to you again after I have looked him over. He ought to remain

in bed a day or two at least, and perhaps more. And he must not be agitated."

"Should we not tell him about the assassination then, sir?" she asked, carefully keeping her voice low.

"What assassination?" She told him. "God bless my soul, what a dreadful thing! No, no, on no account must he be told. Goodness, he may have witnessed the whole thing. Do they know who did it? His evidence may be very important."

"They caught the man at the scene," Reston said in his grave way. "Some poor malcontent who just stood there, the gun still smoking in his hand, till they carried him off. Greyfalcon may have seen what happened. I did not, but I know several others did."

"Well, it's as well they won't want his evidence, because that would put a tremendous strain on the man, and it is much better that we allow his memory to return naturally. He will attempt to force it if he knows where he was and what he may have seen, and that won't help at all, so keep the papers away from him and try to be sure any visitors he may have do not blurt it out. Indeed, I think I will forbid visitors for a few days at least, particularly if his ribs are badly bruised."

He left them then, and Sylvia took Reston farther down the corridor so as not to take a chance of their being overheard. "Do you know anything else, Harry? Who the man was? Why he shot poor Mr. Perceval?"

"Nothing. I learned what had happened at almost the same moment that I saw Greyfalcon. There was a huge flurry of movement just when the shots were fired. Several men were knocked down as others rushed to apprehend the assailant. I should have thought Greyfalcon was large enough and strong enough to avoid such a fate, but it is entirely possible, since he was by the wall, that someone barged into him and he knocked his head against the wall itself. Marble, you know. Hard stuff. No doubt there will be a complete description of the event in all of tomorrow's papers."

There was indeed a complete account of the dreadful

deed in all the morning papers, and Sylvia found her parent and Lady Greyfalcon poring over these when she entered the breakfast parlor rather earlier than was her custom.

"Only listen to this, dear," commanded the countess. "He hid, it says here, 'behind one of the folding doors of the lobby of the House of Commons; and when, about a quarter-past five, the ill-fated Chancellor made his appearance, Bellingham—for that was the unhappy creature's name—shot him through the heart. Perceval reeled a pace or two, faintly called out that he was murdered, and then fell. He was at once raised and carried into the Speaker's apartments, but he died in two or three minutes.' And what is more, the man actually had another pistol in his pocket, in case he missed with the first shot. Oh, it is simply too dreadful. To think that Francis might well have been standing right beside the man, that he might have been shot in his place. Oh, it does not bear thinking about."

"Then do not think about it, madam," recommended Lord Arthur, looking up from his own paper just then. "Your son is quite safe and sound upstairs in his bed."

"Hardly sound, Papa," Sylvia said. "I've just spoken to Wigan, and he says his lordship passed a difficult night. He was forced to slip him some laudanum in a mug of ale, for despite his promise to me, Greyfalcon refused to take the stuff when it was offered."

"Oh, it is always the same with him," said Lady Greyfalcon, shaking her head. "He detests being molly-coddled, as he will call it, and has done since he was a boy. He would never take his medicine, even when he was in the nursery. I can remember Nurse telling me she had been forced to hold his nose until he opened his mouth to breathe, just to get a dose down him. And then, like as not, he'd spit it out again and have to be smacked."

"Well, Wigan cannot do either of those things," said Sylvia, chuckling at the vision these words brought to

mind. "His lordship is sleeping now, and Wigan hopes he will not make too much fuss over being ordered to keep to his bed. He did give me his word, so I believe he will stay there quietly."

She spent the earlier part of the morning persuing the articles in the papers regarding the assassination, and then proceeded to the drawing room to greet morning callers with her hostess. The first of these was Mr. Lacey.

"Hope you'll pardon the intrusion," the young man said, "but I only just heard late last night what happened to Greyfalcon, so I came 'round directly I had had my breakfast, to visit him and see what I might do to help."

"Thank you, sir, you are very kind," Sylvia said, forestalling the countess before she might give her consent to his visiting the earl, "but the doctor has forbidden him any callers until he is feeling more the thing."

"Good God, then it must be serious business!"

"He has a concussion, Mr. Lacey," said the countess, lifting her chin a little as though she feared it might begin to tremble. "His ribs are possibly cracked, and he was still unconscious when they brought him home to us."

"But he is not still—that is, surely—"

"He is recovering well, sir," Sylvia said, taking pity on the young man. " 'Tis merely that the doctor fears he will attempt to do too much too soon. His ribs hurt, and he becomes dizzy when he attempts to sit up, but the doctor assures us these symptoms will pass, as will the pain in his head."

"But what happened? I heard all about the assassination, of course. No one could talk of anything else, which is why I didn't hear sooner about Fran. Don't tell me the fellow knocked him down as well as killing the prime minister."

"No, no, we are certain that that at least was not the case. He has no memory of the events just prior to his

accident, but he was not near enough to Mr. Perceval to
have taken a bullet, and Lord Reston believes he was
merely knocked against the wall in the surge to appre-
hend the assassin."

Mr. Lacey would no doubt have asked more
questions, but just then Mrs. Mayfield and her daughter
were announced, and he had perforce to give way grace-
fully to the newcomers. When they asked similar
questions, though, he spoke up before either of his
hostesses might do so, and Sylvia gratefully let him have
the floor, thinking that the conversation would be
repeated often enough as the day passed. A moment
later, when Lavender approached her to ask if there was
anything she might do to help, Sylvia smiled at her.

"Nothing, thank you. The doctor has ordered
complete rest, and Greyfalcon has agreed to obey him."

"Oh, dear, and I had so hoped he might be well
enough to take me for a drive in the park this afternoon.
He is always saying we will do so one day, but whenever
I mention that a particular day might be just the one, he
has pressing engagements that cannot be put off.
Surely, a quiet drive would not hurt him, Sylvia."

"I'm dreadfully sorry, Lavvie, but the doctor was
most insistent that Greyfalcon remain quietly in bed.
Look here," she added as an idea occurred to her,
"poor Mr. Lacey is quite beside himself with worry, for
he is a very good friend of Greyfalcon's, you know, and
the doctor will not even allow him to visit. I can think of
nothing better calculated to take his mind off his worry
than for him to treat you to a drive through the park.
He has an elegant curricle, you know. I have had the
pleasure of riding in it. One sits up high and can see all
one's friends and show off one's gown. Quite delight-
ful, Lavvie. You would enjoy it above all things."

"Oh, to be sure, but I daresay . . . Why, though we
have met several times, I scarcely know Mr. Lacey,
Sylvia."

"That can be altered in a trice. Mr. Lacey, Miss
Mayfield has just been telling me that she has never been

driven in a curricle, and I was telling her how very well you—"

There was no need to say more. Mr. Lacey would be delighted if Miss Mayfield would do him the honor of driving with him that very afternoon. Thus, when a footman entered the room a moment later to inform Miss Jensen-Graham that Mr. Wigan desired her presence on the second floor, if she could spare the time, Sylvia was able to leave with a sense of having accomplished something rather clever.

On the stairway, however, when the footman said in a low voice, "If it pleases you, miss, Mr. Wigan says can you hurry," she glanced at him and quickened her pace.

Upstairs, her gentle tap on Greyfalcon's door was greeted by a bellow. "Go away!"

A moment later the door opened, and Wigan stood there, his face red, his expression pleading. "Come in, miss. We are not having a good day."

"Out, Wigan," commanded his master, "and do not let me see your face again—ever."

"Dear me," said Sylvia, smiling at the manservant. "You seem to be in his black books, for certain."

"Aye, miss, he's given me the sack again. Only done it twice this month, but this time he sounds as if he means it."

"Nonsense," she said bracingly. "He wouldn't know how to get on without you. I'll stay now, so you may go away for half an hour. But mind you come back, Wigan. He needs you, even though he is too churlish to tell you so."

With these words, she pushed the little man out the door and shut it behind him.

"Open that door."

"I shan't. You are only going to bellow at me, and there is no sense in making a gift to the servants of your childish temper tantrums. You ought not to treat Wigan so badly. He is very kind to you."

"Kind! The man poisoned my ale. If I had a headache yesterday, it is nothing to the one I've got today, and I

recognize this one. 'Tis nothing more than laudanum.''

"The doctor said you were to have it. Wigan was merely following his orders."

"Oh, was he? Well, it can't have been very good to mix the stuff with ale."

"No, probably not, which is why you will henceforth take it when it is offered to you."

He sighed, moving uncomfortably against the pillows. He looked hot and tired. "Sylvia, open the door. You ought not be in my bedchamber with it shut unless someone else is in here with you, even if I am weak as a kitten. Go on," he added when she still hesitated. "I promise I won't bellow, but I promise also that if you do not obey me at once, I shall get up out of this bed and open the door myself."

"Very well, sir," she said, moving to do as he bade her, "but you still have not agreed not to make another fuss when Wigan brings your medicine."

"Nor shall I. Look, Sylvia," he added when she opened her mouth to explain just why he should do as he was told, "laudanum always makes me ill. I discovered that when I was a child. My nurse used to give it to us at the least little sign of anything, and if I refused, I only got a larger dose tipped down my throat while she held my nose. If I spat it out, I got smacked and then got yet another dose. It's a wonder she didn't kill me with the stuff."

"She was only trying to do her job, sir."

"Maybe, but the stuff makes me ill. Once I learned to hold it in my mouth until she turned away and then to spit it out, things went better, but I still react badly to it, so don't ask me to take any more. A mug of ale by itself or a glass of wine will help me sleep if I need a reposer."

"I doubt if spirits are good for you when you are ill, sir, but a mug of chocolate will do. Would you like a cold cloth for your head?"

His expression lightened at the suggestion, so she wrung out a cloth in the washstand basin and smoothed it over his brow.

"No more laudanum?" He looked up at her.

"Very well. Would you like me to read to you? That ought to put you to sleep if anything will."

"Not if you intend to read any of the drivel that Wollstoncroft woman wrote, I don't. It isn't kind to read emancipation nonsense to a man tied to his bed. Why has no one been to see me? I thought surely Lacey and some of the others would come to see if I'd snuffed it or not."

"Mr. Lacey was here this morning," she told him, "but the doctor thinks it best that you have no visitors for a day or two until the dizziness and the pain in your ribs pass off. Miss Mayfield also called," she added to forestall argument. "She was expecting you to drive her in the park today."

"Blast the girl. Well, at least that's something. She won't be able to hold my hand and whisper in my ear."

"Goodness, does she do such things?"

"Much you would care, setting her on to plague me as you did. No, of course, she does not. But I daresay she would, given half an opportunity."

"Well, Mr. Lacey has very kindly offered his services in place of yours. He will not satisfy Lavvie nearly so well, of course, but I daresay she will get by."

"Bless Lacey," said his lordship fervently.

Keeping the news of the prime minister's
assassination from Greyfalcon was more difficult than
Sylvia had expected it to be, because the newspapers
were full of it for days. Even the stately *Times* filled its
pages with verbatim accounts of parlimentary dis-
cussions and proceedings, the Regent's personal
reactions, those of the man in the street, and with dis-
cussions and debates over the apparent freedom of
criminals to do their dastardly deeds anywhere they
pleased. news of Wellington's army took second place,
though that was possibly because the enemy, for once,
appeared to be in retreat.

Sylvia resorted at first to subterfuge, instructing
Wigan simply to forget to take the papers to his master,
and for the first two days, Greyfalcon slept a good deal
and took little note of their absence. On the third day,
when Wigan told her he didn't think the same tactic
would succeed, she told him to do what he could until
the doctor arrived and could be consulted. Wigan
shaved his master and helped him change his nightshirt,
and those two exertions tired him so much that he never
thought to ask about the papers before Baillie arrived to
examine him. When the doctor had gone, Sylvia entered
the bedchamber to discover her patient in no very good
mood.

Wigan received her entrance with a smile of relief, but
Greyfalcon practically snarled at her, "Damned leech
says I've got to stay at least another two days in bed. I
may have promised to obey him, Sylvia, but this is
ridiculous. There's nothing the matter with me barring

the dizziness, which I daresay would pass off if I were to move about more.''

"And difficulty breathing, though he hides it," muttered Wigan. "One o' them ribs is most likely cracked, Doctor says. Best he should rest, Miss Sylvia.''

"Indeed, yes, but no doubt he is bored to distraction. Do you go and fetch some cards, Wigan. Perhaps a few hands of piquet will cheer him up. Will you play with me, my lord?''

He shot an enigmatic look at her from under his brows, but when she met it with a bland one of her own, he smiled. "Can you play well? I am an excellent player, myself.''

"And so modest, too. I play tolerably well, sir. It is one of the few pastimes Papa indulges in when he can be dragged from more academic pursuits.''

She quickly discovered that she was no match for him at cards, but she could hold her own at chess and the next afternoon was able to beat him three times quite soundly at backgammon. He made no more protest after that over staying in bed, and when Baillie pronounced him fit enough on Friday afternoon to remove to a chair in his library, he surprised them all by saying that he thought he would wait a day or two more before attempting to make his way downstairs.

"There's still an occasional dizziness," he told Sylvia when she expressed her surprise at this action.

If she noted a similarity in his demeanor to that of his mother when she was feeling a need to be pampered, Sylvia made no mention of it. As the days passed, she had come to enjoy the privacy of their afternoons and was by no means in a hurry to share him with other visitors.

He was allowed visitors by then, of course, but between them, Sylvia and Wigan kept these to a minimum and made certain that their visits were brief. Each was warned to say nothing about the assassination, for despite his seemingly normal recovery, Greyfalcon had shown not the least sign of having

remembered any of the events that had taken place at the time of his injuries, and it was still thought to be best to let nature take her course.

The cat nearly flew out of the bag one day when Lacey casually mentioned the battles raging in Parliament.

"What battles?"

Lacey shot a grimace of remorse at Sylvia, but spoke up quickly and with much the same casual air he generally affected. "Oh, you know, all the nonsense between Canning and Wellesley over the Regent's debts. The word is that Wellesley may resign his cabinet post."

That incident passed harmlessly enough, because his lordship wasn't particularly interested in any of the combatants. On Monday morning, however, Sylvia had barely filled her plate in the breakfast parlor, when one of the younger footmen rushed in and, without apology, blurted, "Oh, miss, Mr. Wigan says will you come at once. His lordship is in a fine rage and is shouting for his clothes and his curricle. And he wants all of the newspapers for the past week, only, Miss Sylvia, they've been thrown out, the lot of them."

"Never mind, Toby, I shall go up at once."

She found Greyfalcon in his breeches and shirt, trying to tie his neckcloth.

"Damn the thing, why won't it cooperate? What the devil are you doing in here?" he demanded when he caught her reflection in his looking glass. "Can't a man have any privacy?"

"Wigan sent for me," she replied calmly. "What has put you into such a rage, sir?"

"Don't come the innocent with me, my girl. If you are not responsible for the fact of my having been kept in the dark for a week, then I shall be very much surprised. You may count yourself fortunate that I am still a trifle under par, or I would show you just how I feel about your mischief. Only look at that, and tell me if I am not right to be upset." From a stack of papers, he pushed a copy of the *Times* toward her, then pulled it

back again. "Not that. Where is the damned thing? Oh, here." He extracted a broadside from beneath the newspaper and held it out to her. "See anything familiar?"

She saw with a frisson of shock that it was a drawing of the assassination. Both assassin and victim were clearly depicted, and she realized with a gasp that she recognized Bellingham. He was the burly man with the Roman nose who had accosted her outside Greyfalcon House.

Greyfalcon was watching her closely. "Ah, you do recognize him. Have you not seen this picture before?"

"No, sir, there were no pictures in the papers—certainly not in the *Times*—and those accounts are the only ones I have seen. How came you by this?" she asked in a sharper tone.

"I've my methods." Then, as she continued to look at him, he shrugged, and did so without wincing, she noted. "All right, I realized this morning that I hadn't seen the papers for a week and that it couldn't have been entirely by oversight, since I'm quite certain I asked for them on more than one occasion. The most logical explanation would be a conspiracy among the lot of you, so I didn't ask this morning. I greased young Toby in the fist instead and sent him out to get the *Times* and whatever else struck his fancy. His taste in papers appears to be somewhat more plebeian than my own, but the account there of Bellingham's hanging, even in the *Times*, is lurid enough to appeal to the lowest taste."

"He hadn't been hanged yet when this was written," Sylvia said, picking up the newspaper to scan the account indicated. "He's to be hanged today."

"Yes, for the proper amount of time, it says there."

She shuddered, then looked at him curiously. "Why have you ordered your curricle, sir? I can see that you are in fine fettle this morning, but do you think you ought to leap out of bed and into a curricle in practically the same motion?"

"I had thought to find out whatever I might about

that fellow. By this account he clearly had a grievance against the government, but I cannot imagine how he would know about that book when he appears to have spent the last few years languishing in a Russian prison. I want to see if I can discover why he wanted the book.''

"If he had a grievance against Mr. Perceval, possession of the book might have got him an audience at least," Sylvia pointed out.

"Perhaps, but that still doesn't answer the question of how he found out about the book in the first place, or how he knew you had a copy."

"Major Teufel?" Sylvia suggested. "He is the Regent's man, and he knew."

"And Perceval, only Saturday, laughed in Prinny's face when he demanded payment of his debts."

They stared at each other. "Greyfalcon, what are we thinking? This is too dreadful for words."

He nodded. "Teufel is known to have a near doglike devotion to his master. He has no morals to speak of, and fewer notions of civility. We can deduce without much fear of being wrong that Bellingham acted as his agent on at least one occasion in the past, and Teufel is the Regent's faithful minion. Is it possible that the Regent is somehow involved in Perceval's assassination?"

Sylvia's eyes widened as she had another thought. "Greyfalcon, do you remember what happened when you were hurt?"

"Not all," he said. "I don't remember seeing Bellingham, for example, but that's not to be wondered at. By the look of this drawing I must have been behind him, and I'd not have seen him so clearly as this, anyway, because there were a number of people milling about. I heard what must have been the shot and then someone bashed into me and everything went black. No doubt the fellow who hit me was trying to get out of the way. Sensible thing to do with some crackbrain firing off a pistol."

"What are we going to do?"

He was silent for a long moment, then sighed. "I think, however much I dislike the notion, that we are going to do nothing."

"Nothing!"

"Nothing. Consider, Sylvia, what evidence we have. None. You can recognize Bellingham. You are nearly certain that Teufel must have intercepted your letter to Perceval. You never received a reply to your second letter, or I to my first, so they must have gone astray as well. There is a pattern, certainly, but the fact remains that we cannot prove a link from the Regent to Teufel to Bellingham."

"You must talk to Bellingham, then."

He shook his head. "It is too late. Read the paper. He may not have been hanged when the account was written, but he is now. His execution took place at eight o'clock this morning. I had just thought to find people who knew him, to question them, but now even that might be dangerous."

"Gracious, but what if—"

"What? You think he might have been innocent? He wasn't that, whatever else he may have been. He shot Perceval, all right, in front of dozens of witnesses. Moreover, he confessed to it on the spot and handed over not just one gun but two. His only remorse seems to be that he believes he shot the wrong man. He is quoted here as saying under examination that he ought to have shot Leveson-Gower instead."

"Well, Leveson-Gower was our ambassador to Russia when Mr. Bellingham was arrested and imprisoned. No doubt he believed that his ambassador ought to have helped him."

Greyfalcon nodded, but his thoughts were clearly elsewhere. "Look here, Sylvia," he said suddenly, his eyes hard as his gaze caught and held hers, "I want you to promise me you will say nothing of this discussion of ours to anyone. Not to Lord Arthur or Mama, certainly, and not to Lady Joan. The matter of the book has got to be laid to rest. With Perceval dead, there is no

one other than the broadsiders who will be interested in it anyway. The Tories are still in power, and the Regent will just have to deal with them on his own. In fact, probably the best thing to do with that book is to burn it before someone uses it to raise a dust he can't settle."

But although she agreed to obey him in the matter of keeping silent, Sylvia could not agree to destroying the book without at least discussing it with her father. She had been brought up to have too high a regard for books to treat the destruction of one lightly. And Lord Arthur was firmly opposed to the idea.

"Nonsense," he said when she broached the subject to him. "That copy may well be the last in existence. No need to puff off the fact that we have it, of course, but Perceval don't want it now, and we owe it to history to keep the book. Indeed, I think I should perhaps like to dip into it, to see what all the fuss was about. Then I'll just put it with the rest of my books at the manor house."

Even Greyfalcon had no objection to that. Nowhere could a book be more safely lost than among Lord Arthur's other volumes, he told Sylvia with a laugh.

"Indeed, sir, I doubt that anyone would take the time and trouble to look all through Papa's books to find that one."

"You will remember what I said to you earlier, however," he said in a low, commanding tone. "You are not to mention any of our suspicions to a soul. I mean that, Sylvia. It can do no good and may well do harm."

Sylvia agreed, as much because she had come during the past weeks to care a great deal for him and for his opinions as for any other reason. And she had every intention of obeying him, for it was not difficult to realize that her safety might depend upon her silence. After all, the Regent was not without powerful friends.

Having decided that to make their suspicions known would simply not be sensible, Sylvia was a little leery of attending the Carlton House ball the following night. She had every expectation of seeing Major Teufel

among the guests, and she was not by any means certain that she would be able to control her expression well enough to keep the man from guessing that she harbored suspicions of his complicity in the Perceval assassination.

She could not let Joan down, however. They had planned together for this event for weeks, and it was to be one of the major social events of the Season. If she found it surprising that everyone expected life among the members of the *beau monde* to go on as usual after the assassination of the prime minister, she was intelligent enough, too, to realize that when it came to a choice between offending the royal family and offending the family of a politician, there could be no choice. Politicians came and went. The royal family went on forever.

Certainly there was not the least hint of mourning at Carlton House when the carriage carrying the Reston party drew up at the north front Tuesday night. Besides Reston, Lady Joan, and Sylvia, the group included Lady Ermintrude Whitely, who fluttered her fan and began at once to look about for her particular friends, and Mr. Lacey, who was dressed with his usual flamboyance in pantaloons, a maroon coat, and an emerald brocade waistcoat. There was a light rain falling, but the guests did not have to worry about getting damp, for each carriage could be driven right in under the portico, where its passengers stepped down upon perfectly dry carpeting with the assistance of the footmen on duty there.

The Reston party mounted the wide steps to the great hall, which was a spectacular chamber surrounded on all four sides by open screens of Ionic columns and surmounted by a coffered, top-lit ceiling. The mahogany furniture designed many years before by Henry Holland contrasted with the richer gilded furniture the Prince had acquired since that gentleman's departure.

"I have been here many times since the fete last year in celebration of the Prince's accepting the Regency,"

Lady Ermintrude confided behind her fan to Sylvia as they passed through the main hall and then through the pages' hall to the circular drawing room, "and I declare his highness changes the furniture so often that one can scarcely catch a glimpse of each new arrangement before it is turned off for another."

"And each lot," put in Joan, who had overheard, "is more fantastical than the last. Only wait until you see the octagonal vestibule, Sylvie. We will pass through it when we go downstairs to the conservatory later in the evening, for I promise you 'tis a sight that ought not to be missed."

Sylvia was missing very little. She had never been to Carlton House before, and it was truly a sight to inspire awe. Her only wish was that Greyfalcon might be there to share the experience with her. He would mock the extravagance and the magnificence equally. Of that she had no doubt. But it would be fun to hear what he had to say. Indeed, after all the time she had spent in his company during the past week, this evening without him seemed a trifle flat.

She knew that the huge room in which they now found themselves was where the Regent held receptions, and that even more often he used it as a music room. Tonight it was clearly the main reception room for the ball. She looked about her for a glimpse of the queen, who had promised, for once, to act as her son's hostess, but she was disappointed, for her majesty was nowhere to be seen.

"They will both be in the throne room," Joan informed her in an undertone. When Sylvia turned to look at her in astonishment, she smiled. "I couldn't think of anyone else you might be searching for. The throne room is there to the south. The dancing will be in the crimson drawing room, there." She pointed to the north end of the room.

"His highness had the old throne room turned into an audience chamber last year," Reston told Sylvia. "Said it was too small, that he wanted something grander."

"Wait till you see it," his wife said with a grin.

Indeed, the room was all that Joan had promised. Dominated by an elaborate stuccoed, painted, and gilded ceiling supported by an elaborately carved and gilded entablature above gilt pilasters, the vast chamber boasted overdoors representing the orders of the Garter, the Bath, St. Patrick, and St. Andrew, heavy red velvet curtains festooned with gold fringe over white silk, and a magnificent red-and-gold carpet.

The Regent and his mother occupied a pair of matching, heavily carved chairs at the west end of the room, and Lord and Lady Reston, Miss Jensen-Graham, and the others in their party moved to join the guests who were being presented. Since it was not a formal presentation by any means, the line moved quickly, and it was not long before Sylvia was making her curtsy, first to the Regent and then to the queen. She had been formally presented the year of her come-out, but she had not seen her majesty since, and she was appalled to note how much older the woman looked. Still, she received a gracious smile and a kind word. As she rose from her curtsy and began to move aside to make room for the next person, she caught the Regent's eye upon her. She could not mistake the appraising look he gave her and was annoyed with herself for blushing.

"Good gracious, Sylvie," Joan said, laughing as they moved out of the throne room and back into the circular drawing room, "he looked as though he'd like to eat you."

"Don't encourage the man, whatever you do," Reston said in a tone purposely lowered to avoid carrying his words beyond the two ladies to Mr. Lacey or Lady Ermintrude. "Your rank will not protect you from him, and he can be most offensive to those who do not appreciate his attentions."

"I doubt she needs such a warning, Harry," his wife said in a similar undertone. "Sylvia is no green girl, you know."

"Sylvia is a very pretty girl," retorted her husband,

"and if she knows how to snub the Regent, she is unique. The only person I know to have done it successfully is Beau Brummell, who snubs everyone and who is not a mere female. And even he treads on thin ice. A young girl wouldn't stand a chance. What's more to the purpose, my dear, is that it don't become you to dispute such matters with your husband in public."

"Oh, pooh, as if I care a pin for that." But she smiled at Sylvia and said no more.

The Reston party moved on to mingle with their friends as more and more people arrived. No one who was anyone was absent, unless like Lord and Lady Greyfalcon, they were in mourning. Dancing in the crimson drawing room began at ten o'clock, and for some fifteen minutes prior to that time the musicians could be heard tuning their instruments, the sound drawing the guests slowly but surely into the room. The grand promenade began precisely on the stroke of ten, and Sylvia found herself partnered with a perfect stranger for the opening minuet, but after that, Lacey came as he had promised to claim her for the country dances.

By midnight she had danced every dance and was well nigh parched, for the temperature of the room was high, and the Regent forbade the opening of any windows. His fear of the night air being well-known, no one dared to disobey this edict. Thus, when Lady Joan suggested that they visit the famous conservatory, Sylvia agreed immediately.

"Just to get out of this room would be enough," she said.

"Oh, no, you must see the conservatory, mustn't she, Harry?"

Lord Reston smiled. "Indeed, she must, if only so that she might tell our royal host that she has already done so. That is one of his favorite seduction ploys."

They passed through the hall into the two-story vestibule with its portrait gallery of the Prince Regent surrounded by his Whig heroes: Charles James Fox, the

Duke of Devonshire, the Duke of Bedford, and Lord Lake. The flashy crimson-and-gold upholstered benches and curtains were, Sylvia thought, completely in keeping with the rest of the furnishings she had seen. By comparison, Greyfalcon House seemed almost drab.

The lower vestibule was even more flamboyant than the area above, and to Sylvia's dismay, the rooms appeared to be warmer than those she had left behind. There was a hothouse atmosphere long before they reached the conservatory.

"The low ceilings are to blame," Reston said when she complained of the heat. "When we get into the conservatory itself, it will be better."

And so it was, though she was still conscious of a dampness in the air, but once inside the conservatory, she forgot every discomfort. There must have been twenty chandeliers casting a warm glow over the myriad plants beneath the high fan-vaulted ceiling of the Regent's neo-perpendicular extravaganza of cast-iron and translucent colored glass.

"This is where the fete supper was held last year," Joan told her. "The principal supper table, which was two hundred feet long, ran the whole length of the conservatory and on into the dining room there at the far west end of the building. Down the middle of the table flowed a stream of water, supplied by a silver fountain in front of the Prince and enlivened with mossy banks, miniature bridges, and goldfish."

"Yes," Sylvia said, "I saw the broadsides afterward. 'Gudgeon fishing à la conservatory' was my favorite. The ladies in all their finery waving fishing poles over the table." She chuckled, looking up and down the hall, trying to visualize the event. From where she stood, she could look down the length of the lower ground floor to the west end. The floor was black-and-white marble all the way, and all the arched doorways were lined up, giving a tunnel effect, with the tunnel growing smaller and smaller in the distance.

More people seemed to have had the same idea about

visiting the conservatory, and it was rapidly becoming as crowded as any of the rooms above, so Sylvia agreed at once when Reston suggested that they return to the festivities.

"I daresay that although supper will not be served until two, there will be a punch table in the circular room by now."

He was proved to be correct, and Sylvia accepted with enthusiasm the cup of arrack punch he procured for her, then stood back to allow Joan to be served next. A white-gloved hand on her arm startled her, and she nearly dropped her punch. Another hand on her wrist steadied her hand, and she found herself looking into the Regent's protruding blue eyes.

"Sir!" But when she attempted to curtsy, he stopped her.

"No need for that, my dear. I startled you. Here, step away from this mob. I wish to become better acquainted."

She looked around in near panic for Joan or Reston, but both had apparently been swallowed up by the crowd attempting to reach the punch bowls.

"I seem to have been separated from my party, sir," she said steadily. "Perhaps you can see Lord Reston. I am a trifle short to peer over shoulders."

"It will be easier to allow them to find you, Miss Jensen-Graham. Goodness, what a mouthful that is. I shall do myself the honor to call you Sylvia. Come away out of this crowd. Have you had the opportunity to visit my conservatory?"

"Yes, sir, I have. It is very beautiful."

He was, nonetheless, gently guiding her toward the door and short of digging in her heels she knew no way to stop him. There appeared to be no one of her acquaintance in the vicinity, though there were people everywhere. She smiled at the Regent, allowing him to take her into the pages' hall.

There was no one there at that moment except for four young boys in livery who stood stiffly by the wall

waiting for someone to send them on an errand. The
Prince ignored them. Sylvia was grateful for their
presence.

"Now, then, my dear, tell me about yourself.
Damme, but I cannot think why we have not had this
opportunity before."

"I am rarely in London, sir," said Sylvia. "I prefer
country life."

"Like it myself. You must come to Brighton one day
and see my little country house." He chuckled. "Not so
little actually, and a trifle expensive, come to that.
Those damned fellows in Parliament always carping
over what it costs. I ask you, m'dear, ain't it worth it?
Look at this place. Think a man could build a place like
this with coppers?"

"No, sir, I suppose not, but perhaps the men in
Parliament think there are other, more important uses
for the money."

"Important! What could be more important than
preserving our great works of art? Feed the poor, they
say. Well, I tell you this, ma'am, the poor have always
been with us and will always be with us. No one can feed
all the poor. But we can preserve such magnificence as
this, and, damme, we will. Now that that damned
Perceval is gone, maybe someone with a brain in his
head will take his place."

"Mr. Perceval's death was a sad tragedy, sir," said
Sylvia stiffly. "He was a man with a wife and family,
after all, and did not deserve to have his life cut short in
such a despicable fashion." She spoke impulsively and
without thought. When she realized what she had said,
she could not wish the words unsaid, but she was
grateful nonetheless that he did not seem to take
offense.

Indeed, he nodded approvingly. "You appear to
think just as you ought, my dear." He glanced briefly at
a small group of latecomers who chose that moment to
pass through the little hall, then turned pointedly back
to Sylvia, saying pontifically, "I, too, have considered

the poor man's family, and you will no doubt be pleased to know that I have made arrangements for them to be well-looked-after. I sent orders to Parliament only this morning ordering provision made for Mrs. Perceval and her family, and an annuity of two thousand pounds was granted to her, together with a sum of thirty thousand pounds to her family. They are numerous, you know."

"Yes, twelve children, I believe, but—"

"Ah, you are thinking 'twas still not enough to repay the loss of a great man," the Prince cut in with a broad gesture, "and, damme, I agree with you. Not nearly enough, I said. And so, my dear, there will also be a monument to his memory in Westminster Abbey and a grant to his eldest son, who carries his name and who is just on the point of entering Oxford or Cambridge—I forget which—of an annuity of one thousand pounds to begin the day of his father's death. And, in the event of his mother's death, there will be an additional one thousand pounds per year for the lad from a grateful nation. There, what do you think of that?"

So smug was his attitude, as though he had personally awarded the money from his own coffers, that Sylvia's teeth had begun to grind together halfway through his speech, and now, quite blind to the pages and deaf to any sound that might herald new arrivals, she retorted, "I think, sir, that 'twas the very least you could do, considering your own responsibility for the family's bereavement."

The Regent's shocked expression brought home to Sylvia the enormity of what she had said, but before she could speak, he exploded. "What's that you say? *My* responsibility? You dare to speak so to me! Damme, madam, what can you mean by such—"

He was interrupted by a voice a good deal less agitated than his own, and one, moreover that Sylvia was astonished to hear. "Good evening, your highness," Greyfalcon said, speaking over her shoulder. "May I suggest that we adjourn to a more private place to continue this conversation."

The earl's calm tone had the effect of drawing the Regent's attention to him, and of sending a surge of relief through Sylvia's body at the same time, but when she turned to face her rescuer, she encountered a look of such blazing anger that she was not by any means certain that she had been rescued at all.

15

The Prince Regent hovered on the brink of throwing one of his famous temper tantrums, but another group of chatting, laughing guests chose that moment to pass through the hall, and he thought better of it. Favoring the earl with a glare, he muttered grumpily, "Very well, Greyfalcon, though I intend to get to the bottom of this, and I can certainly do so without your assistance. I quite fail to see what my discussion with Miss Jensen-Graham has to do with you."

"She is presently a guest in my house, sir, so you will understand that I feel some responsibility for her." He glanced at Sylvia as though to assure himself that she would not be so foolish as to dispute that point, but she was still feeling the effects of the earlier look he had given her and had no intention of speaking. Having satisfied himself on that account, Greyfalcon turned back to the Regent. "Is there perhaps a room where we might discuss this matter without the rest of your guests becoming party to the conversation?"

"The plate room is nearest," said the Regent, indicating a narrow door in the southwest corner of the hall. "The pages have orders to discourage people from entering. I suppose it will be better there than if we were to traipse about together looking for a more private room. Come along." A page leapt to open the door and shut it behind them when they were inside.

The plate room was as well lit as any other room in the royal residence. Its walls were lined with glass-fronted shelves containing a vast array of silver and china that on any other occasion would have drawn Sylvia's attention to the exclusion of anything else. At

the moment, however, she scarcely noticed her surroundings, merely following in the Regent's wake until he drew up near one of the red-velvet-covered, gilt-legged benches and turned to face not her but Greyfalcon.

"I assume you heard what your ward had the impertinence to say to me."

"She is not my ward, sir, but only my guest," the earl said, "and yes, I am sorry to say that I did hear what she said." He glanced again at Sylvia, and his gaze slashed at her like the flick of a whip, making it all she could do not to flinch. He turned back to the angry Prince. "I hope you will act with your customary generosity, sir, and forgive her for speaking so stupidly."

"I should rather hear why she dared to say such things to her Prince." His highness turned a grim eye upon the culprit, folded his plump arms across his plump chest, and waited.

Sylvia glanced at Greyfalcon, but he showed no inclination to say more on her behalf than he had said already. She was on her own. "If it please you, sir," she said slowly, looking directly at the Regent, "though I spoke hastily and thoughtlessly, I said no more than I believe. No doubt it was unbecoming in me to have said what I did; however, you are known as the first gentleman of Europe and thus a man of honor. Can you honestly deny that you or your aide, Major Teufel, had anything to do with Mr. Perceval's assassination?"

The Regent regarded her in amazement, his eyes seeming ready to pop out of his head. Then he looked at Greyfalcon as though he expected that gentleman, since he had taken responsibility for her, to reprimand her for making such a speech. The earl shrugged, and there appeared a glint in his eyes of sardonic resignation. The Regent looked away again, and for the first time, he seemed unwilling to meet Sylvia's glance.

"What do you know of Teufel?" he muttered at last.

"I have met him," she said quietly, "and I believe he had a certain amount of influence over Mr. Bellingham."

"Well, you needn't make a song and dance about it," blustered the Prince, "and I certainly hope you will have the good sense to refrain from saying such things to anyone else. I shan't deny that Teufel carried influence. Damme, he was my aide, so of course he had power, and perhaps he exerted some of that power over the Bellingham fellow. And I'll not deny, just within these walls, mind you, that he might have overstepped himself." He glared at her, pushed out his lower lip, and straightened his shoulders. "Mistaken loyalty to his master, don't you know. But he's been punished for it already. Damme, I've sent him back to Hanover with a flea in his ear."

He paused for a moment, still glaring, then rushed on defensively, "Don't mistake, Miss Jensen-Graham, Bellingham got no more than he deserved. Fellow was a damned menace. Thought himself ill-used when the Russians gave him his just desserts for falling into debt, and he had the bad taste to go about trying to convince everyone that the British government ought to redress his grievances. Even had the cheek to come crying to me. Didn't see him, of course. Teufel got rid of him. Well, that was his job, wasn't it? Damme, the Bellingham fellow said he was going to kill Leveson-Gower, don't you know. Teufel may have told him I'd be better pleased an he did away with Perceval instead. Reasons he might have thought that. Mind you," he added, looking now from Sylvia to Greyfalcon and back again, "I don't say he did, and I don't think for a moment that Teufel actually believed the man would murder Perceval if he did suggest such a thing. Like Henry the Second telling those men he'd like to be rid of Becket. No sooner said than done, and no one more surprised than Henry. This time, no one more surprised than Teufel."

"I have met Major Teufel," Sylvia said evenly and in a tone that left no doubt as to her disbelief of this version of the major's behavior. "He attempted, sir, to persuade me to give him a book I had meant to give to Mr. Perceval. The very next day, Mr. Bellingham threatened to take that same book from me by force

outside Greyfalcon House. He could not have known
that I had the book unless Major Teufel told him, your
highness, and Major Teufel could only have known of it
if he intercepted a letter I wrote to Mr. Perceval.''

To her surprise the Prince seemed to regain his
balance with these words. "I've no doubt that that is all
quite correct,'' he said with a dismissive gesture. "It was
Teufel's business to keep an eye on Perceval for me. The
man's been a thorn in my side for years, and that
damned book no less so, if it is indeed Perceval's book
we're discussing. Teufel might well have promised my
favor to Bellingham in return for delivery of that book.
Perceval said he'd destroyed all the copies years ago,
but they keep popping up.''

He sighed. " 'Tis no more than a prejudicial account
of a trying time, and one, moreover that would prove
embarrassing to the Tories, just as it would to me.
Perceval decided long since that to publish the book
would only remind people what sort of woman the
Princess of Wales is, make them wonder why the Tories
supported her even if the Whigs did make a mess of
their investigation.

"I'll not deny that with Perceval alive I'd rather have
had the book in my possession than see it in his. Now,
without his glib tongue to make black look white, no
one will be much interested in it. A good deal of time
has passed since the incidents referred to, so that book is
no real danger to me now, Miss Jensen-Graham. In-
deed, if you still have it in your possession, I should be
happy to sign it for you. Someday, after we are all dead
and gone, it may be worth a great deal of money again,
but for now—" He turned up his hands in a dismissive
gesture,

Sylvia opened her mouth to return to the subject of
Teufel's dealings with Bellingham, but Greyfalcon's
large hand on her shoulder stifled the words in her
throat. "Miss Jensen-Graham no longer has an interest
in selling the book, highness. Her father is an eminent
scholar, as you no doubt know, and the book a part of

his collection. There it will remain. Since the matter is not worthy of further discussion, we will not keep you from your guests. I daresay her majesty has begun to wonder what's become of you."

"Lord, she retired an hour ago," the Regent said with a brief shrug. He turned to Sylvia. "I do hope you understand the situation, Miss Jensen-Graham."

She nodded.

His highness's mood changed again swiftly, and he clapped Greyfalcon on the back. "Since you accept responsibility for her behavior, my lord, I shall expect you to see that she keeps a still tongue in her head. Indeed, I suggest you marry her at once in order to keep her in line. Damme, it's not at all good form for a young woman to go about flinging unjustified accusations at her sovereign."

Sylvia's bosom swelled with indignation, but the firm hand on her shoulder kept her silent. She did not dare to look at either man, however, for fear that she would blurt out the words hovering upon her tongue. Simmering, she allowed Greyfalcon to return an enigmatic response, and a moment later they were alone.

"What the devil did you mean to accomplish by all this, you wretched girl?" he stormed the moment the Prince's back had disappeared through the door. "You ought to be beaten for saying such things to him, and, by God, if I have anything to say about it—"

Having quite suddenly no desire to fight with him, Sylvia bowed her head before the storm. Indeed, she recognized in his first words a tone of unmistakable relief that she had emerged from the incident unscathed and knew that his display of temper stemmed more from that relief than from real anger. Nonetheless, when the words continued to flow from him as he vented his fury over not merely the incident of the evening but others from the past, she decided at last that if he were allowed to continue unchecked, he might say more than he wished to say, particularly in view of the fact that the Regent had failed to shut the door tightly

behind himself. There was only one way she knew of to stop him.

She had turned a little away from Greyfalcon, and so wound up was he in his own diatribe that he failed to notice the tears as they began to course down her cheeks, but at the second sob, his words ceased as though someone had turned a tap.

"Sylvia, my God, Sylvia, don't cry!" Both hands clamped down upon her shoulders and he turned her to face him. "What have I said? Oh, Lord, Sylvia, you mustn't—I'm sorry. I've never seen you cry. I never meant for you to cry. Here, take this."

He tried to extract his handkerchief from his coat pocket, but she flung herself into his arms the moment his hand left her shoulder and sobbed against his chest. Greyfalcon, at a loss, first patted her back gently and then put his arms around her and murmured into her curls, "My dearest love, please don't. Every sob is cutting me to the bone. I had no right, no reason. 'Twas fear speakng, or, or . . . Oh, I make no sense. Darling Sylvia, I was so frightened when I heard your words to the Prince. No one has ever accused him of beating a servant to death as they have his brother Cumberland, but the whole family is unpredictable, and he is as good as king. At the very least he could effect your social ruin if he took it into his head to do so. Oh, dearest, do not cry."

"I have stopped, sir." Indeed, he was holding her so tightly she was finding it difficult to breathe, but she had found, too, that she didn't much care about breathing so long as he continued to hold her and to mutter such delightful things to her. But the moment she spoke, he held her away and looked anxiously down into her face.

"You know I didn't mean a word of what I said."

"On the contrary, sir, I am quite certain you meant every word, and that you will continue in future to be as abusive to me as you have been in the past." Her eyes were twinkling now, and although he regarded her searchingly for a long moment, he relaxed at last.

"You deserve to be beaten."

"See, it is just as I said," she told him. "You threaten me, you scold me, and I've not the least doubt you mean every word you say to me. I go in fear of your wicked temper, sir, truly I do."

He shook his head. "There have been times when I could wish that that were true, but you are a sad case, my dear. You pay no heed to me when all I desire is to protect you from your own impulsiveness. I warned you to say nothing to anyone about our suspicions, and what do you do but blurt them out to the Regent himself."

"Are you going to begin again, Greyfalcon? Because if you are, I must tell you that I shan't listen. You haven't the right to take me to task this way, sir."

"Oh, yes I do. You heard the man, I'm going to marry you in order to keep you out of trouble. Unless I much mistake the matter, that was a royal command, and while you may choose to play at ducks and drakes with the royal temper, I can assure you that I do not."

"Marry you? Surely not, sir. Such a notion has never crossed my mind." She looked demurely at her toes and waited to hear what he would say to that.

He shook her. "Never? We'll just see about that, my girl. I've known my own feelings for days." She continued to regard her toes, and a moment later he awarded her another little shake. "Sylvia, please, I know I ought to have waited before declaring myself. I have watched you these past days, and I believe you are beginning to recover at last from Christopher's loss—"

"Christopher?" She looked up at him then, for Christopher's name acted upon her like a splash of cold water. "Why do you speak of Christopher, sir?"

He smiled down at her, his hands caressing her shoulders now. "You loved my brother, sweetheart. I know that. I know, too, that his death was a terrible tragedy to you as it was to his own family, that you have avoided looking about you all these years for a husband because of that love."

Sylvia nibbled at her lower lip, uncertain what to say

to him. Then, at last, she looked up, looked directly into his eyes, searchingly, hopefully.

"What is it, love?"

"Please, sir, I don't wish to hurt you or to make you unhappy, but that simply isn't true. Oh, not that I didn't love Christopher," she added hastily when she saw disbelief in his expression, "for I did. He was the center of my life for so long that I was utterly lost without him when he died. But he was my friend, never my lover. The love I felt for him was a child's love, not—"

"Not what, Sylvia?" He seemed to hold his breath.

"Not what I feel for you, my lord."

He let his breath out in a long sigh. "Are you perfectly certain about that?"

"Yes, sir." She searched again and saw need for more than that by way of reassurance. "We were very close, practically as one when we were small and up to mischief together. But we saw less of each other as we grew older. Not that it seemed to make much difference, you know, once we were together again. We began talking then, each time, as though a conversation, rather than our lives, had been interrupted. But after he went into the army, I never had so much as a letter from him. It wasn't his way to write, and since we were not officially betrothed, he wouldn't have done so anyway because of the impropriety. He knew I should still be here when he came home, so it didn't seem necessary to write."

"That sounds like love," Greyfalcon said gently.

"Yes, surely, but when he died—and a part of me died with him—I didn't feel the loss like I expected to. There was still that feeling that one day he would return as he always had and we would be together again. Not a longing, sir, not like that. Only a feeling, and the feeling passed. I long since ceased to look up expecting to see him when a caller would arrive midsummer."

"But you stayed at the manor house. You never came to London again."

She chuckled. "You know my father, sir. I felt

needed, and I was content to let matters remain as they are. Papa needed me and was reluctant to frank me through another Season. I just assumed that I was meant to live my life a spinster lady. It didn't seem so terrible a fate."

He looked into her eyes, and she was able to meet his gaze without a blink. He was satisfied. "And now?"

"Now, I think I should prefer to be a married lady, sir, if anyone should ask me."

"Anyone?" His look became fierce.

She grinned at him. "Well, perhaps not just anyone. Mr. Lacey is very nice."

"Damn Lacey. With any luck your dear Miss Mayfield will capture him. Serve them both right. You're going to marry me, my dear, and that's the long and the short of it."

"Am I, sir?" She blinked at him.

"Aren't you, sweetheart?" His voice was gentle again, and the way he looked at her just then sent warmth rushing through her veins and a tingle to the center of her body.

"Oh, yes, I believe I am. Oh, Francis, I once told your mother that I should like to meet someone with whom I could be myself and say whatever I liked, instead of always talking drivel. And now, with you—" But she could say no more, for he had swept her into his arms again as his lips claimed hers.

At first the kiss was gentle, exploratory, but when she moved against him, his passions took over, and his arms tightened briefly before his hands moved over her body, touching, caressing, stirring her senses as they had never been stirred before. Sylvia responded enthusiastically. It seemed as though she had been waiting a lifetime for this moment. This man was not Christopher. Christopher had been a boy, a gentle laughing boy, a mischievous boy. He had been her best friend. But Greyfalcon was a man. He would be her husband, her lover, her life. When she was with him, he made her feel as though she might do anything, as though she could be

more than she had ever been before. He made her like herself better, for he brought out the best in her.

"Well, this is a fine thing, I must say!"

They broke apart, whirling as one to face the doorway. The door stood wide now, and an interested page could be seen peeping over Lord Arthur Jensen-Graham's shoulder.

"Papa!"

"Aye, Papa, and what are you doing, miss? And you, sir? A fine example." Lord Arthur swung the door shut behind him, nearly catching the page's nose in it.

Greyfalcon grinned at him. "You may demand to know my intentions anytime you like, sir. I assure you they are quite honorable."

"Eh? What's that you say?" He peered at them both through his silver-rimmed spectacles. "You mean to marry the chit, do you? Well, by all that's holy, that's a fine thing. We must discuss settlements."

"Papa, what on earth are you doing here?" Sylvia demanded.

"Doing here?" He blinked at them, thrown off his stride by what he had just discovered. "Well, I'm here to fetch Greyfalcon, of course."

"Fetch him. Good gracious, is something wrong? The countess, is she ill?"

"No, no, nothing of the sort," he retorted testily. "You women are all alike, always thinking the worst. Men are more sanguine, always. I must write a treatise on that fact. We don't go imagining foolish things—"

"Papa, for goodness' sake, have done. You just thought the most dreadful things about Greyfalcon not a moment since."

"Well, the man's a rake, and I found him kissing my daughter in a private room at a practically public ball," said Lord Arthur stoutly. "What am I expected to think?"

"Just what you did think, sir," Greyfalcon replied calmly, "but that gets us nowhere at present. What brings you to us?"

"But that's just what I was telling you. Women! Your mama sent me to fetch you because she insists you ought not to be at a ball." He drew himself up. "Not the thing, Greyfalcon, and you know it. Damme, man, you're in mourning. She would have it you'd do something foolish and disgrace not just yourself but her as well. Said you was jealous, couldn't stand the thought of Sylvia here, dancing with a lot of handsome young men like that Lacey fella. Told her she was imagining things, that it was all a hum. Would she listen?"

"I don't suppose she would," Greyfalcon said with a smile. "She was right, you know."

"Was she? I'd as lief you didn't tell her that if it's all the same to you. Not that she wasn't right about the mourning, certainly. Your father hasn't been in his grave six months yet, let alone twelve. You've no business at a ball, sir."

"Perhaps not," Greyfalcon agreed, "but I hope you don't expect to see me wearing black or observing more than the barest of—"

"I'll not debate the matter with you," Lord Arthur said in a lofty tone. " 'Tis no business of mine what you do—well, except an you wish to marry my daughter, of course," he added, coming back to earth again. "Your father . . . Well, the less said, the better."

"Agreed, but I must say this much. I've no intention of waiting the year out before I marry Sylvia. If you fear that people will talk, we'll take a ship to Italy or India for that matter, but I mean to marry her just as soon as I can find a parson willing to oblige me."

"Well, in that case," Lord Arthur suggested with a slight flush in his cheeks, "might I suggest that you discuss the matter with your mama's chaplain? I have done so, and he agrees that six months is quite a long-enough period for her ladyship to mourn a husband who caused more grief than happiness to everyone before his demise."

"My mama?" Greyfalcon frowned.

Sylvia stared from one to the other, for she had taken her father's meaning more quickly. "The countess intends to wed, sir? I declare I had no notion. Who is the lucky gentleman?"

Lord Arthur withdrew a handkerchief from his pocket and wiped his brow. "I have the honor to be that gentleman."

Sylvia and Greyfalcon exchanged looks of amazement, then both burst into laughter. Sylvia moved to hug her father. "Oh, Papa, I think you will suit each other excellently well."

"Yes, I believe we shall, though it came as the greatest surprise to me," confessed her parent. "I had not the least notion of marriage, but I see that it will do very well."

"Oh, it will," she agreed, "and I know just the gift to give you on the happy occasion. His highness has offered to sign your copy of *The Delicate Investigation*. I shall ask him to do so."

"No, you won't!" snapped Greyfalcon.

She chuckled, and Lord Arthur glanced from one to the other. "What's this in aid of? What are you talking about, Sylvia? I thought we had already decided not to mention that book to anyone. How can the Regent have offered to sign it."

"Never mind, sir," said Greyfalcon, still regarding his love with disfavor. "It is a long story."

"Well, I think you had better both accompany me back to Curzon Street at once, because I wish to hear it," Lord Arthur said. He looked at his daughter, who was controlling her features with obvious difficulty. "I say, Sylvia, you ought not to—that is, I daresay it ain't wise to stir the man's temper just for the fun of it. I don't think you can realize . . . Look here, Sylvia, do you not think you will dislike some of his—that is, I do not mean to cast aspersions, but he does have some habits, some pursuits—"

"Papa, I have never before heard you at such a loss for words, but I can assure you that Greyfalcon will

learn to do without some of those pursuits if he values
his skin." Sylvia turned a laughing face to the earl. "No
more actresses, sir, I warn you, or wild parties. Not
unless I am at your side."

His expression softened. "You will be there, my
dearest love, always."

"Look here," put in Lord Arthur, clearly uncom-
fortable, "do you not think we ought to take our
departure? This is scarcely the place to discuss—"

"No, you are quite right, sir," Greyfalcon agreed.
"Let us go at once."

"Wait, the both of you," Sylvia said, chuckling.
"Papa, how did you find us? Have you seen Reston or
Joan?"

He shook his head. "Asked the pages, of course.
What they're there for, ain't it? They pointed to the
door. It was open. I came in. Haven't seen anyone
else."

"Well," she said, "I can scarcely disappear when I
came in their carriage. Harry would be scandalized,
Lady Ermintrude would be sure I had been kidnapped,
and even Joan would fret. Indeed, I shouldn't be at all
surprised if they are not searching for me now, because
we had only just got separated when the Prince
demanded my attention."

"Yes, and I should still like to know what you meant
by going apart with him," Greyfalcon put in just then.

She smiled at him. "We can discuss the matter as
much as you like, sir, at the proper time. Just now I
think we ought to find Joan and Harry and tell them
that since you do not trust me to keep the line of what is
becoming, you are taking me home at once."

"Would you prefer to stay?" Greyfalcon asked sud-
denly but with noticeable effort. "I do not really
distrust you, you know. Indeed, to say that I was
jealous is—" He paused, unable to complete the
sentence.

"The truth, sir?" Sylvia suggested helpfully.

His lips twisted into a wry grin, and he nodded. " 'Tis

a new feeling for me, sweetheart, one I didn't recognize when first I took exception to your flirting."

"Well, don't apologize, sir. I like it very well. Papa, perhaps you would not mind just stepping into the circular drawing room—that door to the left opposite the one through which you entered. No doubt you will see either Harry or Joan somewhere in the crowd. Then you can tell them we are leaving."

Lord Arthur shot a look at Greyfalcon, who grinned at him again. "Very well, daughter, but I shall return at once."

"So we can't get up to mischief," Greyfalcon murmured when he had gone.

Sylvia laughed. "I can always get up to mischief, sir. 'Tis my nature."

He bent his head and kissed her lightly. "You will have to learn to be an obedient wife, will you not?" Then, as a new thought struck him, he straightened and looked down at her with a gleam of triumph in his eyes. "I will finally have my revenge, won't I, sweetheart? You have agreed to marry me, so I shall soon be your lord and master. By law, you will have to obey my every command or suffer the consequences."

She bowed her head submissively, so that he would not immediately see the twinkle in her eyes. "That will certainly be the case, sir. I shall be a most submissive wife, completely obedient, unceasingly observant of your every need." Then she looked up, delighted to see the disbelief written clearly upon his countenance. "I shall begin, sir, the same day upon which the sun begins to rise in the west."

Laughing, Greyfalcon caught her into his arms again, and when Lord Arthur returned, he found them just as he had found them before.